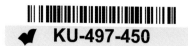
IMPRESSIONISM

Author: Tamsin Pickeral Foreword: Michael Robinson

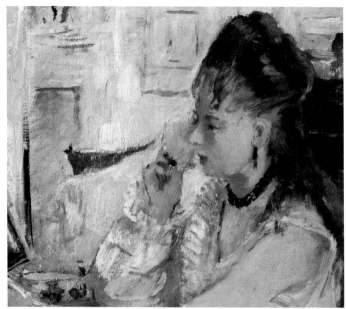

Berthe Morisot, *Young Woman Powdering her Face* (detail)

**FLAME TREE
PUBLISHING**

Pierre-Auguste Renoir, *Woman with Parasol* (detail)

Contents

Alfred Sisley, *Winter Morning*; Pierre-Auguste Renoir, *The Umbrellas* (detail); Claude Monet, *Impression, Sunrise*

Edouard Manet, *La Rue Mosnier with Flags*; Paul Cézanne, *The Card Players* (detail); Edgar Degas, *Woman in a Tub* (detail)

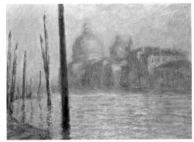

Claude Monet, *Santa Maria della Salute and the Grand Canal*; Édouard Manet, *Argenteuil*; Pierre-Auguste Renoir, *The Mosque (Arab Festival)* (detail)

Gustave Courbet, *Sunset, Trouville* (detail); Vincent Van Gogh, *Portrait of Père Tanguy*; Paul Gauguin, *The Yellow Haystacks* (detail)

Edgar Degas, *Green Dancers* (detail); Claude Monet, *The Parliament, Sunset* (detail); Pierre-Auguste Renoir, *The Bathers* (detail)

How To Use This Book

The reader is encouraged to use this book in a variety of ways, each of which caters for a range of interests, knowledge and uses.

- The book is organized into five sections: **Movement Overview**, **Society**, **Places**, **Influences** and **Styles & Techniques**.
- **Movement Overview** takes a look at the whole movement, beginning with some of the earliest Impressionist works of the 1860s right through until the end of the movement and beyond, to give the readers a perspective of the development of the movement itself and the artists involved.
- **Society** shows how the Impressionists' work reflected the times in which they lived, and how events in the wider world of the time were a source of inspiration to them.
- **Places** looks at the work the Impressionists created in the different places they lived and travelled, and how these places affected their painting.
- **Influences** reveals who and what influenced the movement, and touches on their inspiration to future generations of artists.
- **Styles & Techniques** delves into the different techniques the Impressionists used to produce their pieces, and the varying styles they experimented with throughout their careers.

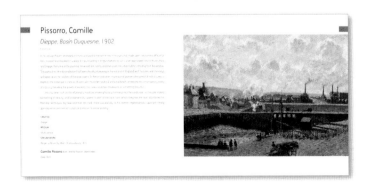

2. Title of work

1. Name of artist, by surname then forename

3. Date of work (if known)

Pissarro, Camille

Dieppe, Basin Duquesne, 1902

4. Information about the work and the context within which it was created

9. Picture credit

8. Location in which the work was created (if known)

CREATED

MEDIUM

SIMILAR WORK

Camille Pissarro

7. Medium in which the work was created (if known)

6. Similar work(s), either from the same or other artists, with similar styles, techniques or subject matter

5. Biographical information about the featured artist: name, date and place of birth and date of death

Foreword

During the last 25 years in particular, art historians have endlessly debated issues around Impressionism, its culture and its legacy. For example, Richard Shiff, writing in 1984, discussed how we define such a term. If the Impressionists were characterized by the social group to which they belonged then that would include Édouard Manet (who refused to participate in any of their exhibitions), and exclude Berthe Morisot, who was effectively barred from the café society to which her male counterparts belonged, on grounds of bourgeois impropriety. If Impressionism can be defined by its style or technique then it would include artists such as Jean-Baptiste-Camille Corot, whose paintings Émile Zola referred to as 'Impressionism corrected'. Based on technique, such a definition would call into question the inclusion of Edgar Degas, who participated in several of their exhibitions, but whose painting style was more akin to Manet's realism than Claude Monet's or Pierre-Auguste Renoir's bravura brushstrokes and use of colour. However, everyone agrees that Impressionism was a phenomenon that could only have taken place in Paris because of the extraordinary set of circumstances in the 1870s and 1880s.

As early as 1846 the writer Charles Baudelaire, writing a critique of that year's Salon exhibition, was persuading artists of the need to celebrate the 'Heroism of Modern Life' instead of endlessly depicting the past. Within 20 years of that call, Manet was painting his extraordinary and shocking pictures that offended bourgeois sensibilities. People were shocked both by the frank depictions of modern subject matter, and the anti-Academic style in which they were painted, which to most appeared to lack draughtsmanship and finish. From the 1860s on, Manet was holding court with a number of younger artists including Monet, Renoir and Camille Pissarro at the Café Guerbois, where with writers such as Zola they discussed the modernity of their transformed city and its depiction.

Claude Monet, *La Rue Montorgueil* (detail)

After the revolution of 1848, Paris, under the emperor Napoleon III and his prefect Baron Haussmann, was transformed from a medieval to a modern city. Many of the old buildings were torn down to make way for wide boulevards containing new shops, apartments and sites of leisure, such as the new opera house. There were new cafés and bars, restaurants and theatres with Paris becoming a centre of conspicuous consumption for the new and burgeoning bourgeoisie who were occupying the city's centre. The lower middle classes were also flocking to Paris at the prospect of finding work in the city, travelling to the city centre on the new railway system from the developing suburbs where they lived. Conversely, at the weekend, the bourgeoisie would travel out to the suburbs on the train to enjoy the leisure opportunities afforded along the Seine at places such as Argenteuil.

It was these sites of consumption that the circle of young artists around Manet would find so challenging to capture on canvas. How would they capture the essence of Baudelaire's modernity that called for elements of the immutable and the transitory, the eternal and the fleeting? Their paintings had to contain a sense of past traditions in art (that is paint on canvas), with a new style that would portray a sense of modernity's transitory moments. Furthermore, after the appalling events in Paris of 1870–71, the time was ripe for a more uplifting art, one that looked to the future, one that rejected the past and embraced colour to portray a sense of *joie de vivre*. Impressionism was born.

It marked the beginning of a change of direction in painting that emphasized colour to express form and create mood – a change that was to precipitate the exploration of paint itself, for its own aesthetic qualities, by subsequent generations of artists. Indeed it would be hard to imagine the luscious paintings of the twentieth century by artists such as Henri Matisse and Mark Rothko without the innovations of Impressionism.

Today, judging by the numbers in recent years that have attended the blockbuster exhibitions of the Impressionists' work, we are still fascinated and excited by their use of colour. We still adore the landscapes of Monet and Sisley, Pissarro's townscapes and the delicate, intimate portraits by Renoir and Morisot. We are equally enthralled by the voyeuristic depictions of the *demi-monde* by Degas and Manet.

This book is a celebration of the work of those artists whose names are now legendary. It is also a reminder of a time when painting ruled the visual arts. Our passion for these artists and their paintings remains.

Michael Robinson, 2007

Paul Cézanne, *A Modern Olympia*

Introduction

On 15 April 1874 an independent art exhibition opened at the former studio of the photographer Felix Nadar (1820–1910) in Paris. The exhibition was staged by a revolutionary group of artists who called themselves the *Société Anonyme des Artistes, Peintres, Sculpteurs, Braveurs, etc.*, and was in retaliation against the despised regime of the Salon jury. The organization of the exhibition was difficult, and complicated by clashes within the group, but eventually 165 works were hung and a catalogue put together by Edmond Renoir, brother to the artist Pierre-Auguste Renoir (1841–1919). One painter in particular was proving difficult to catalogue: he had sent too many works and they had uninspiring titles. When Edmond queried yet another of his paintings depicting a misty Le Havre harbour, the artist suggested he call it *Impression*. The artist was Claude Monet (1840–1926) and the painting appeared as, *Impression, Sunrise (Le Havre)*, 1872. It was this work that inadvertently gave rise to the label by which these artists and their paintings came to be associated, in large part due to a sardonic review that appeared on 25 April by the critic Louis Leroy who titled his piece, *Exhibition of the Impressionists*, and mercilessly ridiculed the pictures. It is no small irony that one of the most important and definitive art movements of the nineteenth century earned its name from a derogatory comment.

The development of art through the centuries is an organic and essentially evolutionary process. Changes in artistic style, technique and approach grow from what has gone before, either directly or antagonistically. It is a process that is inevitably associated with, and directly affected by, the historical and cultural climate. In this context, Impressionism emerged from the shaded forest of Fontainebleau, from Barbizon and the Realist and Naturalist painters Gustave Courbet (1819–77), Jean-François Millet (1814–75), Théodore Rousseau (1812–67), Charles-François Daubigny (1817–78), Jean-Baptiste-Camille Corot (1796–1875), and from the seascape artists Eugène Boudin (1824–98) and Johan Barthold Jongkind (1819–91). It grew from the ashes of war years and of revolution, through economic slumps and rises that saw the growth of the bourgeoisie, and through the expansion of industry and commerce and its invasion on the countryside.

Nineteenth-century Paris was the culture capital of the world – a capital of art, music, literature, philosophy, theatre, opera and dance – and it was to Paris that young artists gravitated to study and train. The emergence of the

Impressionists as a group is set against this background, and it is the sense of community, of shared ideas, relationships within the group, both good and bad, that is significant in the artists' development. Paris had a huge café culture, a lively exotic nightlife and was a bohemian centre, based around Montmartre, the Right Bank district and the Batignolles, to which many young artists were drawn. These places, and Café Guerbois in particular, were gathering spots for like-minded individuals where ideas, theories and banter were shared, often accompanied by absinthe, the noxious green beverage of choice.

Two establishments are of particular importance with regard to the Impressionist artists, and these are the Académie Suisse and Charles Gleyre's (1806–74) studio. The Académie Suisse did not offer tuition but provided studio facilities and models to artists for a small fee. Édouard Manet (1832–83) had used the studio while he was still a pupil of Thomas Couture (1815–79), and it was here that Manet met Camille Pissarro (1830–1903) in 1859. In 1861 Pissarro met and befriended Paul Cézanne (1839–1906) and Armand Guillaumin (1841–1927) at the Académie – the three would remain close and worked together for some time at Pontoise. Gleyre's studio was the scene of other auspicious meetings, such as when in 1862 Monet, Renoir, Alfred Sisley (1839–99) and Frédéric Bazille (1841–70) all met and became friendly. That same year, Manet and Edgar Degas (1834–1917) forged a turbulent but lifelong allegiance after meeting in the Louvre. The two principal women Impressionists became involved in the group slightly later, with Berthe Morisot (1841–95) being introduced to Manet in 1868. Ironically Manet never exhibited with the Impressionists in spite of his admiration for their work, but Morisot subsequently exhibited at seven of the eight exhibitions, going against Manet's advice. The American artist Mary Cassatt (1844–1926) became familiar with the Impressionists through their early exhibitions, and studied for a time with Pissarro, however it was Degas with whom she most aligned herself after meeting him in 1877. Gustave Caillebotte (1848–94), who was important as an artist and a collector, met Monet around 1874 and formed a close friendship with him and Renoir, the three artists sharing a love of boating.

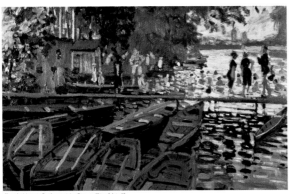

Claude Monet, *Bathers at La Grenouillère* (detail)

So the foundations for the Impressionists were laid through a series of relationships, some that endured, others that crumbled, and from this web of interlinked ties there rose two figureheads, Pissarro and Monet. Today it is these two artists who are considered most representative of and important within the movement. It was Monet who, along with the ill-fated Bazille, had first suggested organizing an independent and self-funded

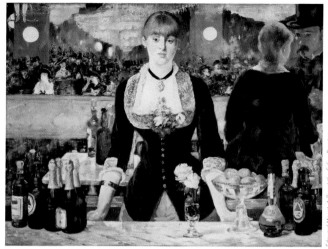

Edouard Manet, *A Bar at the Folies-Bergère*

exhibition as early as 1867. By the end of 1873 the idea was put forward more strongly and Pissarro set about creating an organization (*Société Anonyme des Artistes, Peintres, Sculpteurs, Braveurs, etc.*) to formalize the arrangement and handle the administration involved in running the exhibition – it was agreed that every exhibitor would donate one tenth of any sales into a communal fund to pay the running costs. The event was disastrous in critical terms, but succeeded in bringing together under one roof the works of a group of artists with similar ideals, and so propagated a sense of solidarity amongst the dissidents of the Salon. These were the new painters of modernity – of nature, weather and atmosphere – in direct opposition to the timeless history paintings of the Salon. These works represented a fleeting moment, they were indeed impressions of contemporary life and were conceived with an entirely new visual language that was causing uproar amongst the academic painters and critics. When the accounts were finalized at the end of the exhibition, instead of making money the artists owed money to the communal fund, and they decided, led by Renoir, to disband the group. Although the formal group was no longer in existence, the foundations had been laid, and this collective circle of artists have been referred to as a 'group' ever since, a further irony inherent in the Impressionist movement. It is ironic too that the term 'Impressionist' was not one that was accepted by all the artists, perhaps still stinging from its original acerbic use, and Degas in particular rallied against it. He insisted

that the word be dropped from the third exhibition, but at the same time Renoir's friend Georges Rivière (1855–1943) published four issues of a paper called, *L'Impressionniste*, and the artists were never able to shake off the label.

Inevitably with any collection of artists and their divergent temperaments, the Impressionist group suffered their share of ructions, and eventually the circle was fragmented with the artists going their own way, stylistically and geographically. Initially the first exhibition was born primarily in retaliation against the Salon jury who had so derided the Impressionists, and therefore the artists were expected to renounce the Salon. While in the initial glow of reactionary comradeship this seemed like a good idea, eventually many of the artists were forced or chose to approach the Salon in later years to gain public recognition and improve their commerciality – Pissarro and Degas being notable

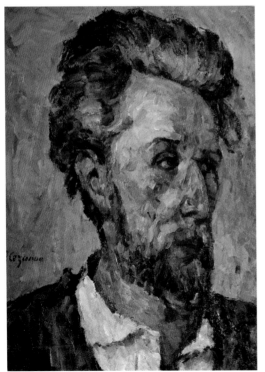

Paul Cézanne, *Portrait of Victor Chocquet*

exceptions. The third exhibition in 1877 is considered the most cohesive of all and the major Impressionists were all represented. By the following year however, Renoir, Sisley, Morisot, Guillaumin and Cézanne were absent, and by the fifth show Monet too had pulled out. The reasons for the gradual disintegration were many. Monet and Renoir wanted to disassociate themselves from the image of the rebellious artist and try to garner a better commerciality for financial reasons. They, along with Sisley, submitted to the Salon, which infuriated Degas who saw it as a total betrayal. Degas introduced his own circle of admirers, who were unpopular and considered to be lacking in talent, while Pissarro's insistence on the inclusion of the Neo-Impressionists Georges Seurat (1859–91) and Paul Signac (1863–1935) at the eighth exhibition, and his own temporary adoption of their Divisionist technique, caused consternation.

A defining year for the Impressionists, 1886 marked both an end to an era and the birth of something new. Their eighth and last exhibition was held from 15 May to 15 June,

with Monet, Renoir, Sisley and Caillebotte refusing to show. The exhibition itself caused the usual uproar amongst the critics, with Pissarro, Seurat and Signac singled out for special vitriolic attention, matched almost by that accorded to Degas's nudes. Following the exhibition there was no mention of organizing the next one. The Impressionists had moved on, but their art remained an

Pierre-Auguste Renoir, *Le Moulin de la Galette* (detail)

indelible inspiration to those who followed. It was not the end but the beginning of a new phase for the artists, whose work had evolved naturally through their careers, and it was a period that would see Monet, the so-called leader of the movement, be the first to achieve the financial success and critical acclaim they had all worked so hard for. A small group of friends and associates working in a groundbreaking way in the late 1860s gave rise to one of the most important art movements of the nineteenth century. They had broken conventions, challenged the Salon and exhibited independently, breaking new ground for the traditions of art. Significantly, they also had some success changing the opinion of the Salon, which, by the time the Impressionists disbanded, had become somewhat more enlightened in its acceptance of what constituted worthy art. The Impressionists gained a reputation as revolutionaries, and many of their group such as Pissarro and Monet were strongly political in their views, however rather than overtly political in content, their art was revolutionary because it defied hundreds of years of tradition and shaped a new path for the future. Despite being a 'group' for a relatively short, though hugely productive time, their innovations in technique, expression, subject matter, colour and even abstraction laid the foundations for Post-Impressionism and the birth of modern art.

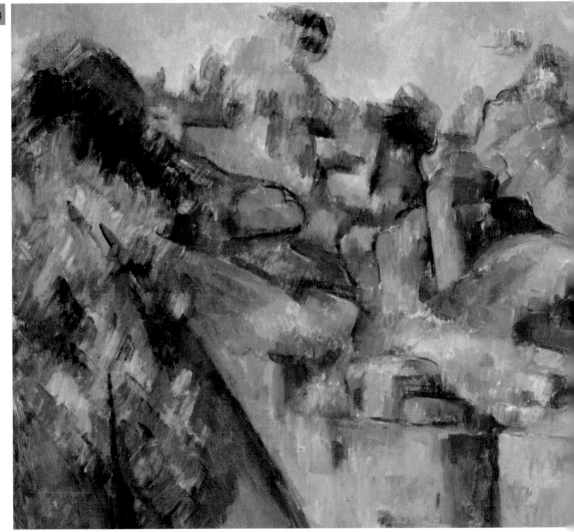

Impressionism

Movement Overview

Degas, Edgar

The Bellelli Family, c. 1858–60

A propitious year in artistic terms, 1855 saw a number of circumstantial events occur that inadvertently contributed towards the emergence of a small, progressive group of artists, later called the Impressionists. It was the year of the first *Exposition Universelle* in Paris, an unashamed boasting of France's glories that included a prestigious art show. Ironically it was the rejection of one artist's work, Gustave Courbet (1819–77) that would prove most significant. The Realist artist, furious at being spurned by the traditionalists, built a gallery and staged his own exhibition in retaliation. Though shunned by the public, the *Pavillon du Réalisme* attracted a number of young artists who were struck by Courbet's inspiring Realism and his non-conformity. Some of these artists would later stage eight of their own exhibitions and increasingly embrace a radical approach to their art.

It was also the year that the young Edgar Degas enrolled in the *École des Beaux-Arts*, and entered the studio of Louis Lamothe, a pupil of Jean-Auguste-Dominique Ingres (1780–1867). This group portrait of the Bellelli family, painted early in his career, already indicates Degas's interest in the details of modern life and his astonishing capacity to create tension and character through his figures.

CREATED

Florence and Paris

MEDIUM

Oil on canvas

SIMILAR WORK

The Family Reunion by Frédéric Bazille, 1867

Edgar Degas *Born* 1834 Paris, France

Died 1917

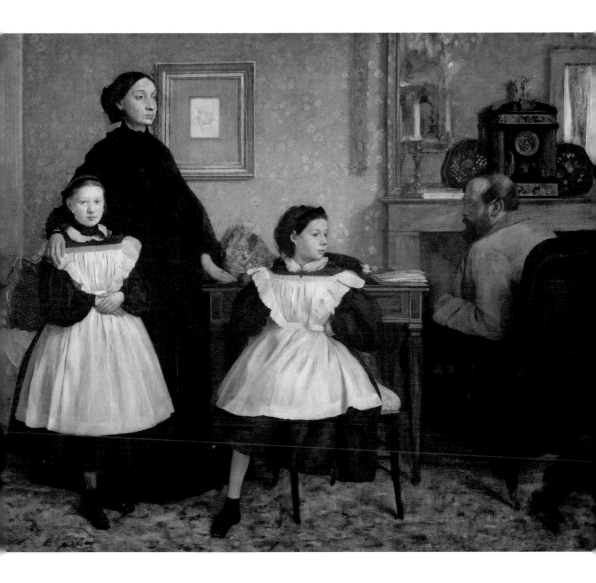

Manet, Édouard

Le Déjeuner sur l'Herbe, 1862–63

One of the most striking aspects of the Impressionists, in terms of an artistic movement, was the communal spirit in which the different young artists initially worked. Despite their differences in background, financial stability and temperament, they tended to mix socially, frequenting the same cafés, and many enjoyed close friendships. Édouard Manet first met Degas while they were both making copies of Old Masters at the Louvre in around 1862. The two men were perhaps closest in terms of social standing, education and money within the Impressionist group, and quickly formed an enduring, but tempestuous, relationship. The following year saw the first *Salon des Refusés*, hastily organized by Emperor Napoleon III in response to the uproar generated by the rejection of a massive number of paintings from the hallowed Salon.

Manet's *Le Déjeuner sur l'Herbe* was just one of many paintings to hang at the *Salon des Refusés*, and instantly caused a scandal, much to the chagrin of the artist. It was pronounced immodest and amoral, but the public outcry served to elevate Manet to a hero amongst his contemporaries who saw him as a leader for a new type of artistic expression.

CREATED

Paris

MEDIUM

Oil on canvas

SIMILAR WORKS

Judgement of Paris by Marcantonio Raimondi after Raphael, c. 1517–20

Country Concert by Giorgione, c. 1508

Édouard Manet *Born* 1832 Paris, France

Died 1883

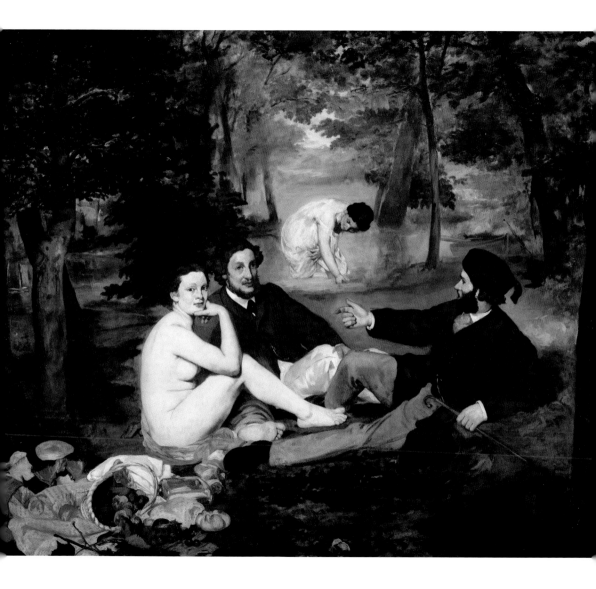

Monet, Claude

Le Déjeuner sur l'Herbe, 1866

Claude Monet, Frédéric Bazille (1841–70), Pierre-Auguste Renoir (1841–1919) and Alfred Sisley (1839–99) met while studying at Charles Gleyre's (1808–74) studio in 1862 – a formidable quartet of talent to emerge from one stable, though it seems Gleyre's cheap studio space and benevolence did more to further these students than his teaching doctrines. Monet and Bazille formed a strong bond and frequently painted alongside each other, travelling to the Forest of Fontainebleau (immortalized by the Barbizon painters) and to Honfleur, where Johan Jongkind (1819–91), Eugène Boudin (1824–98) and Courbet often painted. Boudin, like Monet, had grown up in Le Havre, and was a great influence on the younger artist – it was Boudin who encouraged Monet to take up painting '*en plein air*'.

Monet had two seascapes accepted for the Salon in 1865, and was subsequently labelled a marine painter. In an effort to dispel this and to move his art forward, he decided to attempt a large-scale painting of *Le Déjeuner sur l'Herbe*, inspired by Manet's picture of the same subject. Bazille joined Monet in Fontainebleau and posed for the male figures, but the project was never completed and much of the canvas was later damaged by water.

CREATED

Fontainebleau and Paris

MEDIUM

Oil on canvas

SIMILAR WORK

Le Déjeuner sur l'Herbe by Édouard Manet, 1863

Claude Monet *Born* 1840 Paris, France

Died 1926

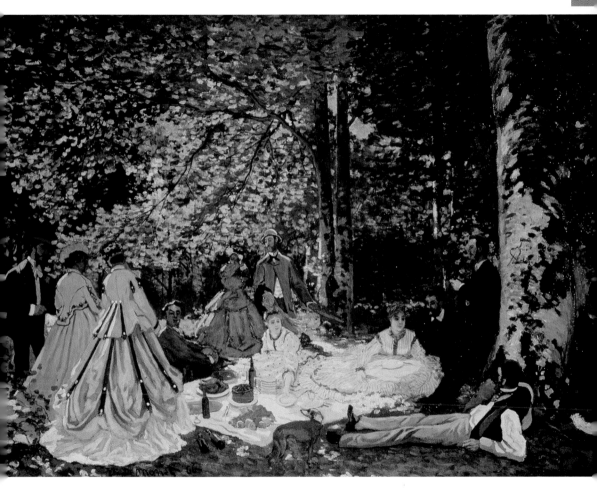

Renoir, Pierre-Auguste

The Sisley Family, 1868

© akg-images

Within the Gleyre studio circle Renoir and Sisley struck up a close friendship, and, like Monet and Bazille, the two travelled to Fontainebleau to paint. Renoir began his career as an apprentice painter of porcelain plates, before turning to painting and decorating, producing murals and saving his money until he could afford to enrol at the *École des Beaux-Arts* and Gleyre's studio. He was, like Monet and later Sisley, beset with financial worries, though at first Sisley was given partial financial support by his family.

The two friends shared an apartment in 1866 near Port Maillot, and the same year Sisley married his mistress Eugénie (Marie) Lescouezec, who had also modelled for Renoir. Renoir painted this tender picture of his friend and his wife the year after the birth of their first child and it went on to become one of his most famous images, with Pablo Picasso (1881–1973) paying homage to it through a series of drawings *c.* 1919. Ironically there is now some dispute over the painting, with the female figure cited as Lise Tréhot, Renoir's usual model. Although not proven, this would indicate the work was done commercially rather than for his friend.

CREATED

Paris

MEDIUM

Oil on canvas

SIMILAR WORK

The Box at the Théâtre des Italiens by Eva Gonzales, 1874

Pierre-Auguste Renoir *Born* 1841 Limoges, France

Died 1919

Sisley, Alfred

Vue de Montmartre, 1869

© akg-images

Unlike his friend Renoir, Sisley was not drawn to the hustle and bustle of Parisian life, and preferred instead to remove himself to more rural locations. He is perhaps one of the least documented of the Impressionists, and his work was for many years overshadowed by that of his more flamboyant contemporaries. His style remained fairly constant throughout his career and was unaffected by social or political content. He painted landscapes almost exclusively, and, even when working in London, concentrated on views of the Thames near Hampton Court Palace.

This unusual view of Montmartre shows the still fairly rural area seen looking southeast from the Cité des Fleurs, a street in the 17th arrondissement where Eugénie, his wife, lived until around 1870. The Butte de Montmartre is silhouetted in the middle ground against a strongly horizontal and somewhat dramatic sky, with the bulk of the single tower contrasting with the spindly and scattered saplings of the foreground. It is an image reminiscent of Constant Troyen's (1810–65) work and Dutch landscapes, although Sisley's structure, and in particular his use of the vertical seen in the trees, attests to his developing vision.

CREATED

Paris

MEDIUM

Oil on canvas

SIMILAR WORK

The Hills at Triel by Paul-Victor Vignon, *c.* 1881

Alfred Sisley *Born* 1839 Limoges, France

Died 1899

Bazille, Frédéric

The Artist's Studio, 1870

Bazille was from a wealthy family and began a career in medicine before turning to painting. He was, by all accounts, very well liked, dashing and loyal, and spent much of his tragically short life bailing out his impoverished artist friends.

In 1868 Bazille moved to a studio in the Rue de la Paix which he shared with Renoir in the same building that Sisley occupied. The Batignolles, as the area was called, was home to a tight circle of artists who were later referred to as the Batignolles Group. This fashionable neighbourhood was between Montmartre and l'Arc de Triomphe, and was also home to the Café Guerbois, a central meeting place for artists and bohemians.

From a historical perspective, *The Artist's Studio* provides a fascinating account of Bazille's working environment, and attests to the relationship of these artists. Seated at the piano is the musician Edmond Maitre while the figure of Bazille (painted by Manet) is in front of the canvas with Manet and Monet next to him. The figure on the stairs is Emile Zola (1840–1902) and the seated figure is Renoir.

CREATED

Paris

MEDIUM

Oil on canvas

SIMILAR WORK

Atelier des Batignolles by Henri Fantin-Latour, 1870

Frédéric Bazille *Born* 1841 Montpellier, France

Died 1870

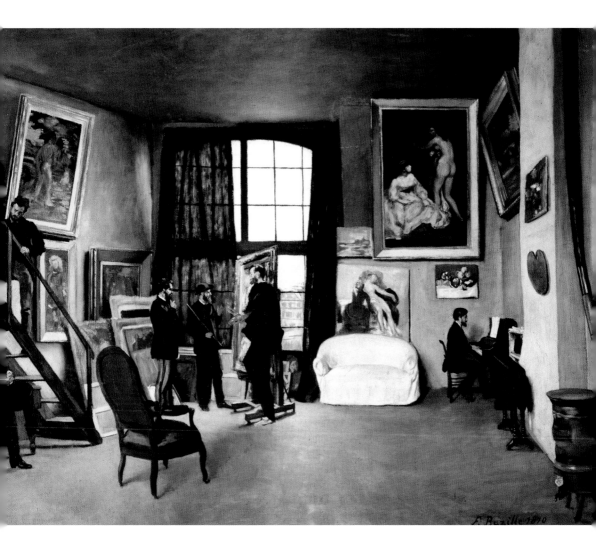

F. Bazille 1870

Pissarro, Camille

The Road from Louveciennes, 1870

Pissarro was the eldest of the Impressionists, and the only one of the group to exhibit at all eight Impressionist exhibitions. He was widely perceived as the father figure amongst his circle and was reputed to be unfailingly kind. He was also however the most radical in his political beliefs.

In 1869 Pissarro and his family moved from Pontoise to Louveciennes, which was nearer to Paris. Monet lived nearby and the two kept in contact with Renoir and Sisley, primarily through evenings spent at the Café Guerbois. By this time Pissarro had had some small success with his paintings, but was still struggling financially, so much so that in 1868 he resorted to painting shop signs with the artist Armand Guillaumin (1841–1927) to earn a little extra money.

This painting, with its particularly lyrical quality, was made shortly before the catastrophic events of July 1870, when France went to war with Prussia, and was one of a number of similar scenes Pissarro painted of the streets of Louveciennes. Pissarro primarily concentrated on landscapes and scenes of rural life, and constantly experimented with different techniques and application of paint in his quest to capture light and atmosphere.

CREATED

Louveciennes

MEDIUM

Oil on canvas

SIMILAR WORK

Rue de la Princess, Louveciennes by Alfred Sisley, c. 1873

Camille Pissarro *Born* 1830 St Thomas, West Indies

Died 1903

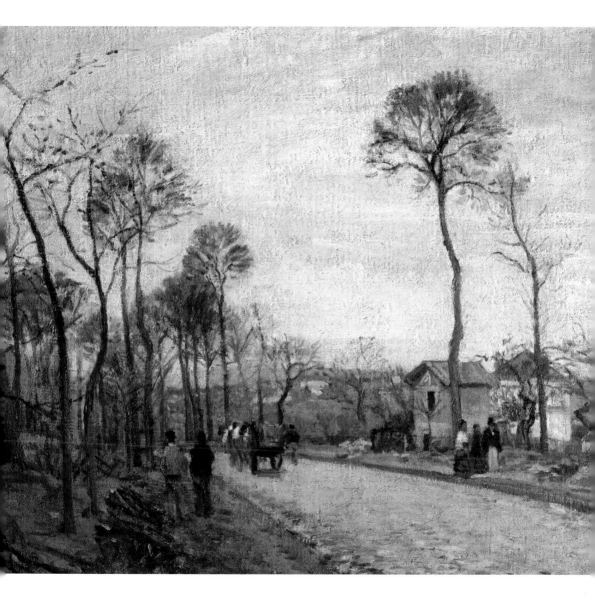

Pissarro, Camille

Lordship Lane Station, Dulwich, 1871

© Samuel Courtauld Trust, Courtauld Institute of Art Gallery/The Bridgeman Art Library

In July 1870 France disastrously declared war on Prussia, which was a move that took most of the French people by surprise, and led to the fall of the Second Empire. As Prussian troops broke through the French lines and the reality of war became apparent, people started to flee the country and the circle of Impressionists was geographically dispersed.

Bazille was killed in action at the end of the war in November 1870, and the news of his death greatly affected his artist friends, Renoir in particular. Pissarro, like Monet, fled to London to avoid being called up to fight in the war. During his absence the Prussians took over his studio in Louveciennes and most of his paintings there were destroyed.

Pissarro and Monet were fortunate to be able to continue painting. London offered a new range of subjects, a different environment and the opportunity to study works by Joseph Mallord William Turner (1775–1851), John Constable (1776–1837) and John Crome (1768–1821). Pissarro was particularly fascinated by the London suburbs, many of which were still rural, such as Dulwich seen here.

CREATED

London

MEDIUM

Oil on canvas

SIMILAR WORK

Hyde Park by Claude Monet, 1871

Camille Pissarro *Born* 1830 St Thomas, West Indies

Died 1903

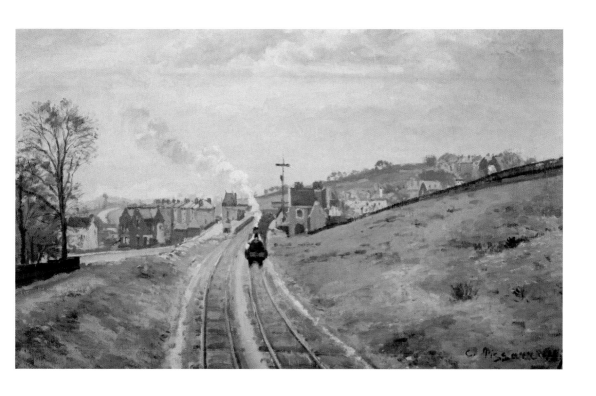

Monet, Claude

Impression, Sunrise, 1872

© akg-images

While in London, Monet met Charles-François Daubigny (1817–78), and he in turn introduced Monet to a dealer, Paul Durand-Ruel (1831–1922). Durand-Ruel, who became the Impressionists' greatest champion and most stalwart supporter, put Monet and Pissarro in contact, the two being unaware of each other's presence in the capital.

Meanwhile in Paris, the newly formed Republic was shaken by the Commune – largely an uprising of workers fighting for social and political reform that lasted for three months before they were repressed in a bloody massacre. Monet returned to Paris in 1872 to a city still reeling, but rebuilding, with news of Durand-Ruel, who bought works from Monet, Pissarro, Monet, Sisley, Degas and others. Monet moved to Le Havre in 1873 and painted two views of the harbour looking out of his window, one with a rising sun and one at sunset. This painting of a misty, wet sky has since become one of his most famous, and gave rise to the term by which one of the most important art movements came to be known. When deciding on a name for the work to appear in a catalogue for the first group exhibition, Monet suggested 'Impression' and the term was taken up, disparagingly at first, by the critic Louis Leroy.

CREATED

Le Havre

MEDIUM

Oil on canvas

SIMILAR WORK

Calais Sands at Low Water, Poissards Collecting Bait by Joseph Mallord William Turner, 1830

Claude Monet *Born* 1840 Paris, France

Died 1926

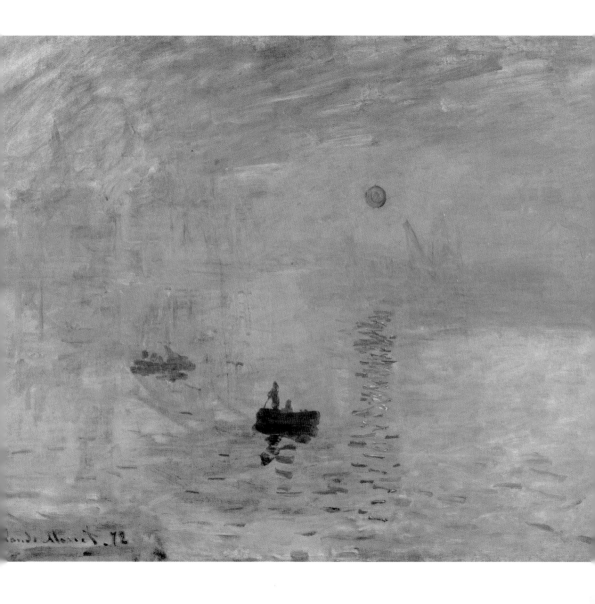

Cézanne, Paul

The House of Dr Gachet in Auvers, c. 1873

© akg-images

Paul Cézanne studied law in his hometown Aix-en-Provence before deciding to pursue a career as an artist. He moved to Paris in 1861 where he joined his childhood friend Emile Zola, and painted at the Académie Suisse. It was here that he first met Pissarro and Guillaumin, and the Spanish painter Francisco Oller (1833–1917). Cézanne remained somewhat apart from the Impressionist group – he shunned the social scene in Paris preferring the quiet of the countryside, and was emotional and at times difficult. Of his contemporaries it was Renoir and the affable Pissarro with whom he became most friendly.

Cézanne's early works lacked the finesse in draughtsmanship of, for example, Monet and Pissarro, and reflect a certain unease and a stumbling paucity of self-confidence. It was not until years later he developed his astonishingly unique and strong visual expression. This painting of Dr Gachet's house shows Pissarro's influence on his friend, although Cézanne's strident but simple composition foretells the direction in which his art would develop. The flamboyant Dr Gachet, who was friends with Pissarro and Cézanne, would some time later treat Vincent Van Gogh (1853–90) in the last months of the troubled artist's life.

CREATED

Auvers

MEDIUM

Oil on canvas

SIMILAR WORK

Road in Louveciennes by Camille Pissarro, 1870

Paul Cézanne *Born* 1839 Aix-en-Provence, France

Died 1906

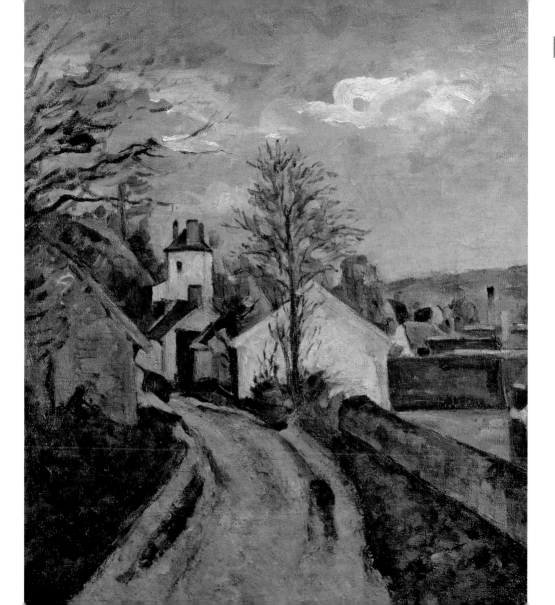

Degas, Edgar

The Dance Class, 1873–75

By 1873 the idea that a group of artists could challenge the Salon and operate independently, bringing a progressive art with a new language to the public, had grown. Towards the end of the year discussions about forming an independent exhibitor's association were rife and eventually, on 27 December 1873, the *Société Anonyme des Artistes* was registered. They held their first exhibition two weeks before the Salon opened in April 1874, and although well attended by the public, the financial handling of the Société was poor and by December of that year the members decided to disband it.

Degas, who was a founding member of the group, had by this time already made a name for himself as a painter of modern life. He focused his attention on people, turning to dancers, theatre and racecourses for his inspiration, and tackled his subjects with an unerringly honest eye. He concentrated on composition and the relation of his figures to each other, often incorporating unusual angles and truncated views that created 'a moment of life' sensation, much like a photograph.

CREATED

Paris

MEDIUM

Oil on canvas

SIMILAR WORKS

The Letter by Louis Robert Carrier-Belleuse, 1890

Quadrille at the Moulin Rouge by Henri de Toulouse-Lautrec, 1892

Edgar Degas *Born* 1834 Paris, France

Died 1917

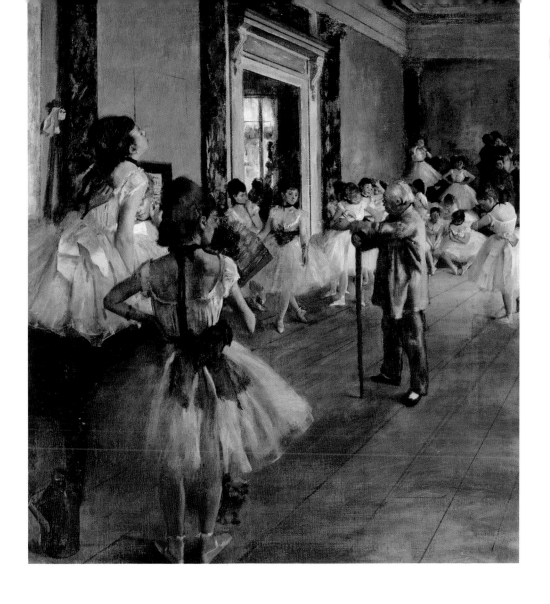

Pissarro, Camille

Piette's House at Montfoucault, Snow Effect, 1874

It was at the first Impressionist exhibition in 1874 that the group derived their name. The critic Louise Leroy wrote a satirical review of the exhibition for the magazine *Le Charivari*, focusing on Monet's painting *Impression, Sunrise*, and the term stuck. In respect of bringing their work to a wider audience, the exhibition was a success, but financially it did little to help the artists, who for the most part (a notable exception being Degas) were struggling. France was in the grips of an economic depression, unemployment was high, bankruptcy rife and the art market was suffering.

One of Pissarro's closest friends was the painter Ludovic Piette (1826–77) whom he had met in 1860, and who was also independently wealthy. Piette lived on a farm in Montfoucault in Brittany, and Pissarro would often visit him taking his large family with him. This picture of Piette's house in winter reflects the artist experimenting with different techniques to capture the 'impression' of a cold winter's day and the translucent light and almost eerie quiet that heavy snow in the early morning produces.

CREATED

Montfoucault

MEDIUM

Oil on canvas

SIMILAR WORK

Snow in Louveciennes by Alfred Sisley, 1878

Camille Pissarro *Born* 1830 St Thomas, West Indies

Died 1903

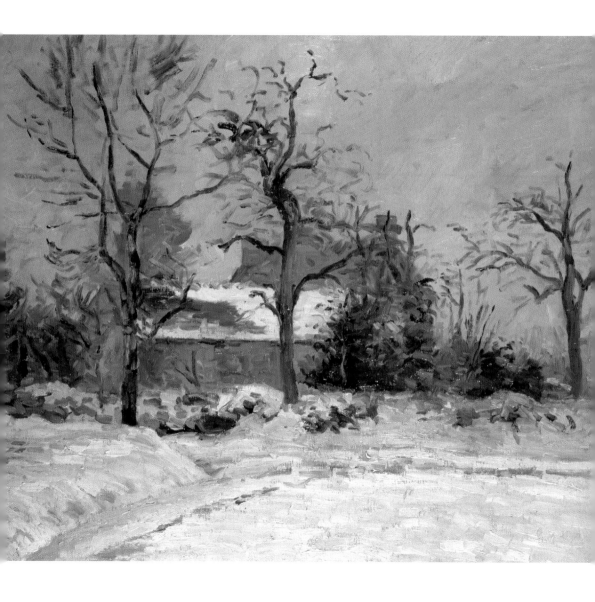

Guillaumin, Armand

Sunset near Ivry, 1874

© akg-images

Guillaumin is one of the less well documented of the Impressionist painters, although his work was important in the development of the style, and, particularly towards the end of the century, in the progression towards the work of the Fauves. He first met Pissarro and Cézanne in 1861 at the Académie Suisse, and remained close friends with both artists throughout his long life. In the 1870s he worked alongside Pissarro in Pontoise, a rural farming village surrounded by beautiful landscape. Guillaumin, Pissarro and Cézanne, were also friendly with the indomitable Dr Gachet, and painted together at Auvers. Like his friends it was landscape that Guillaumin concentrated on, and in particular he developed a unique approach to his use of colour.

This evocative painting is almost romantic in its depiction of the smoking factory chimneys set against a brilliant orange sunset sky. The expressiveness of his use of colour here predicts the direction that his art would move in, and sets him apart somewhat from his Impressionist friends. Significantly he also befriended Van Gogh in the late 1880s, whose works were fundamentally defined by colour.

CREATED

Ivry

MEDIUM

Oil on canvas

SIMILAR WORK

The Sower by Vincent Van Gogh, 1888

Armand Guillaumin *Born* 1841 Paris, France

Died 1927

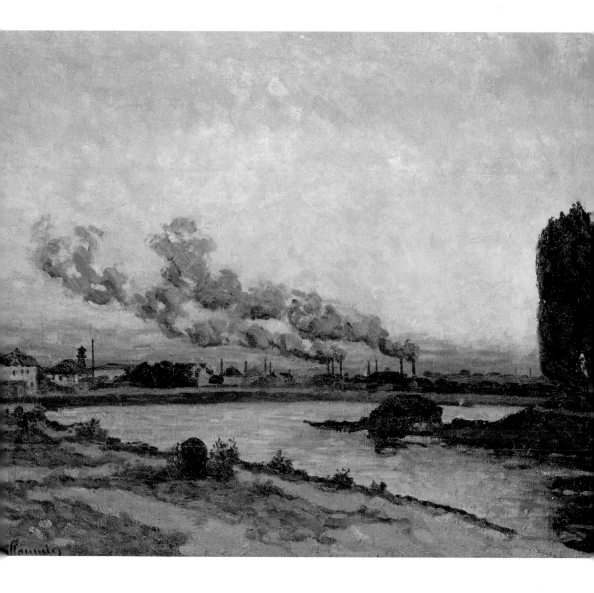

Morisot, Berthe

Boat Building, 1874

Berthe Morisot is generally considered one of the leading female artists of her time, and her contribution to Impressionist painting added a different dimension from that of her male contemporaries. She was born in Bourges to a wealthy family, and had the distinction of being the granddaughter of Jean-Honore Fragonard (1732–1806), the last Rococo painter. Her family supported her decision to study art, and she moved to Paris where she was taught by Jean-Baptiste-Camille Corot (1796–1875). In 1868 she was introduced to Manet by Henri Fantin-Latour (1836–1904), and the two subsequently became close friends. Morisot was an enthusiastic supporter and member of the Impressionists, and saw their work as the way forward for modern art.

In 1874, the year of this painting, Morisot married Manet's brother Eugène and they later had a daughter, Julie, whom she painted frequently. *Boat Building* reflects Morisot's great freedom of expression, with the composition and structure of the work maintained through minimal but effective use of line. It is also an interesting piece because of its ambiguous gender base. Much of her work depicts women and the life of women, and her paintings are recognisably feminine, but *Boat Building* addresses a male occupation in a neutral manner that disguises the identity of the artist.

CREATED

Paris

MEDIUM

Oil on canvas

SIMILAR WORK

The Barge by Édouard Manet, 1874

Berthe Morisot *Born* 1841 Bourges, France

Died 1895

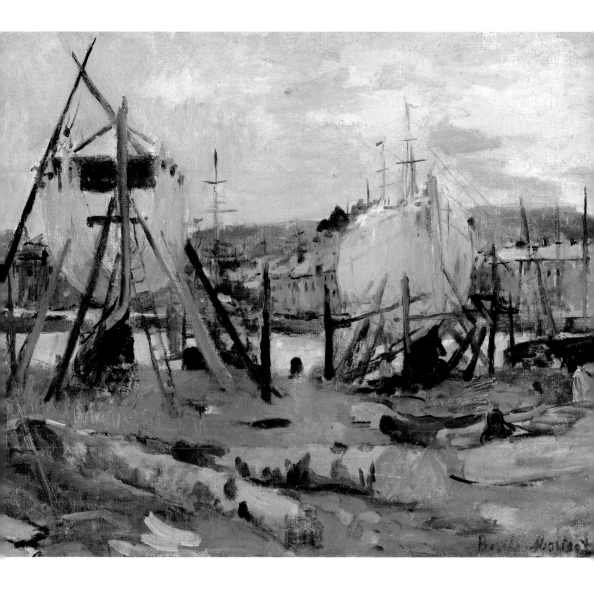

Renoir, Pierre-Auguste

Woman with Parasol (detail), 1875

© akg-images

Following the predominantly unfavourable reception of the Impressionists' work at their first exhibition in 1874, the group came up with the idea of holding an art auction to boost their sales. The auction was held at the Hôtel Drouot, with paintings by Renoir, Monet, Sisley and Morisot on display, and was an unmitigated disaster. The paintings failed to inspire any kind of sustained bidding, and many were withdrawn by the artists. Of all of them, Morisot's work sold the best, though her husband bought many of her paintings. There was one positive element however, in the form of the publisher Georges Charpentier, who bought a small painting by Renoir at the auction, but more significantly went on to become a great supporter of the Impressionists and especially Renoir.

Renoir and Monet had periodically worked alongside each other, and Monet's influence on Renoir at this point in his career is quite evident in this painting. Renoir addressed this subject of carefree women appearing dwarfed amidst a glorious natural background several times, but in general his works focused more on the figures themselves and on scenes of modern life rather than landscapes.

CREATED

Unspecified but probably Argenteuil

MEDIUM

Oil on canvas

SIMILAR WORK

Wild Poppies near Argenteuil by Claude Monet, 1873

Pierre-Auguste Renoir *Born* 1841 Limoges, France

Died 1919

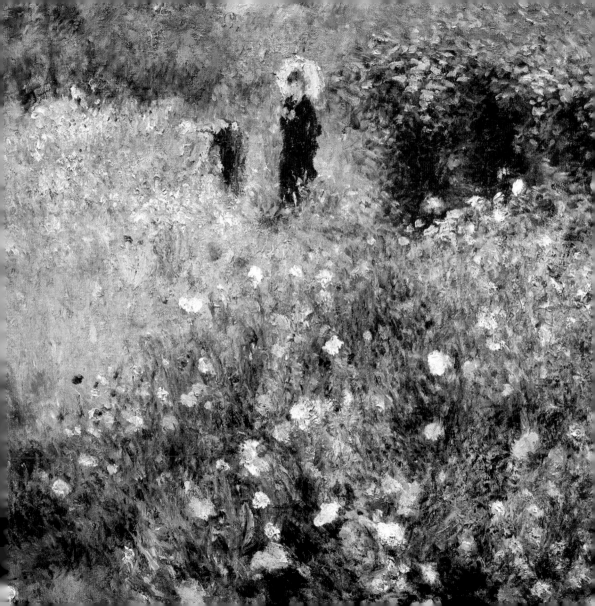

Manet, Édouard

Nana, 1877

Although the Impressionists are invariably discussed as a group they did not all see eye to eye, and increasingly the group became fragmented. In 1874 for example, Manet had visited Monet at his home in Argenteuil, where Renoir was also staying. Manet reportedly found a painting of Renoir's to be 'terrible' and suggested Monet should talk him out of being a painter.

In 1876 the second Impressionist exhibition was held, and was again ridiculed by the critics. The third exhibition opened in 1877 – the same year as the magazine *L'Impressionniste* was circulated. Founded by Georges Rivière and with Renoir contributing, the magazine was designed to answer the critics and redress the balance of public opinion.

The same year Manet exhibited *Nana* in a shop window on the Boulevard des Capucines, a move viewed as utterly scandalous. The woman in her underwear staring frankly from the canvas under the stern gaze of a gentleman was Henriette Hauser, who was reputed to be having an affair with the Prince of Orange. Manet's friend Zola had published a series of stories featuring a girl called Nana, and undoubtedly Manet was aware of Zola's plan to turn her into the heroine of his next book, published in 1879.

CREATED

Paris

MEDIUM

Oil on canvas

SIMILAR WORK

Young Woman Powdering her Face by Berthe Morisot, 1877

Édouard Manet *Born* 1832 Paris, France

Died 1883

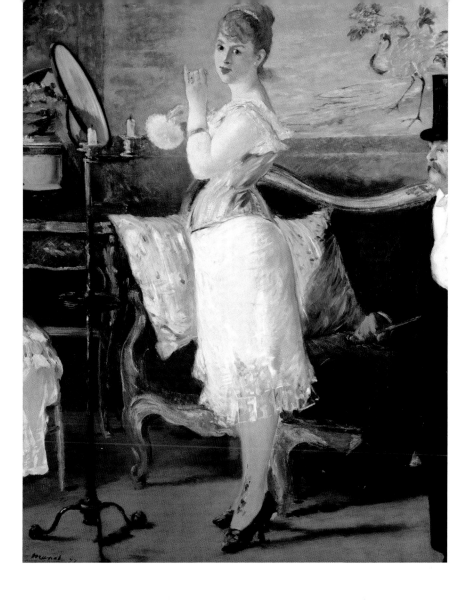

Sisley, Alfred

Winter Morning, 1878

The third Impressionist exhibition, held in 1877, is now regarded as one of the most successful in terms of the cohesive nature of the paintings that underlined the original aesthetics of the new artists. It can also however be seen as something of a pinnacle within the Impressionists as a group, and it was from here on that they increasingly moved in different directions, stylistically and personally. Ironically it was also the time that the term 'Impressionist' began to be used on a universal basis when describing their work. Some of the painters — Degas in particular — were completely averse to being labelled in this way.

In 1878 Sisley moved from Marley-le-Roi to Sèvres. Being closer to Paris, this was probably a move designed to keep him in better contact with the centre of art dealings. He was still in a terrible financial situation, something that plagued him his entire life. The years 1876–79 were something of a transitional period for Sisley — his compositions were becoming more complicated and his brushwork increasingly assured — and works such as this can be ranked amongst his best.

CREATED

Along the Seine

MEDIUM

Oil on canvas

SIMILAR WORK

Louveciennes by Camille Pissarro, 1872

Alfred Sisley *Born* 1839 Paris, France

Died 1899

Renoir, Pierre-Auguste

Madame Georges Charpentier and her Children, 1878

© Metropolitan Museum of Art, New York, USA/The Bridgeman Art Library

The World Fair in Paris opened in 1878 and again the Impressionists were excluded, as were the art giants of previous decades, Eugène Delacroix (1798–1863) and Jean-François Millet (1814–75). It was yet another demoralising blow to the group. It was also the year that Manet's friend, the critic Théodore Duret (1838–1927), published *Les Peintres Impressionnistes*, a pamphlet intended to encourage the public's understanding of these new painters. In it Duret listed Sisley, Monet, Pissarro, Renoir and Morisot as the true leaders of the movement.

Renoir made the decision to submit to the Salon of 1878 in an effort to reach a wider public, but it was a move seen as a defection amongst his contemporaries. *The Cup of Chocolate*, 1877 was accepted and he started work on another painting, *Madame Georges Charpentier and her Children* in 1878, which was accepted at the Salon of 1879. This painting was received relatively favourably by the critics, who were in the delicate position of not wanting to offend the powerful Madame Charpentier but not wanting to gush over Renoir. It was largely through this painting that the artist finally found some degree of acclaim. Georges Charpentier, a publisher, was an ardent supporter of the Impressionists and Renoir in particular.

CREATED

Paris

MEDIUM

Oil on canvas

SIMILAR WORK

Woman in Black at the Opera by Mary Cassatt, 1880

Pierre-Auguste Renoir *Born* 1841 Limoges, France

Died 1919

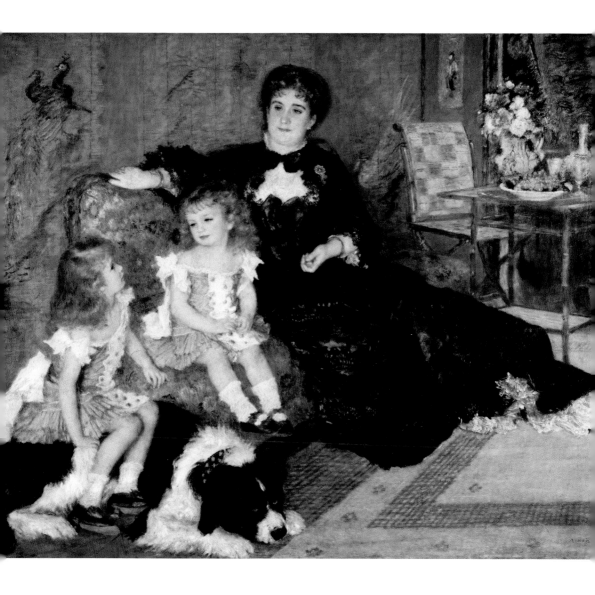

Cassatt, Mary

The Reader (Lydia Cassatt) (detail), c. 1878

Mary Cassatt was the daughter of a wealthy Pittsburgh businessman and studied art for four years at Pennsylvania Academy of the Fine Arts, Philadelphia. She travelled widely through Europe, visiting Paris where she copied Old Masters and furthered her studies. She returned to the United States during the Franco-Prussian War and then settled in Paris around 1875. She exhibited at the Salon several times, but became increasingly disillusioned with the strictures of academic art and became drawn to the work of the Impressionists. She met Degas in 1877, and the two remained close friends throughout his life. Degas, and also Manet and Courbet to a degree, influenced her work, although she developed a highly individual style in line with her independent character.

She was invited by Degas to exhibit with the Impressionists, which she did at their shows in 1879, 1880, 1881 and 1886. Cassatt, like Morisot, typically painted women and children within their domestic setting, which was a choice of subject matter that was in part dictated by the social conventions of the time. Her subtle and evocative use of colour, as seen here, is typical of her work.

CREATED

Paris

MEDIUM

Oil on canvas

SIMILAR WORK

La Lecture by Berthe Morisot, 1869–70

Mary Cassatt *Born* 1844 Pennsylvania, USA

Died 1926

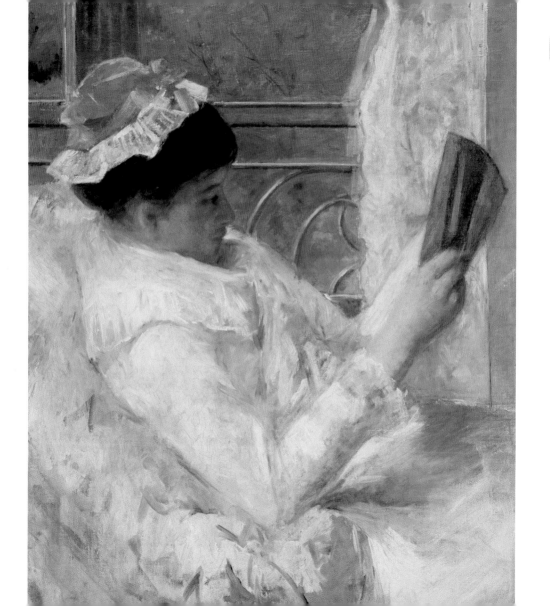

Degas, Edgar

Edmond Duranty (detail), 1879

© akg-images

In 1879 Degas co-ordinated the fourth Impressionist exhibition, but he insisted that the name Impressionist (which he hated) be dropped, calling it instead 'An Exhibition for a Group of Independent Artists'. Notable by their absence were Renoir – whose relations with Degas were fraught – Sisley, Cézanne and Morisot, and Monet was a reluctant participant, possibly due in part to his difficult domestic situation at that time. Degas's friend Jean-François Raffaëlli (1850–1924) was invited to show, as well as Cassatt and Paul Gauguin (1848–1903), who arrived too late to have his name listed in the catalogue.

The subject of this painting, Louis Edmond Duranty (1833–80), was an art critic and friend of Degas who wrote a favourable review of the 1879 exhibition. Some years previously Duranty had written a pamphlet, which many believed Degas to have instigated. The leaflet praised the work of the artists, but also strongly derided aspects of them, implying that though some were genuinely great, others were 'naïve ignoramuses alongside scholars'. It was a move that caused great resentment amongst the painters, especially between Degas and Renoir and Monet.

CREATED

Paris

MEDIUM

Pastel and tempera

SIMILAR WORK

Edmond Duranty by Marcellin Gilbert Desboutin, *c.* 1876

Edgar Degas *Born* 1834 Paris, France

Died 1917

Cézanne, Paul

Apples and Biscuits, c. 1879–82

© akg-images

Around 1870 Cézanne had met a young model, Hortense Fiquet, and the two had set up home together. The artist chose to keep this fact from his wealthy bourgeois family, worried about their disapproval and the possible end of his allowance. During the 1870s he spent time with Pissarro at Pontoise before moving to Auvers, where he gravitated towards Dr Gachet, an eccentric art collector. He later moved between Paris and Aix-en-Provence, his hometown, and concentrated on landscapes and still life paintings such as this. In 1878 his father discovered the truth about Hortense, who now had a son with Cézanne, and furious, he cut his allowance in half. Zola, a childhood friend of the artist, had just had his first literary success, and offered to support Hortense and the child for a year in Marseille, while Cézanne remained in Aix trying to rectify the situation with his father.

Cézanne painted over two hundred still life pictures and concentrated in particular on apples or oranges. His experiments with form and structure and his geometric approach to still life painting, which became more pronounced through his career, foreshadowed the astonishing developments in modern art.

CREATED

Probably Aix-en-Provence

MEDIUM

Oil on canvas

SIMILAR WORKS

Still Life with Apples and a Pomegranate by Gustave Courbet, 1871–72

Apples in a Basket on a Table by Henri Fantin-Latour, 1888

Paul Cézanne *Born* 1839 Aix-en-Provence, France

Died 1906

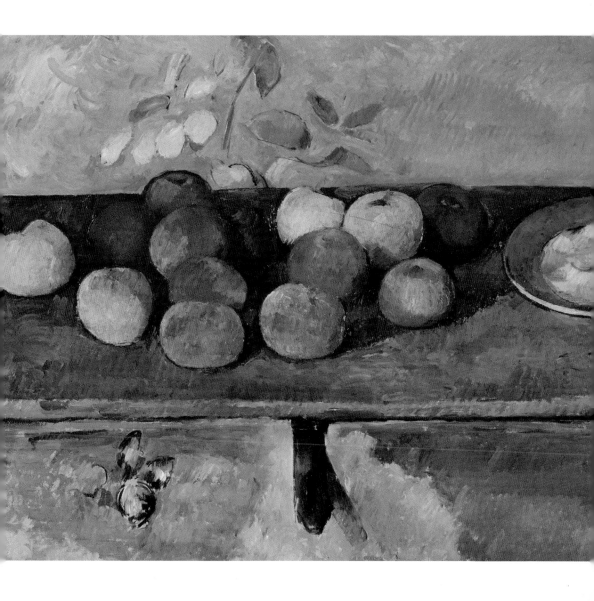

Monet, Claude

The Ice Breaking Up, 1880

© Interfoto, Museu Calouste Gulbenkian, Lisbon, Portugal/The Bridgeman Art Library

Ernest Hoschedé, the wealthy owner of a Parisian department store, was an early and enthusiastic collector of Impressionist works. He was in particular a supporter of Manet and Monet, the latter of whom did a series of decorative panels and landscapes for him in 1876. The Impressionists relied on their small but loyal circle of collectors, and it was therefore a huge blow when Hoschedé was financially ruined in 1878, selling off his collection and ending his support.

At the same time, Madame Hoschedé left her husband and moved with her six children to Vétheuil where she lived with Monet, and helped him to nurse his desperately ill wife Camille, and looked after his children. This expanded household had a dramatic effect on the artist's already diminutive finances. Camille died in late 1879, with Monet pawning his possessions to pay for her care during her illness. In 1880, the year of this painting, he made the decision – much to Degas's horror – to submit two canvases to the Salon in an attempt to improve his commercial success. Despite being one of the original fathers of Impressionism, this decision alienated him from other members of the group.

CREATED

Vétheuil

MEDIUM

Oil on canvas

SIMILAR WORK

Snow Effect at Marly by Alfred Sisley, 1876

Claude Monet *Born* 1840 Paris, France

Died 1926

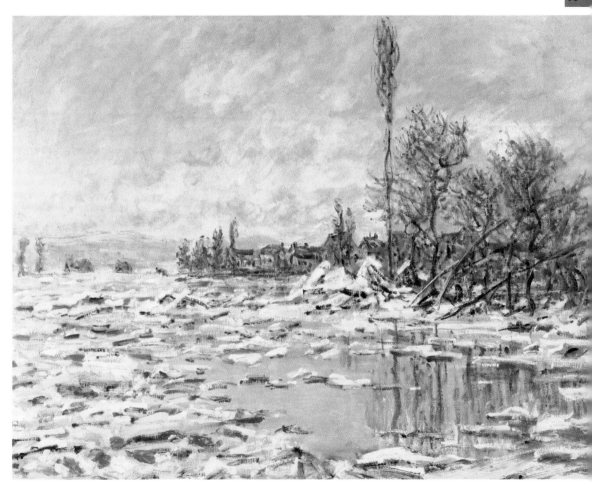

Caillebotte, Gustave

The Boulevard Viewed from Above, 1880

© Giraudon, Private Collection/The Bridgeman Art Library

Gustave Caillebotte was born into a wealthy family and studied law. Gaining his degree in 1868 he was eligible to start practice in 1870. After serving in the *Garde Mobile de la Seine* during the Franco-Prussian War, he decided to study art and, with the support of his family, trained under Leon Bonnat (1833–1922) before entering the *École des Beaux-Arts* in around 1873. Frustrated by the traditionalist strictures of academic art he left the *École* in 1876, and shortly afterwards was invited by Renoir to exhibit at the second Impressionist exhibition.

Caillebotte's father had died in 1873 leaving him a sizeable inheritance that allowed him to paint without financial worries, and, more importantly for his contemporaries, to become a vital supporter and collector of Impressionist art. He was particularly good friends with Monet and Renoir with whom he shared a common love of gardening and sailing.

At the time of this painting he kept a studio on the fourth floor of his house on Rue de Miromesnil in Paris, and characteristically painted bird's-eye views of the street below. The unusual composition of this work lends the surface a pattern-like quality, and recalls the influence of Japanese prints that were popular at the time.

CREATED

Paris

MEDIUM

Oil on canvas

SIMILAR WORK

The Avenue de l'Opera, Paris by Camille Pissarro, c. 1880

Gustave Caillebotte *Born* 1848 Paris, France

Died 1894

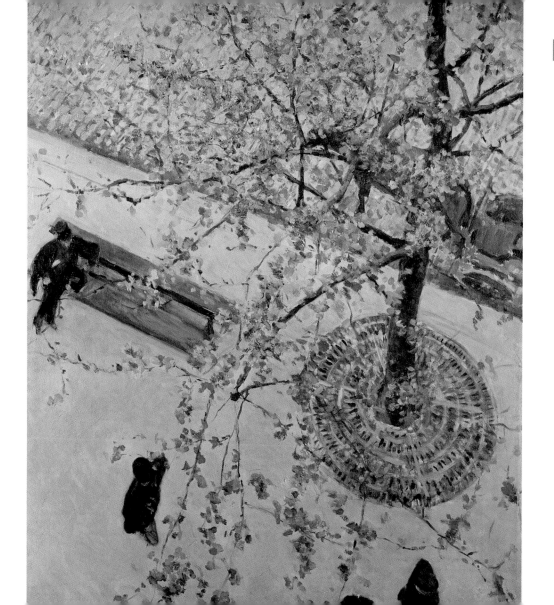

Renoir, Pierre-Auguste

The Umbrellas (detail), *c.* 1881–86

© National Gallery, London, UK/The Bridgeman Art Library

The fifth exhibition of the Impressionists was held in 1880, but the structure of the group had changed dramatically, and with Renoir, Sisley, Cézanne and Monet not participating it could hardly be called Impressionist. The same year Manet, Renoir and Monet exhibited at the Salon and the original Impressionist group remained strongly divided. In April 1881 the sixth exhibition was held, and Caillebotte joined Renoir and his friends by declining to enter.

By 1881 Renoir had achieved some financial success, in part due to the unfailing support of Durand-Ruel. In March the artist travelled to Algeria, following in the footsteps of the great colourist Delacroix, and then to Italy where he studied the work of Ingres and absorbed his dry and linear approach.

The Umbrellas is an interesting work within Renoir's oeuvre and is clearly divided in style and therefore date. The figures to the right were painted first, and have been dated to 1881, based largely on his feathery style and the precise fashion of the women's clothing. The figures to the left are more linear and incorporate flatter areas of colour. Again based on the style of the dresses, these figures have been dated to *c.* 1885–86.

CREATED

Paris

MEDIUM

Oil on canvas

SIMILAR WORK

A Bar at the Folies-Bergère by Édouard Manet, *c.* 1881–82

Pierre-Auguste Renoir *Born* 1841 Limoges, France

Died 1919

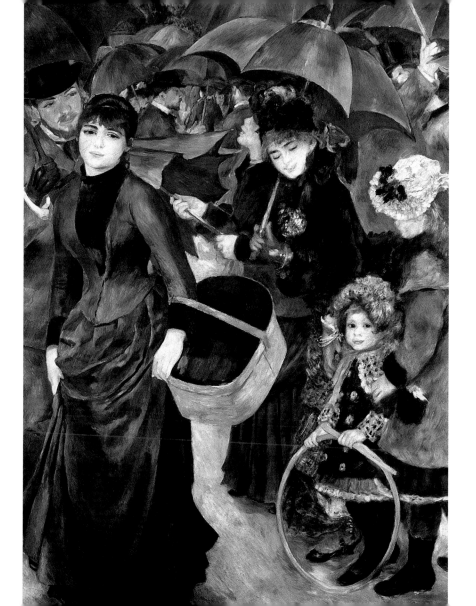

Degas, Edgar

Breakfast after the Bath, 1883

In 1881 the Salon underwent a significant change. It was no longer supervised by the State, but was run by an association of artists. Any artist who had in the past exhibited at the Salon was now allowed to vote for the election of jury members, which resulted in a marginally more liberal attitude. While this could only be seen as an improvement, the situation amongst the Impressionists continued to disintegrate. Caillebotte decided to organize the seventh exhibition of the group in 1882 and tried to reenlist the original members. Degas was asked to separate himself from the artist Raffaëlli and others who had been unpopular participants in the group's exhibitions, in the hopes of persuading Monet and friends to return. Degas refused. Monet, Renoir, Sisley, Pissarro, Caillebotte, Morisot, Gauguin, Victor Vignon (1851–1917) and Guillaumin exhibited, but significant absentees included Degas and Cassatt.

This pastel was one of a series of works made by Degas in 1883 of women at their toilet, seemingly unaware they were being observed. This new approach to the subject, that was itself considered scandalous and in poor taste, depicted women unashamedly, going about their intimate business.

CREATED

Paris

MEDIUM

Pastel on paper

SIMILAR WORK

Morning Toilet by Mary Cassatt, 1886

Edgar Degas *Born* 1834 Paris, France

Died 1917

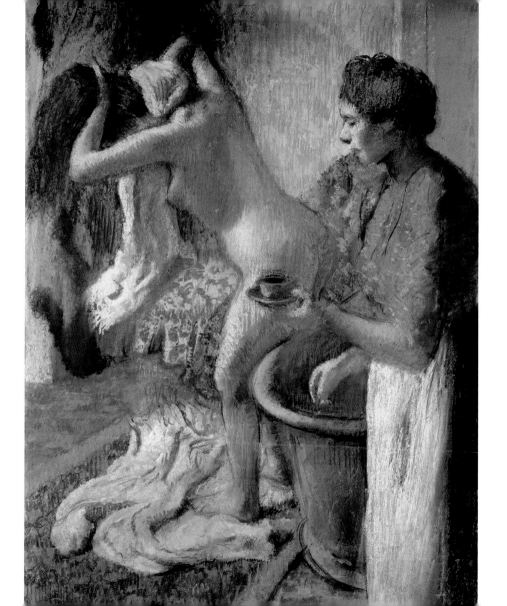

Morisot, Berthe

Portrait of a Young Woman, 1885

© akg-images

The seventh Impressionist exhibition in 1882 (which did not include Degas or Cassatt) was received slightly more favourably by the press, and even attracted new buyers. Morisot, who was unable to attend the exhibition, sent instead her husband Eugène Manet, who was full of praise for the artists' achievements. At the Salon of the same year, Manet exhibited his large *Le Bar aux Folies-Bergère*, which did not receive the acclaim he was hoping for. By this time he had started to suffer from locomotor ataxia and it was with some bitterness that he accepted the official *Chevalier de la Légion d'Honneur* after the close of the Salon, commenting that a little State recognition a lot earlier in his career would have helped. He died the following year in April 1883 – a devastating blow to Morisot.

During the mid-1880s Morisot was dividing her time between Bougival and Nice, with occasional trips to Paris. It was a period that is widely considered to have been her most productive and best, with her style fully evolved and her brushwork brilliantly rendered. She continued to concentrate on female subjects such as this, and often used her daughter, Julie, as a model.

CREATED

Probably Paris

MEDIUM

Oil on canvas

SIMILAR WORK

Two Sisters (On the Terrace) by Pierre-Auguste Renoir, 1881

Berthe Morisot *Born* 1841 Bourges, France

Died 1895

Pissarro, Camille

Woman Hanging up her Washing, 1887

In 1880 Durand-Ruel, possibly the greatest supporter of and dealer in Impressionist works, became more financially stable, and was able to start purchasing works again. Pissarro particularly benefited from the semi-regular income provided by Durand-Ruel, small though it was. It was a short-lived phenomenon however, and in 1882 the dealer and collector had again suffered devastating losses, though he continued to promote the artists through a series of one-man shows followed by two exhibitions in London.

During the early 1880s Pissarro had become frustrated with his work, no doubt amplified by his tenuous finances, and in 1885 a chance meeting led to an extraordinary development in his style. While at Guillaumin's studio he was introduced to Georges Seurat (1859–91), and became interested in his colour theories and the rationale of his brushwork that replaced instinctive painting with a more scientific approach. This dramatic new style can be seen in this painting of a domestic scene, itself something of an unusual subject for the artist. Durand-Ruel was surprised at the change, but Pissarro explained that he '...wanted to seek a modern synthesis by methods based on science...'

CREATED

Eragny

MEDIUM

Oil on canvas

SIMILAR WORK

Lady with Parasol by Georges Seurat, 1884–85

Camille Pissarro *Born* 1830 St Thomas, West Indies

Died 1903

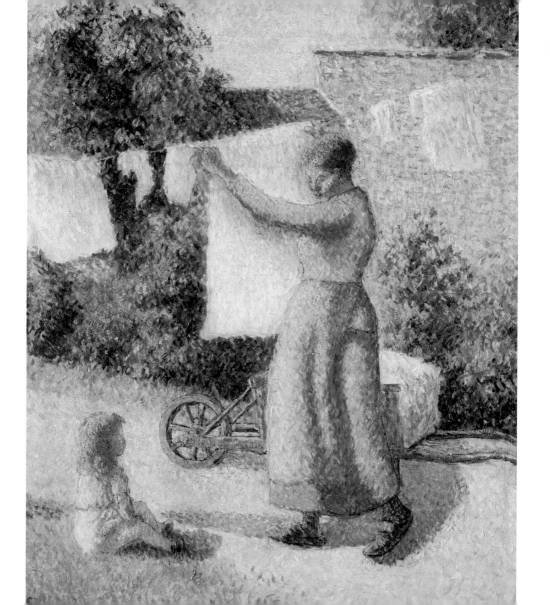

Cassatt, Mary

Mrs Cassatt Reading to her Grandchildren, 1888

© Private Collection, New York, USA/The Bridgeman Art Library

Independently wealthy, Cassatt was removed from commercial pressure. She frequently bought works from her artist friends, and even lent Durand-Ruel money when his finances had collapsed. She was also active in drumming up support for the Impressionists amongst her American friends, in particular the Havemeyers of New York. Durand-Ruel subsequently organized two successful exhibitions in the United States at the invitation of the American Arts Association.

The eighth and final Impressionist exhibition was held in 1886, and again the organization of it was beset with difficulties. Pissarro wanted Seurat and Paul Signac (1863–1935) to exhibit, which caused consternation, as did the inclusion of Claude-Emile Schuffenecker (1851–1934). Monet, Renoir, Sisley and Caillebotte pulled out, as well as Raffaëlli, whose presence at earlier shows had caused problems within the ranks. Cassatt did exhibit however, alongside her long-time friend Degas. This painting, completed several years later, reflects Cassatt's developing style – her use of controlled brushwork and the juxtaposing of bold areas of colour. Into the 1890s her use of strong, vibrant colours increased alongside the use of broader, flatter areas of colour and unusual perspectives.

CREATED

Paris

MEDIUM

Oil on canvas

SIMILAR WORK

The Mother and Sister of the Artist by Berthe Morisot, 1869–70

Mary Cassatt *Born* 1844 Pennsylvania, USA

Died 1926

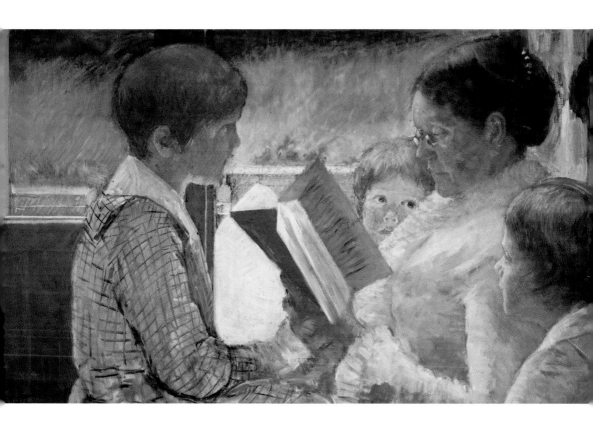

Cézanne, Paul

The Smoker, c. 1890–92

© akg-images

The age of the Impressionists was coming to an end as the artists' styles developed away from each other, and away from their original form. In 1886 Zola published his novel *L'Oeuvre*, featuring as its hero a failed Impressionist artist. It expressed his own views that Impressionism was inadequate in reflecting the realities of modern life. Unfortunately his hero was perceived by many to be based on his friend Cézanne and, deeply hurt, the artist broke off their long relationship. At the same time new and radically different artistic styles were emerging.

Cézanne lived in relative artistic isolation in Aix-en-Provence where he devoted himself to his art. His extraordinarily unique visual language evolved over the years, and he, along with Gauguin, Seurat and Van Gogh, is now regarded as a forefather of modern art. He shunned Paris and did not exhibit from 1877 until 1889 when he showed with the *XX* group of artists. *The Smoker* reflects many of the qualities in Cézanne's work that younger artists admired, in particular the structure in his composition and his use of bold, clearly defined, broad areas of colour.

CREATED

Aix-en-Provence

MEDIUM

Oil on canvas

SIMILAR WORK

The Potato Eaters by Vincent Van Gogh, 1885

Paul Cézanne *Born* 1839 Aix-en-Provence, France

Died 1906

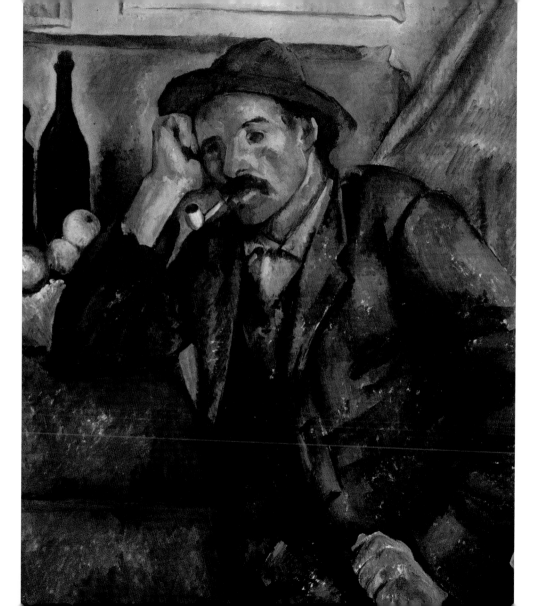

Monet, Claude

Haystacks at Sunset, Frosty Weather (detail), 1891

© Private Collection/The Bridgeman Art Library

In 1883 Monet moved to Giverny and rented the house where he lived for the rest of his life. He later bought the house and established a large garden in which he painted his final, and possibly most famous works. By the end of the 1880s Monet had achieved some level of financial success, aided in part by his astute business sense. Although he continued to work with Durand-Ruel, he also turned to Durand-Ruel's main competitor, Georges Petit (c. 1835–1900) and sold many of his paintings through him and to other galleries. Eventually he left Durand-Ruel and signed a contract with Theo Van Gogh, who was acting for rivals Boussod & Valadon.

Monet had shown a tendency to concentrate on a single subject, seen for example in his paintings of *Gare Saint-Lazare*, and increasingly focused on the fleeting effects of light on his subjects. By 1891 this aim had been condensed, and he produced his first major series: a group of 18 pictures of haystacks in different light and weather conditions. The paintings were an immediate commercial success, selling in a matter of days. However, they were met with a level of disapproval amongst the critics, and even his artist friends railed against their lack of construction and form.

CREATED

Giverny

MEDIUM

Oil on canvas

SIMILAR WORK

Haystacks at Moret in October by Alfred Sisley, 1891

Claude Monet *Born* 1840 Paris, France

Died 1926

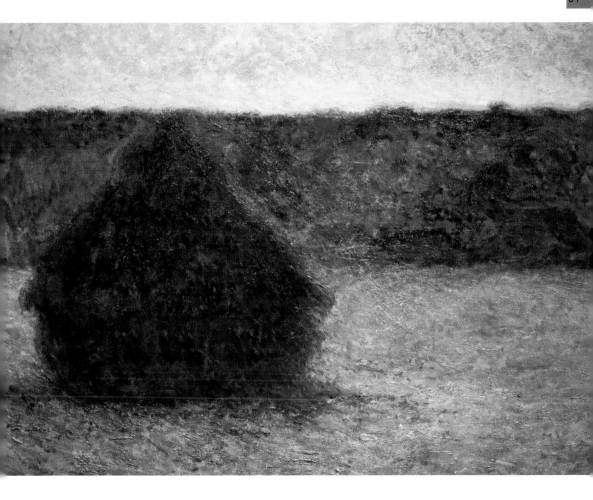

Degas, Edgar

Blue Dancers, 1897

© akg-images

While nearly all the original members of the Impressionist group had migrated away from Paris over the years, Degas remained in the city, living and working from 1891 at his studio on Rue Victor Massé. This lively street was at the heart of the artistic and entertainment areas of the city, close to art supplies shops, dealers, galleries and nightclubs. This intractable artist, often described as a recluse, had a close circle of friends including Cassatt, Morisot, Pissarro, the model and artist Suzanne Valadon (1865–1938) and the industrialist and collector Henri Rouart. His extraordinary character, combining charm and loyalty with fierce temper and impatience, frequently led to ructions within the artistic community, and it is doubtless that he in fact propagated and embellished the stories surrounding his eccentricities, thus adding to the air of mystery surrounding him.

His steadily failing eyesight contributed towards his use of bright colours and strong use of line. He worked mainly in pastels, and also started producing sculptures, for which he is now as famous for as his paintings. This intense picture of ballet dancers was one of many, his subject matter in latter years becoming restricted primarily to dancers and women bathing.

CREATED

Paris

MEDIUM

Pastel

SIMILAR WORK

Jane Avril Dancing by Henri de Toulouse-Lautrec, *c.* 1892

Edgar Degas *Born* 1834 Paris, France

Died 1917

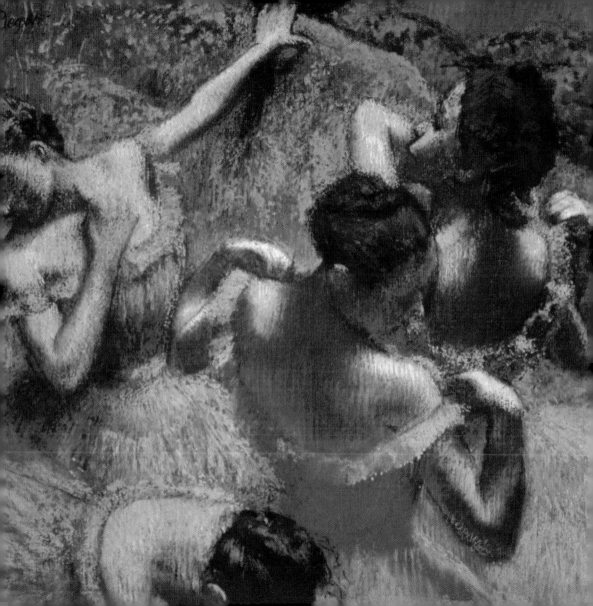

Pissarro, Camille

Place du Theatre Français, Afternoon Sun in Winter, 1898

Pissarro had experimented with a divisionist technique under the influence of Seurat and the Pointillists in the mid-1880s, but he found their methods too restrictive and by 1888 had returned to a more impressionistic approach. Despite this he retained a fondness for small dots of colour, which can be seen here in this bird's-eye view of a busy street. He continued to paint landscapes, going on painting trips to Normandy, and increasingly turned back to city scenes. This was due mostly to his deteriorating health and eye problems which made it difficult for him to paint outside. Instead he travelled to Paris, Rouen, Dieppe and Le Havre where he rented rooms and painted the urban view from his window.

His treatment of the urban setting, including his paintings of factories around Rouen and the teeming surge of humanity seen here, demonstrated the deeply political aspect of the artist celebrating modern life and progress in a way that his contemporaries had not. Where other artists saw industrialisation as a hideous blot on the landscape, to Pissarro it was the way forward, and he attempted to treat it as he would a field full of poppies or the gentle Seine.

CREATED

Paris

MEDIUM

Oil on canvas

SIMILAR WORK

La Sainte-Chapelle, Paris by Maximilien Luce, 1901

Camille Pissarro *Born* 1830 St Thomas, West Indies

Died 1903

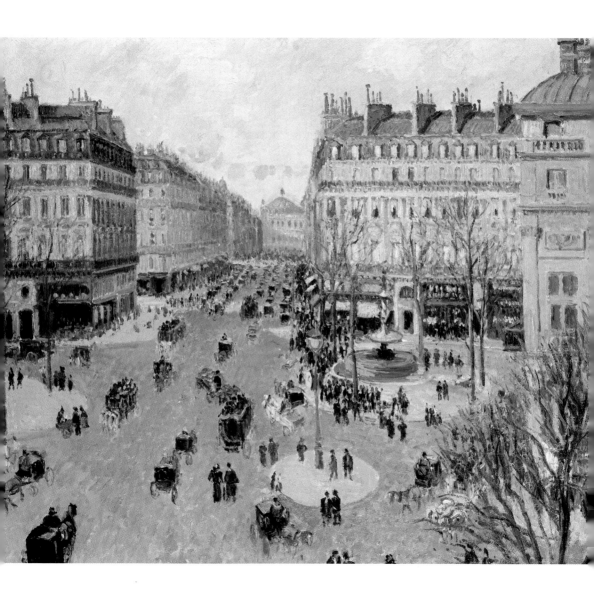

Cézanne, Paul

The Quarry of Bibemus, 1898–1900

© akg-images

Cézanne inherited a large sum of money from his father in 1886 allowing him the freedom to paint without financial worry. Perversely this very freedom that his contemporaries sought seemed more of hindrance to the artist who constantly struggled with self-doubt. He believed the public viewed him as dabbling in art and did not take his work seriously. He lived in Aix-en-Provence with his wife and son in a state of semi-isolation, and evolved a highly original style based on strong, often geometric forms and bold colour.

He craved to be accepted at the State Salon and even to win an official medal, not so much for the glory, but to cement his position as a 'serious' artist, but it was not to be. In spite of the public's reluctance to accept and understand Cézanne's work, he had become famous amongst the younger generation of artists, who venerated him and even made trips out to his home in Aix. This painting made near Aix is defined by the strident structure and form, and the bold use of line, and can be seen as a synthesis of light and colour impressions – an entirely new approach to depicting nature.

CREATED

Near Aix-en-Provence

MEDIUM

Oil on canvas

SIMILAR WORK

Houses at L'Estaque by Georges Braque, 1908

Paul Cézanne *Born* 1839 Aix-en-Provence, France

Died 1906

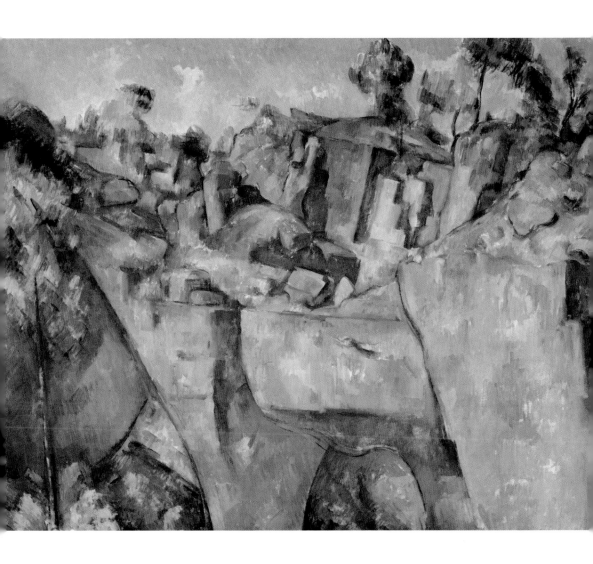

Cézanne, Paul

La Montagne Sainte-Victoire, c. 1906

© akg-images

For much of his life Cézanne had declined to exhibit in Paris, and when he did it was invariably to public ridicule. His work started to become slightly better received in the mid-1890s, shortly after he had been introduced to a young art dealer called Ambroise Vollard by the ever congenial Pissarro. Vollard ran his gallery in the Rue Laffitte, where many of the large galleries were located, and shortly after meeting Cézanne arranged a one-man show. In 1899 Vollard bought everything that Cézanne would sell and his prices started to go up.

The extent to which Cézanne was respected by a growing group of young artists was reflected in a large painting by Maurice Denis. *Hommage à Cézanne* was exhibited in 1901, much to the delight of Cézanne, and was similar in concept to Fantin-Latour's famous *Hommage à Delacroix* of 1864. In his latter years Cézanne continued to paint vigorously, walking into the countryside around his home and in particular painting Mont Sainte-Victoire – a favourite subject. In 1906 he was caught in a rainstorm while painting and subsequently contracted pneumonia, dying shortly afterwards.

CREATED

Near Aix-en-Provence

MEDIUM

Oil on canvas

SIMILAR WORK

Rocks by Andre Derain, 1912

Paul Cézanne *Born* 1839 Aix-en-Provence, France

Died 1906

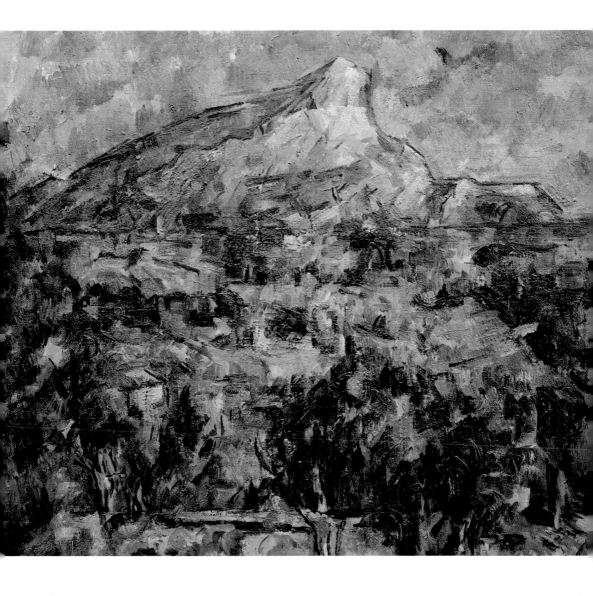

Monet, Claude

Nympheas, 1907

© akg-images

One of the most devastating episodes in late nineteenth-century French history was that of the Dreyfus Affair, an event that shocked the country to the core. The Jewish army captain Alfred Dreyfus had been accused, tried and found guilty of selling military secrets to the Germans in 1894. He was banished to Devil's Island until Zola took up his cause in 1897. France was split between those that believed him innocent and those who believed him guilty, and this led to violent anti-Semitic feelings. Surprisingly Monet, who had previously fallen out with Zola, sided with the writer. Zola was subsequently tried for libel, twice, and fled the country, only to return and die shortly afterwards. Monet was left distraught over the affair and did not paint for a year and a half.

When he started to paint again he turned to his beloved water lilies and the pond in his garden at Giverny, producing countless paintings of varying sizes, of which this is one. Later in 1922 the Orangerie of the Tuileries was gifted to the nation to house a permanent exhibition of his later works, but sadly he died in 1926 before the show opened.

CREATED

Giverny

MEDIUM

Oil on canvas

SIMILAR WORK

View of Agay by Armand Guillaumin, 1895

Claude Monet *Born* 1840 Paris, France

Died 1926

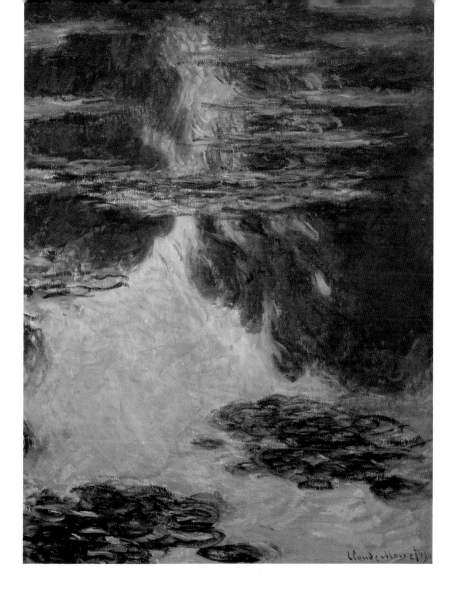

Impressionism

Society

Manet, Édouard

Olympia, 1863

© akg-images

Édouard Manet trained under Thomas Couture (1815–79) at his atelier, but felt restricted by the dry, academic approach to art and his mentor's aversion to Eugène Delacroix (1798–1863), the great colourist. He set up his own studio and produced works with characteristically dark tones and at first a Spanish feel having been influenced by the Spanish Masters, Diego Velasquez (1599–1660) and Francisco de Goya (1746–1828). He strove to depict the modern emerging Paris and to paint subjects beyond the grasp of the Academy, but still yearned for official acceptance and recognition.

He painted *Olympia* in 1863, the year of his marriage to Suzanne Leenhoff, and it was exhibited at the Salon of 1865, causing an immediate scandal. Although modelled on Titian's (c. 1488/90–1576) venerated *Venus of Urbino*, 1538, Manet's *Olympia* was bereft of a similar subtle, coy charm. She was instead exactly what she was: a highly paid prostitute who stares confrontationally out of the canvas. Shock waves rippled through French society at the audacity of the painting, and Manet, realizing the impact of the picture, chose never to sell it.

CREATED

Paris

MEDIUM

Oil on canvas

SIMILAR WORK

Venus of Urbino by Titian, 1538

Édouard Manet *Born* 1832 Paris, France

Died 1883

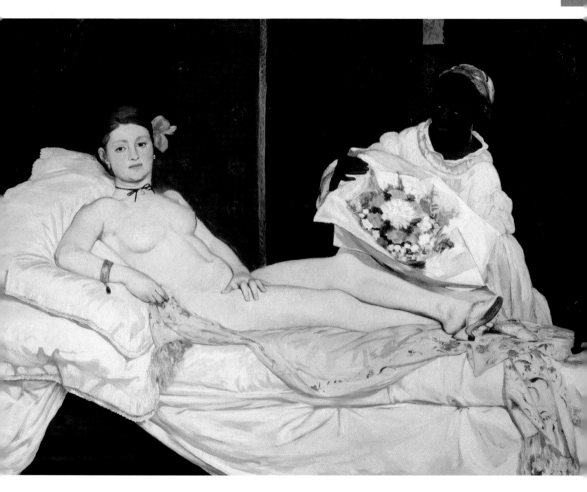

Manet, Édouard

La Rue Mosnier with Flags, 1878

© akg-images

On 30 June 1878, the Republic celebrated its first public festival since the end of the disastrous Franco-Prussian war of 1870–71 and the bloody months of the Paris Commune in 1871 following the war. A feast was planned in Paris to honour the Republic, and it coincided with the opening of the World's Fair. Claude Monet (1840–1926) travelled back to Paris for the event and painted two pictures of the flag-festooned streets. Manet also depicted the scene, similarly painting two versions, of which this is one.

He painted the Rue Mosnier (now Rue de Berne) from the window of his studio in Rue Saint-Pétersbourg, and created a strongly conflicting sensation of festivity and melancholy. In contrast to Monet's packed street teaming with life and movement, Manet's is curiously empty. Brilliant sunlight bathes the street and the bright flags deck the buildings, but it is the one-legged man on crutches who poignantly struggles up the road that catches the eye. It is perhaps the human cost of the celebrations, and in particular that of the Commune where French fought French, that Manet tips his cap to in this work.

CREATED

Paris

MEDIUM

Oil on canvas

SIMILAR WORK

National Holiday, Rue St Denis, Paris by Claude Monet, 1878

Édouard Manet *Born* 1832 Paris, France

Died 1883

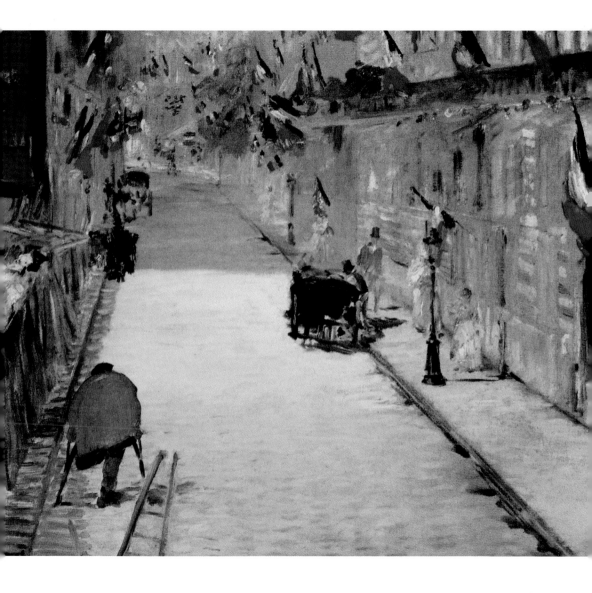

Manet, Édouard

A Bar at the Folies-Bergère, 1881–82

The Folies-Bergère opened in 1869 as a venue for comic opera, operettas and other public entertainments. It became famous as a dancehall, and by the late 1870s was one of Paris's hottest nightspots. At this time there was a burgeoning culture for nightclubs, dancehalls and social entertainments, many of which were situated around the bohemian district of Montmartre, and were famously documented by, amongst others, Henri de Toulouse-Lautrec (1864–1901).

Manet's huge painting of a bored barmaid gazing at the clientele of the Folies-Bergère was his final masterpiece, and a work of Herculean effort – he had already begun to suffer from locomotor ataxia, the disease he would die from just one year later. There is an inherent sadness to the work but, rather than sentimentalised, the barmaid and her apparent tiredness (of life and work, the two closely joined here) also challenges the public she serves. The painting was treated with critical acclaim at the 1882 Salon, and Manet was finally awarded the official *Chevalier de la Legion d'Honneur*. He continued with his work after the Salon, mostly in pastels and watercolours, but the following spring his condition deteriorated and he died in April 1883.

CREATED

Paris

MEDIUM

Oil on canvas

SIMILAR WORK

La Goulue Entering the Moulin Rouge by Henri de Toulouse-Lautrec, 1892

Édouard Manet *Born* 1832 Paris, France

Died 1883

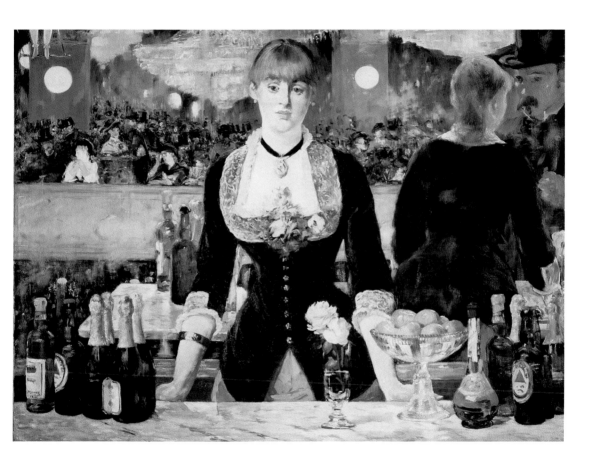

Monet, Claude

On the Beach at Trouville, 1870–71

© Giraudon, Musée Marmottan, Paris, France/The Bridgeman Art Library

1870 was another year of drama for the people of France, who had endured successive periods of fighting and social, economic and political change. It was also a year that would have a marked effect on the lives of many of the painters of the Impressionist circle. In May of that year Emile Zola (1840–1902), the art critic and one-time friend of the Impressionists, was married with Paul Cézanne (1839–1906) as his best man, and in June Monet married Camille Doncieux, the model in many of his paintings. The following month, and taking most of the country by surprise, war was declared on Prussia. It was to be a disastrous move and one that led to the bloody Paris Commune in the following year.

Monet was in Trouville at the time painting with Eugène Boudin (1824–98) and depicting the bourgeoisie at leisure. Many of the paintings include his new wife and child and Boudin's wife, with the main figures thrown up against the front of the picture plane, almost portrait-like, and the landscape drawing out behind. It was a technique that gave the works an immediacy, creating the sense of a 'slice of modern life'.

CREATED

Trouville

MEDIUM

Oil on canvas

SIMILAR WORK

On the Beach by Édouard Manet, 1873

Claude Monet *Born* 1840 Paris, France

Died 1926

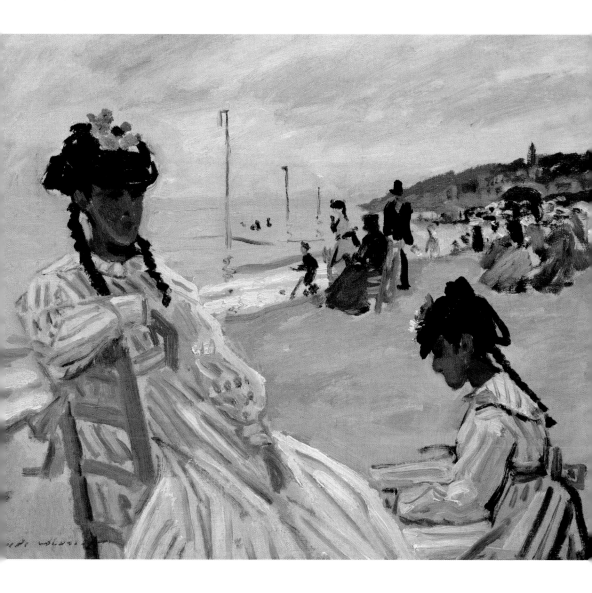

Monet, Claude

The Thames below Westminster, 1871

By September of 1870 the public had realized the enormity of France's plight against the Prussians and many started to flee. Monet witnessed a frenzied rush of people at Le Havre boarding boats for England, and he finally decided to follow, leaving his wife and child behind. Already in a poor financial state, Monet struggled to get by in London until by chance he met Charles-François Daubigny (1817–78) who in turn introduced him to the art dealer Paul Durand-Ruel (1833–1922), who would become one of the most important supporters of the Impressionists. Durand-Ruel then reunited Monet with his friend Camille Pissarro (1830–1903) who was also working in London.

London offered a new catalogue of subjects for Monet who frequently painted along the Thames. At this time the city was beset with smog caused by factories springing up in the course of the widespread industrialisation, and the visual effect of the heavy atmosphere entranced Monet. Later in his career he returned to London and produced a series of around 100 paintings depicting Charing Cross Bridge, Waterloo Bridge and the Houses of Parliament.

CREATED

London

MEDIUM

Oil on canvas

SIMILAR WORK

Crystal Palace, London by Camille Pissarro, 1871

Claude Monet *Born* 1840 Paris, France

Died 1926

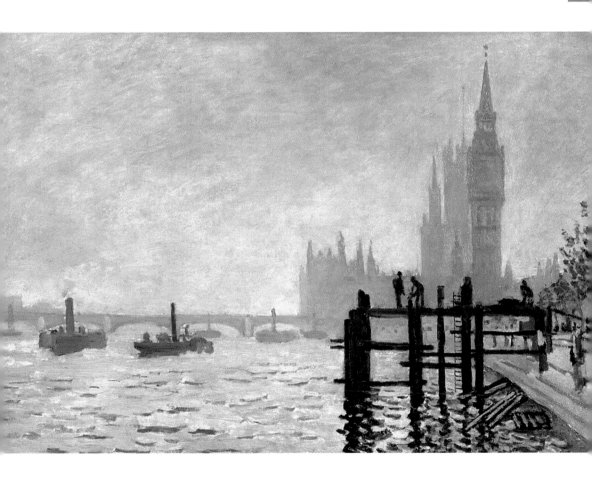

Monet, Claude

The Gare Saint-Lazare: Arrival of a Train, 1877

Following the Franco-Prussian war of 1870–71, Monet left London and travelled to Holland before returning to France in 1872. Frédéric Bazille (1841–70) had been killed during the war, and the country had been rocked by the events of the Paris Commune, a three-month bloody civil war fought in Paris, which had seen Gustave Courbet (1819–77) imprisoned for his part in the destruction of the Vendome Column – a symbol of the Empire. France entered a period of economic, social and political fluctuation as the country strove to right itself in the wake of post-war distrust. It was, however, a time that saw extraordinary accomplishments in the work of the Impressionist painters, brought together in their first exhibition as a group in 1874.

It was also a time of giant steps in terms of industry and technology, not least the continued and expanded use of steam and steam engines. In 1876 Monet moved with his family to Paris and embarked on a series of paintings of the Gare Saint-Lazare. The busy glass-roofed station with its chugging engines billowing great clouds of steam provided Monet with the perfect subject for his continued experiments in depicting atmospheric effects.

CREATED

Paris

MEDIUM

Oil on canvas

SIMILAR WORK

Le Pont de l'Europe by Gustave Caillebotte, 1876

Claude Monet *Born* 1840 Paris, France

Died 1926

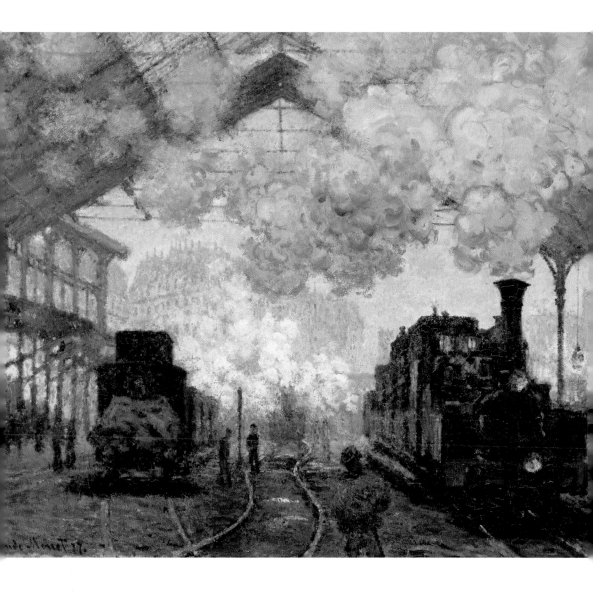

Monet, Claude

La Rue Montorgeuil, 1878

© akg-images

The Impressionists as a group were considered revolutionaries and reactionaries. Their innovative style went against everything the Academy stood for and their independence from the Academy and State protocol set them up for endless ridicule and criticism as the public failed to understand their work. Amongst Monet and his contemporaries Pissarro was the most politically charged, and he stoically refused to exhibit at the Salon his entire life, making choices that inevitably led to his continued lack of financial success.

1878 was a difficult year for the Impressionists, and Monet in particular. The World Fair was held in Paris and the country was finally becoming stable within its republican status, to such effect that anything construed as a threat to the stability and image of the Republic, including the work of the Impressionists, was shunned. Monet's work was rejected from the 1878 Salon and in the same year the planned Impressionist exhibition was cancelled. He moved from Argenteuil to Vétheuil with his desperately ill wife, and was again in virtual poverty, added to which was his extended household that now included Alice Hoschedé (his mistress) and her six children.

CREATED

Paris

MEDIUM

Oil on canvas

SIMILAR WORKS

The Boulevard Montmartre by Camille Pissarro, 1893

La Rue Mosnier with Flags by Édouard Manet, 1878

Claude Monet *Born* 1840 Paris, France

Died 1926

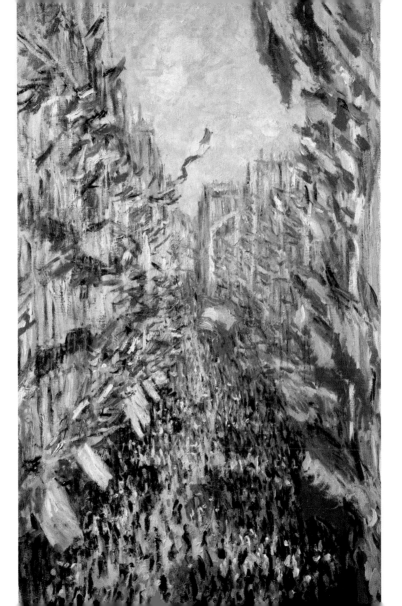

Sisley, Alfred

Flood of Port-Marly (detail), 1876

© akg-images

In March 1875 Monet, Alfred Sisley (1839–99), Pierre-Auguste Renoir (1841–1919) and Berthe Morisot (1841–95) organized a sale of their works, both for obvious financial reasons and also in an attempt to win a wider public audience. The sale was poorly received and their work slated by the acerbic critic Albert Wolff, but it resulted in a meeting with Victor Chocquet (1821–91), who became a friend and collector of the Impressionist circle. The second Impressionist exhibition was held in 1876, but was again poorly received, and had fewer exhibitors due to some artists' reluctance to be associated with the greatly criticized group.

Sisley, who is perhaps one of the least documented of the Impressionists, had been severely affected by the war of 1870–71 and was by this time struggling with poverty, exasperated by the ruin of his father's business. In 1875 he moved to Marly and during 1876 painted what are now considered some of his best landscapes. Heavy flooding of the area provided him with a new subject for a series of beautifully lyrical and serene paintings. The large areas of floodwater reflect the glittering light and the fragmented façades of buildings and trees.

CREATED

Marly

MEDIUM

Oil on canvas

SIMILAR WORK

Riverbank in Morning Haze by Gustave Caillebotte, 1875

Alfred Sisley *Born* 1839 Paris, France

Died 1899

Pissarro, Camille

Père Melon Sawing Wood, Pontoise (detail), 1879

© Christie's Images, Private Collection/The Bridgeman Art Library

The congenial Pissarro, who was the only member of the Impressionist circle to exhibit at all eight exhibitions, was regarded as a father figure amongst his fellow artists. It seems he was predominantly affable to his contemporaries and went out of his way to help younger, emerging artists. At the same time he is considered the most radical in his political convictions and was a fervent advocator of socialism. He was instrumental in the organization of the Impressionist exhibitions and, though Monet is regarded as the leader of the Impressionists, it was Pissarro who most doggedly stuck with the circle.

At the time of this painting Pissarro was living in Pontoise. In 1877 Cézanne joined him and the two painted side by side. Pissarro was beset with financial difficulties, and by the late 1870s was being helped sporadically by a restaurant owner, Eugène Murer, who also aided Sisley. In this work Pissarro echoes the tradition of Jean-François Millet (1814–75) and the Barbizon painters in his depiction of the man sawing, but has treated the background impressionistically with diffuse light and colours that foreshadow his later explorations into scientific colour theories.

CREATED

Pontoise

MEDIUM

Oil on canvas

SIMILAR WORK

The Gleaners by Jean-François Millet, 1857

Camille Pissarro *Born* 1830 St Thomas, West Indies

Died 1903

Pissarro, Camille

Portrait of Madame Pissarro Sewing, c. 1885

By the 1880s the original group of the Impressionists had begun to disperse, a move that the critic and one-time friend of the Impressionists, Emile Zola, had predicted. Pissarro was the only member to doggedly stick with the group through all eight exhibitions, refusing to be drawn by the infighting between Edgar Degas (1834–1917) and his followers, and Monet and Renoir. The fragmentation of the painters was further cemented as they began to physically move away from each other, with Pissarro settling in Eragny by the River Epte with his wife and six children in the spring of 1884.

There was also a wealth of younger artists developing new styles at this time, and Pissarro welcomed the diversity of the fresh talent, inviting the younger artists to exhibit with the group against the wishes of Monet. Pissarro's open-minded approach may have been influenced by his son Lucien, who was himself an aspiring and talented artist. This painting of Madame Pissarro with its evocative light-flooded picture plane and the use of short, quick brushstrokes reflects Pissarro's evolving style as he became interested in the techniques of the new artists.

CREATED

Eragny

MEDIUM

Oil on canvas

SIMILAR WORK

The Gardener by Georges Seurat, c. 1882

Camille Pissarro *Born* 1830 St Thomas, West Indies

Died 1903

Pissarro, Camille

Apple Picking at Eragny-sur-Epte (detail), 1888

Pissarro was introduced to Paul Signac (1863–1935) and Georges Seurat (1859–91) in 1885 through Armand Guillaumin (1841–1927), and was immediately drawn to their innovative and scientific approach to painting. During the early 1880s Pissarro's style had been evolving and he had turned to different subject matters – street scenes of Paris and Rouen, busy market scenes and figural works – in his search for a new expression. His use of new subjects and techniques was no doubt partially influenced by a necessity to gain better commercial success. He began to experiment with Pointillism in the manner of Seurat, applying his paint in small dabs of ordered colour based on colour theories developed by the scientists Chevreul and Maxwell.

At Pissarro's insistence Signac and Seurat were included in the eighth and last Impressionist exhibition in 1886, but it was a move that Monet and others violently objected to. By 1888 Pissarro was selling a few works through Theo Van Gogh (1857–91) and his prices had marginally improved. He had, however, become disillusioned by the rigorous approach of Pointillism, and in this sun-drenched picture his brush strokes have become slightly broader and less regimented.

CREATED

Eragny

MEDIUM

Oil on canvas

SIMILAR WORK

Seated Female Nude by Georges Seurat, c. 1886–87

Camille Pissarro *Born* 1830 St Thomas, West Indies

Died 1903

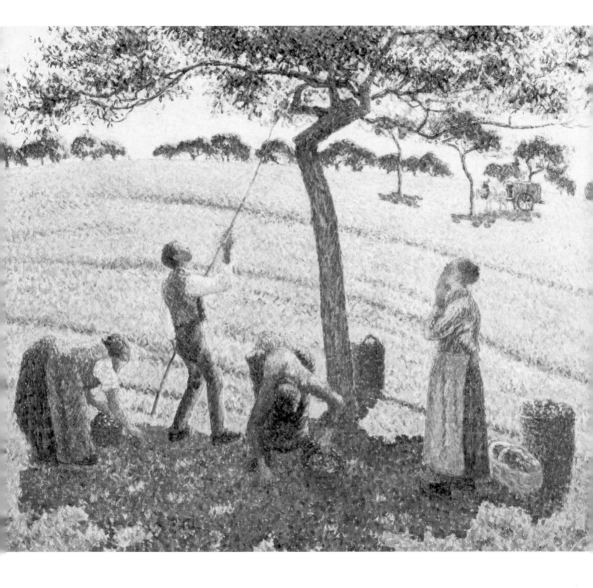

Pissarro, Camille

Dieppe, Basin Duquesne, 1902

© akg-images

In his old age Pissarro developed a chronic and painful infection in one of his eyes that made open-air painting difficult for him. Instead he embarked on a series of trips, to England where his son Lucien was based, and to Rouen, Paris and Dieppe, the scene of this painting. He would rent rooms and then paint the urban scene unfolding from his window. Throughout his life industrialization had been steadily increasing, both in France and in England, with factories and chimneys springing up on the outskirts of the large towns. To Renoir and other Impressionist painters this spread of industry was a blight on the landscape. In contrast Pissarro, with his strident political and social beliefs, embraced the contemporary reality of industry, heralding the growth of working class areas and their inhabitants as something beautiful.

His city views, including this one, this effortlessly meld the smoking factory chimneys into the landscape so they are indeed something of beauty, and fundamentally appear 'a part' of the land from which they rise. He had abandoned his Pointillist techniques by now and had returned, more successfully, to his former impressionistic approach finally gaining some commercial success and relative financial stability.

CREATED

Dieppe

MEDIUM

Oil on canvas

SIMILAR WORK

Barges at Rouen by Albert-Charles Lebourg, 1903

Camille Pissarro *Born* 1830 St Thomas, West Indies

Died 1903

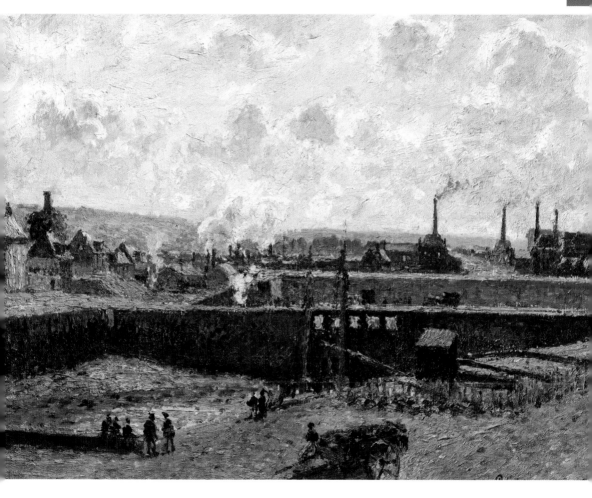

Renoir, Pierre-Auguste

La Grenouillère (detail), *c.* 1869

The group of Impressionist painters as they are referred to now at first developed through the strong friendships that these painters had. Renoir, Monet, Bazille and Sisley in particular formed a tight-knit circle, and this sense of affinity was reaffirmed through the social scene at the Café Guerbois in Paris. Here artists would meet for lively debate and long evenings of discussions where their ideas and theories were shared.

France was entering what would be a long period of change and growth that continued throughout the nineteenth century. Industry and commerce were increasing, and, despite the political and economic fluctuations, there was a steady rise in the middle classes. Leisure and promenading were popular, and *La Grenouillère* (literally translated as 'the frog pond') became a favourite bathing spot amongst the bourgeoisie. Monet and Renoir spent some weeks together here, both attracted by the sparkling river scene and fashionably dressed revellers who travelled the short distance from Paris. The two artists painted the same motif more than any of their contemporaries during their careers, and here Renoir's delicate colours and translucent light reflect the basic foundations for his later artistic development.

CREATED

La Grenouillère

MEDIUM

Oil on canvas

SIMILAR WORK

Bathers at La Grenouillère by Claude Monet, 1869

Pierre-Auguste Renoir *Born* 1841 Limoges, France

Died 1919

Renoir, Pierre-Auguste

La Loge, 1874

Following the Franco-Prussian war in 1870–71 (during which Renoir had served with a regiment of the Cuirassiers), many of the Impressionists moved away from Paris. But not Renoir. He remained, attracted to the whirl of social activity and endless choice of subject matter, and painted a number of portrait commissions to supplement his income. His brother Edmond, a journalist and champion of the Impressionists, also stayed in the city. Immediately after the war France had enjoyed a brief period of economic growth and in turn picture prices and sales had increased. By the end of 1873, however, the market had again crashed and Durand-Ruel, upon whom many of the Impressionists relied, had suffered great losses. In 1874 Monet again suggested organizing an independent exhibition with the hopes of improving their commercial viability.

Renoir was responsible for hanging the paintings in the first Impressionist exhibition, and it was his brother Edmond who famously named Monet's painting *Impression* in the catalogue. The exquisite *La Loge* of opulent colour and gleaming pearls was one of Renoir's paintings on show, and was eventually sold under the asking price to the dealer Père Martin.

CREATED

Paris

MEDIUM

Oil on canvas

SIMILAR WORK

Une Loge aux Italiens by Eva Gonzalès, c. 1874

Pierre-Auguste Renoir *Born* 1841 Limoges, France

Died 1919

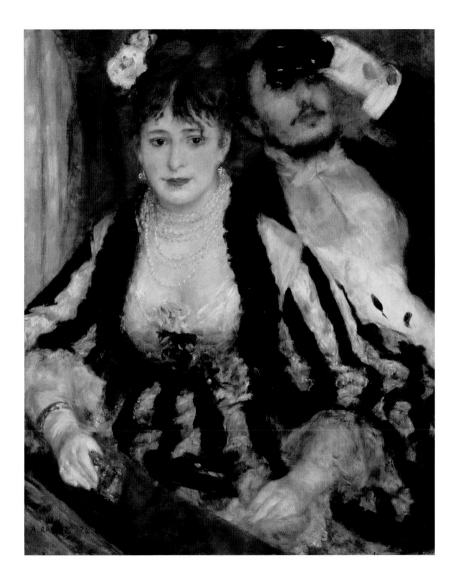

Renoir, Pierre-Auguste

Le Moulin de la Galette (detail), 1876

© akg-images

By the late nineteenth century, Montmartre had become one of the fashionable entertainment districts of Paris. Originally Montmartre was outside the city limits and therefore free from Paris taxes, a factor that, combined with a community of winemaking nuns, led to its popularity as a place of drinking and making merry. The decadent and bohemian nature of Montmartre also attracted many artists, drawn no doubt for lascivious reasons, but also to paint the wealth of characters and frenzied social activity.

In March 1875 the Impressionists held a largely unsuccessful auction of their works, although Renoir sold one of his paintings to the publisher Georges Charpentier (1846–1905). It was a fortuitous meeting and shortly afterwards Renoir was able to move to a house, complete with studio and garden, on Rue Cortot in Montmartre. It became a daily meeting place for friends and artists who posed for his works, and helped him carry his large canvas to the Moulin de la Galette where he painted this work. The popular club provided the perfect subject for Renoir and was one of the first multi-figural works he did. It was also well received by the critics and was bought in 1877 by Gustave Caillebotte (1848–94).

CREATED

Paris

MEDIUM

Oil on canvas

SIMILAR WORK

The Café-Concert, Les Ambassadeurs by Edgar Degas, 1876–77

Pierre-Auguste Renoir *Born* 1841 Limoges, France

Died 1919

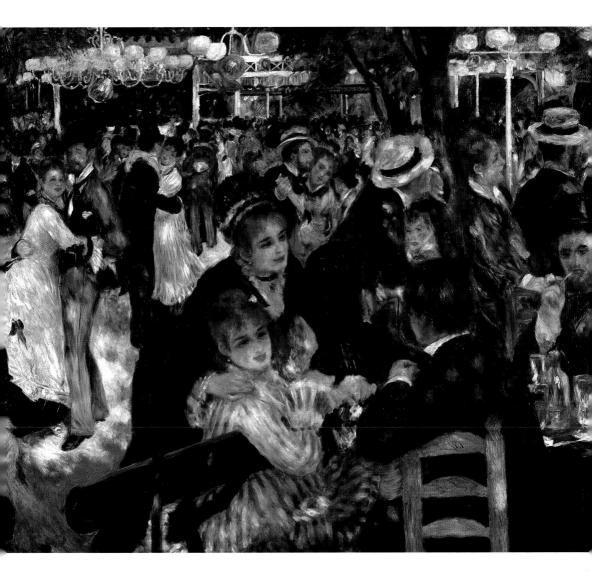

Renoir, Pierre-Auguste

The Luncheon of the Boating Party, 1880–81

The Impressionists had started to fragment as a group by 1880 and there was increasing disillusionment amongst them. In 1879 the critic Zola wrote a Salon review for Russia in which he harshly criticized the Impressionists (his one-time friends) and the following year the critic Joris-Karl Huysmans (1848–1907) again attacked them. In the same year, again after the Salon, Zola challenged the Impressionists to paint large-scale works of modern life in a considered manner and to abandon their hasty sketches. It was perhaps these words that inspired this work by Renoir. Painted on the same-sized canvas as *Le Moulin de la Galette* of 1876, this multi-figural painting is more spatially complex and demonstrates the artist's progression. He paid much greater attention to the specific figures, many of which are identifiable as various friends and models, making them less impressionistic and lending them a portrait quality.

The painting depicts the upstairs terrace of the Fournaise Restaurant situated on an island in the Seine at Chatou. At this time it was a popular meeting place for oarsmen who rowed regularly on the Seine to the west of Paris, and was the scene of many rowdy lunch parties.

CREATED

Paris

MEDIUM

Oil on canvas

SIMILAR WORK

In the Garden Restaurant of Père Lathuille by Édouard Manet, 1879

Pierre-Auguste Renoir *Born* 1841 Limoges, France

Died 1919

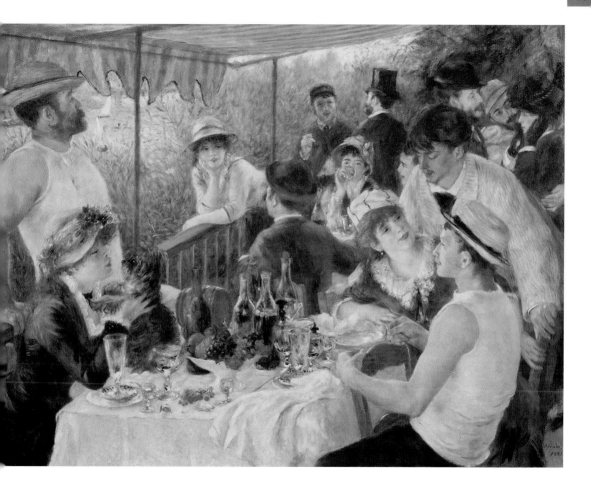

Renoir, Pierre-Auguste

Blonde Bather, 1882

© akg-images

Following in the footsteps of so many artists before him, Renoir started to travel in early 1881. He went first to Algiers in North Africa where Delacroix had been so greatly affected, then at the end of the year he travelled to Italy seeking the work of Raphael (1483–1520). This painting of the *Blonde Bather*, which marks a distinctive change in his style, was done while the artist was on a boat in the Bay of Naples. The model was Aline Charigot, a seamstress who became his wife in 1890, and whom Renoir had first painted in *The Luncheon of the Boating Party*, 1880–81.

He was moved by Raphael's frescos, their simplicity and grandeur, though he later wrote that he preferred the oil painting of Jean-Auguste-Dominique Ingres, (1780–1867). There is certainly a sense of classical stillness and monumentality in this work that reflects Renoir further distilling the outline and features of his figures – something that had begun to emerge in T*he Luncheon of the Boating Party*, 1880–81. Despite this, Renoir's modelling through soft colour is seen to beautiful effect here, and the bather's skin shines with the luminosity of sun-drenched flesh.

CREATED

Italy

MEDIUM

Oil on canvas

SIMILAR WORK

Nude by Paul Gauguin, 1880

Pierre-Auguste Renoir *Born* 1841 Limoges, France

Died 1919

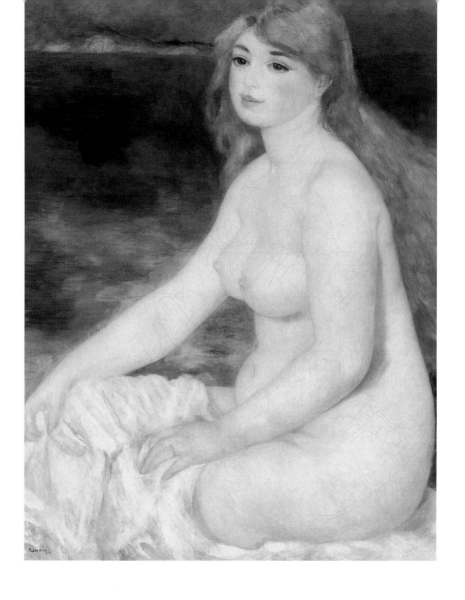

Guillaumin, Armand

Quai de la Gare, Effet de Neige (detail), c. 1875

© akg-images

Late in life and due to a fortuitous lottery win, Guillaumin was finally able to devote himself fully to his painting. Prior to this he worked out of necessity, first for the Paris-Orleans Railway and later in a department of the public sector that dealt with bridges and paths. He practised his art on a part-time basis at the Académie Suisse, where he became friendly with Cézanne and Pissarro, with whom he stayed close through his life and whose influence can be seen in this painting. Guillaumin treated scenes of modern expansion, such as stations and smoking factories, in a similar manner to Pissarro by embracing them within the landscape. Significantly, Guillaumin also went to school with Eugène Murer, who would later become a restaurateur and a major collector of the Impressionists, in particular the works of Pissarro.

Guillaumin exhibited at the first Impressionist exhibition in 1874 during which time he was living in the same building as Cézanne. He went on to exhibit at the third, fifth, sixth and seventh exhibitions, but was increasingly criticized by Monet. Towards the end of his life he travelled around Normandy, Brittany and Dauphiné and concentrated primarily on landscapes.

CREATED

Paris

MEDIUM

Oil on canvas

SIMILAR WORK

The Road, Effect of Winter by Camille Pissarro, 1872

Armand Guillaumin *Born* 1841 Paris, France

Died 1927

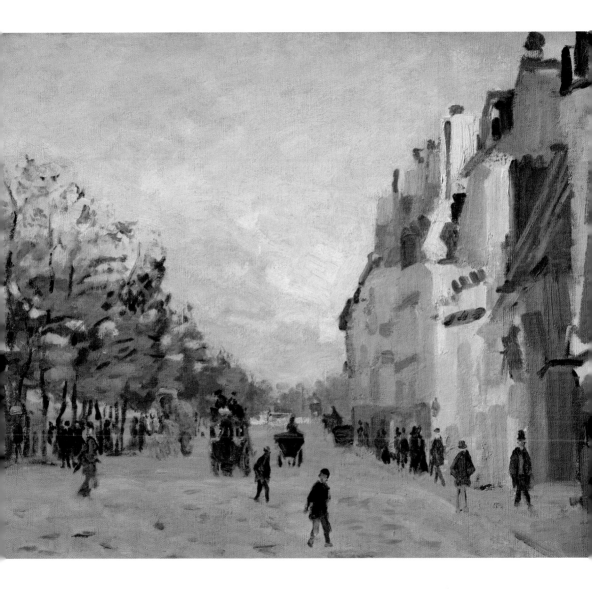

Degas, Edgar

The Cotton Exchange, New Orleans (detail), 1873

© Giraudon, Musée des Beaux-Arts, Pau, France/The Bridgeman Art Library

In 1866, Jules and Edmond de Goncourt published their novel *Manette Salomon*, in which they propounded the idea that art should 'precisely render life, embrace from close at hand the individual, the particular, a living, human, inward line...'. It was an approach based on the examination of modern life, and one that Charles Baudelaire (1821–67) had also addressed, but more significantly it was one that had great effect on Degas. The eccentric artist, who was already working in a highly original manner, strove to find new vehicles to express modern life, filling notebooks with his ideas about subjects to paint.

The year after the Franco-Prussian war Degas travelled with his brother René to New Orleans where his other brothers had set up business as cotton merchants. It was an experience that exposed him to a completely different culture and, although he enthused about it, he found it difficult to capture the exotic, flamboyant city on canvas. Instead he focused on interior scenes such as this depiction of the busy cotton exchange. The influence of his friend Manet is apparent here, but so too is Degas's striking manipulation of space and use of unusual, oblique angles that make his paintings so unique.

CREATED

New Orleans

MEDIUM

Oil on canvas

SIMILAR WORK

At the Café – Concert by Édouard Manet, 1878–79

Edgar Degas *Born* 1834 Paris, France

Died 1917

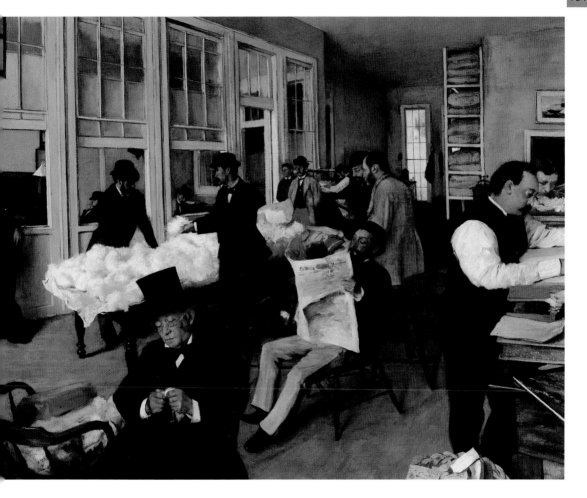

Degas, Edgar

Absinthe, 1876

In the early 1870s Degas painted numerous scenes of the famous Paris Opera, studying the performers from the wings and watching their rehearsals. His family was upper middle class and were members of polite society, and Degas was exposed from a young age to the delights of opera, music, ballet and erudite conversation, and was introduced to many of the performers he later captured on paper.

In contrast to the refinement of the opera was the lively café culture which enjoyed a boom through the late nineteenth century. The various cafés drifted in and out of vogue amongst Degas and his circle of artist friends who would meet for lively debates whilst drinking absinthe. This green cocktail (also called the Green Fairy) was the most popular aperitif in Paris at this time, and was consumed in large quantities. Degas, Manet and Vincent Van Gogh (1853–90) in particular painted people drinking absinthe, or the depressing side effects of its over indulgence. This painting depicts the actress Ellen Andrée and Marcellin Desboutin at the Café de la Nouvelle-Athènes, which was frequented by Degas and Manet and featured a large dead rat painted on the ceiling.

CREATED

Paris

MEDIUM

Oil on canvas

SIMILAR WORKS

The Plum by Édouard Manet, 1877

Monsieur Boileau by Henri de Toulouse-Lautrec, c. 1893

Edgar Degas *Born* 1834 Paris, France

Died 1917

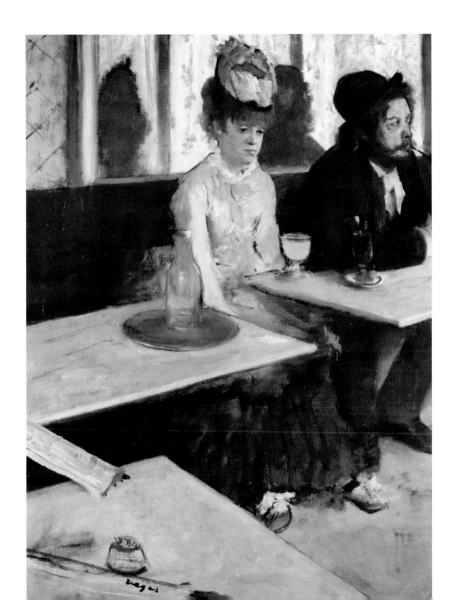

Degas, Edgar

The Laundresses, c. 1884–86

© akg-images

Unlike the other members of the original group, Degas painted primarily in the studio from memory and sketches rather than in front of the motif. He also chose to depict those subjects of modern life that had not been addressed before, such as the tired laundresses in this painting, women bathing, his scenes from the racecourse and his famous ballet dancers. Increasingly he concentrated on just a few subjects that were gradually whittled down to images of women, their gesture and movement eventually eclipsing background details.

Here the honesty of his image and the candid depiction of women working recalls the spirit of the Barbizon artist Millet and his paintings of labourers toiling. Degas has painted the women, seemingly unaware of his scrutiny, so they appear totally unaffected and natural in stance and attitude. It was an angle he took almost consistently, especially in his later works, and is one that evokes the sense of a photograph, a snapshot of mundane life. At this time great advances were being made in photography, something that Degas was aware of.

CREATED

Paris

MEDIUM

Oil on canvas

SIMILAR WORK

The Laundress by Henri de Toulouse-Lautrec, 1884–86

Edgar Degas *Born* 1834 Paris, France

Died 1917

Degas, Edgar

Jockeys in the Rain, c. 1886

Horseracing was, and continues to be, a celebrated and fashionable sport in France, with one of the most famous tracks, the *Hippodrome de Longchamps* being located on the outskirts of Paris. The first race was run in 1857, and from then on it became an increasingly popular venue for socializing amongst the Parisian bourgeoisie. Degas had a long affinity with Longchamps and other racecourses and, from 1860 to approximately 1900, depicted around 90 different scenes of horses and jockeys. Longchamps was also a favourite destination for Manet and Toulouse-Lautrec, both of whom painted several pictures of the races. The young Toulouse-Lautrec became a great admirer of Degas, though whether the feeling was reciprocated is unclear.

From around the late 1870s Degas increasingly began to work in pastels, a medium that allowed him a greater freedom of expression, and also offered less opportunity for re-working his paintings. This pastel work of racehorses milling around at the start of a race in the pouring rain is full of the tension and excitement of the event, while Degas's use of a soaring diagonal composition places the viewer right alongside the horses.

CREATED

Paris

MEDIUM

Pastel on paper

SIMILAR WORKS

Racecourse at Longchamps by Édouard Manet, 1864

At the Racecourse by Henri de Toulouse-Lautrec, 1899

Edgar Degas *Born* 1834 Paris, France

Died 1917

Degas, Edgar

Woman in a Tub, c. 1883

© akg-images

1886 was the year of the eighth and last Impressionist exhibition, though by this point the group had in terms of style and technique dramatically fragmented. It was also the year that the dealer Durand-Ruel staged the first exhibition in New York, showing works by Degas, Manet, Renoir, Monet and other members of the group. Despite some criticism, overall they were well received across the Atlantic, and the American market looked set to be relatively favourable.

By this time Degas was suffering from poor eyesight which steadily worsened. Unlike his friends he had remained in Paris where he lived and worked, increasingly in pastels and making small sculptures and wax models. He embarked on a series of works depicting women bathing or drying themselves, which was a subject he would return to in the last two decades of his life, producing over 200 different images. This particular work is one of the most delicately and beautifully rendered, and has a timeless monumentality that evokes the classical past in spirit. The lack of detail in the background focuses attention on the figure and prevents any assumptions regarding her social position. She appears therefore as a classless ideal, almost goddess-like, while remaining grounded in the reality of her mundane ablutions.

CREATED

Paris

MEDIUM

Pastel on paper

SIMILAR WORK

Study of a Nude, Suzanne Sewing by Paul Gauguin, 1880

Edgar Degas *Born* 1834 Paris, France

Died 1917

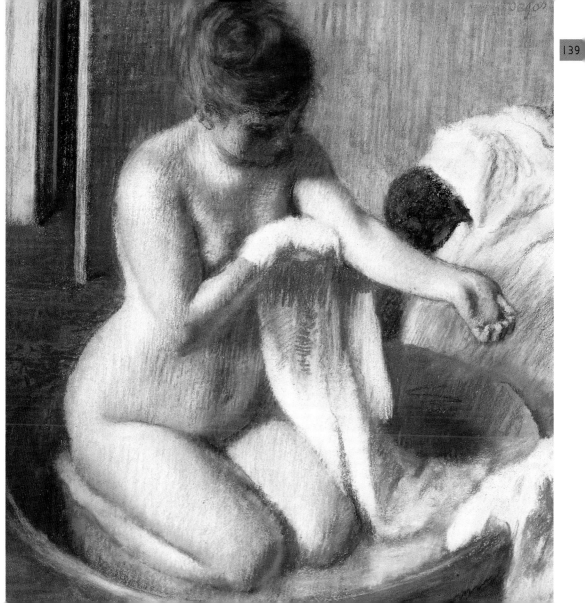

Degas, Edgar

Blue Dancers (detail), c. 1895

© akg-images

From the mid-1880s to the end of his life, Degas increasingly surrounded himself with his few close friends, the Rouart family, the model and artist Suzanne Valadon (1865–1938) and the sculptor Paul Albert Batholomé. He stayed in Paris but did not participate in the monthly gatherings at the Café Riche, which many of his contemporaries attended. After the last Impressionist exhibition Degas refrained from showing his work in public, with the exception of one small exhibition of a series of pastel landscapes in 1892.

At the time of *Blue Dancers* Degas had changed his working practice and instead of producing a single picture he had started to work on series of related images. He would draw and sketch a succession of very similar works that formed a group of pictures, some as small as three different images, while others were as large as 30. *Blue Dancers* can be most closely compared to *Dancers, Pink and Green, c.* 1885–95, both of which were executed in oils. Degas was also concentrating on his sculptural works, although he only ever exhibited one. After his death a host of models of dancers and horses, many of them damaged and crumbling away, were discovered in his studio.

CREATED

Paris

MEDIUM

Oil on canvas

SIMILAR WORK

Quadrille at the Moulin Rouge by Henri de Toulouse-Lautrec, 1892

Edgar Degas *Born* 1834 Paris, France

Died 1917

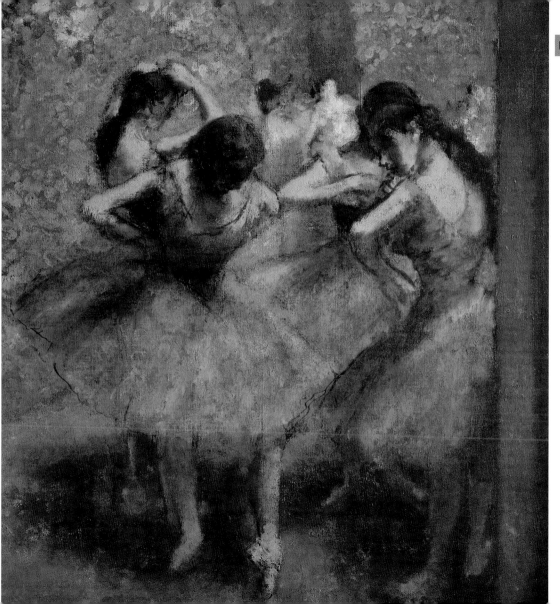

Caillebotte, Gustave

Interior, Woman at the Window, 1880

© Private Collection/The Bridgeman Art Library

Caillebotte was a respected member of the Impressionist group, and was also a major collector and supporter of his contemporaries' works. His work was most influenced by that of Degas, but the two artists had a fraught relationship and in 1881, the year after this painting, Caillebotte tried to persuade Pissarro to organize an exhibition without including Degas. Although Pissarro declined it was a measure of the disunity amongst the artists; a disunity furthered by Degas's championing of Jean Raffaëlli (1850–1924) and Eugène Vidal (1847–1907) and his disgust at Monet and Renoir turning back to the Salon.

This painting reflects something of Degas's influence, but characteristically of Caillebotte, combines a realistic and impressionistic approach. The scene of a middle class interior is one he painted several times, and this one emits a sense of boredom and frustration through the figure of the woman gazing out of the window.

Caillebotte amassed a collection of Impressionist paintings, including works by Monet, Renoir, Manet, Pissarro, Degas, Sisley and Cézanne, that he bequeathed to the State on his death. The bequest caused the Government embarrassment at the time – the Impressionists were still being largely ridiculed by the mid-1890s.

CREATED

Paris

MEDIUM

Oil on canvas

SIMILAR WORK

Alice Villette by Edgar Degas, 1872

Gustave Caillebotte *Born* 1848 Paris, France

Died 1894

Morisot, Berthe

The Cradle, 1872

© akg-images

Morisot is regarded as the leading female painter of the Impressionist group alongside Mary Cassatt (1844–1926), and had a long and loyal relationship with the Impressionists. She exhibited at all but the fourth exhibition (due to pregnancy and illness), and her style stayed truly impressionistic throughout her career. In 1868 she met and befriended Manet, with whom she remained close, eventually marrying his brother Eugène in 1874.

This intimate painting of Morisot's sister Edmé gazing into her child's cradle is a particularly tender rendition of an essentially feminine subject. Morisot and other female artists were still restricted at this time by strong social constraints that limited to some extent their choice of subject matter. It is no coincidence that the majority of Morisot's and Cassatt's works are images of domestic interiors and women with their children. Edmé had also trained as an artist alongside Morisot, and the two sisters were extremely close, as we can see from this picture. Edmé married a naval officer in 1869, and shortly afterwards all but gave up her painting. An apparently passionate artist, she must have missed painting.

CREATED

Paris

MEDIUM

Oil on canvas

SIMILAR WORK

Mother About to Wash her Sleepy Child by Mary Cassatt, 1880

Berthe Morisot *Born* 1841 Bourges, France

Died 1895

Morisot, Berthe

At the Ball, 1875

© akg-images

In 1874 Morisot's father died and she inherited a sum of money that, combined with her husband Eugène's money, allowed her the freedom to paint without financial worries. Her husband, who was Édouard Manet's brother, fully supported Morisot in her choice to paint and was a champion of the Impressionists.

The beautiful *At the Ball*, that shows the influence of Manet and Renoir, was painted the same year as the Impressionist's first disastrous auction. The public were unwilling to invest in artwork and the French economy was still reeling from the crash of 1873. Out of desperation Renoir, Monet and Sisley held an auction at the Hôtel Drouot, and Morisot joined them, not because she needed the money, but in order to reaffirm her solidarity with the painters. Ironically, it was Morisot's works that sold the best, although even these went for little, and the other painters' works were either withdrawn or sold for virtually nothing. Following the auction Morisot travelled to England and painted various evocative scenes of the beach at Ramsgate and further along the coast.

CREATED

Paris

MEDIUM

Oil on canvas

SIMILAR WORK

La Loge by Pierre-Auguste Renoir, 1874

Berthe Morisot *Born* 1841 Bourges, France

Died 1895

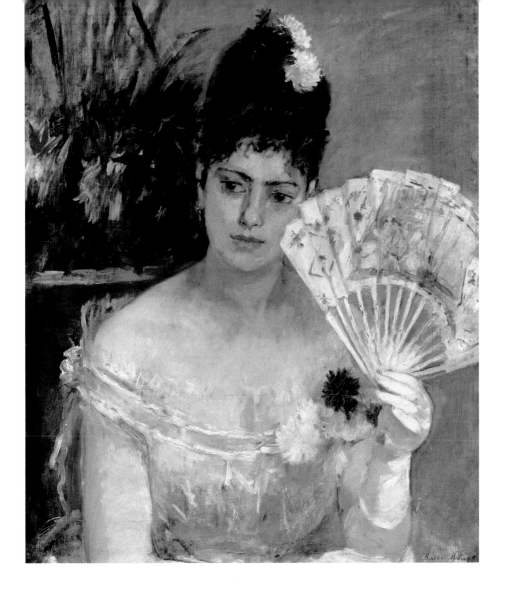

Morisot, Berthe

Young Woman Powdering her Face, 1877

© akg-images

After meeting Manet in 1868, Morisot worked closely with the older artist for some time and enjoyed his support and encouragement. As her work became more accomplished and original however, the definitions between teacher and pupil became blurred and the two inevitably influenced each other. Morisot also absorbed the works of her fellow artists, in particular Renoir. There are elements of Renoir in this painting of a *Young Woman Powdering her Face*, although Morisot had developed an impressionistic language of her own, that here perfectly reflects the iridescence of a softly lit room. The painting was completed the year of the third Impressionist exhibition and the following year the artist gave birth to her only child, Julie, and hence missed the fourth exhibition.

During the course of the third exhibition the critic Georges Rivière, who was a friend of Renoir, published a journal, *L'Impressionniste*, in an effort to sway public opinion in favour of the artists. In the paper he applauded the 'new' style and named Monet, Pissarro, Sisley, Renoir and Morisot as the true Impressionists and leaders of the movement.

CREATED

Paris

MEDIUM

Oil on canvas

SIMILAR WORK

Woman with a Mirror by Pierre-Auguste Renoir, c. 1915

Berthe Morisot *Born* 1841 Bourges, France

Died 1895

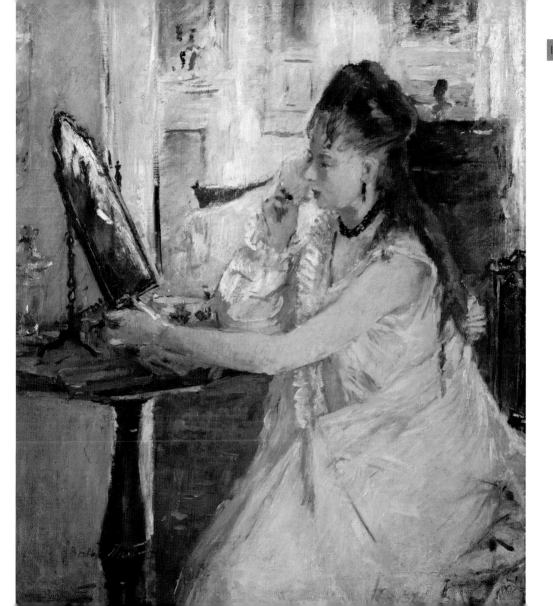

Cassatt, Mary

Young Mother Sewing, c. 1890

Young Mother Sewing was painted at the beginning of one of Cassatt's most productive and accomplished periods, and reflects her gradual development away from the pure impressionist style. Her use of strong line, especially in the pattern on the woman's dress, anticipates her work of the 1890s when she employed larger, flatter areas of colour.

The fiercely independent American artist first exhibited with the Impressionists in 1877, after being invited to join the group by Degas. She remained close friends with the artist and his influence can be seen in her work, particularly in her use of pastels. She became increasingly original in style and execution however; a series of lithograph prints done in 1891, for example, reflect an appreciation of Japanese masters. Cassatt was important in introducing the Impressionists to the American market (something Durand-Ruel had also achieved through his exhibitions) and in securing a number of wealthy American patrons for her friends. During the 1890s she became a role model for aspiring young American painters, offering them help and advice, and in 1892 was commissioned to paint a mural for the World Fair in Chicago, USA.

CREATED

Paris

MEDIUM

Oil on canvas

SIMILAR WORK

Portrait of Mary Cassatt by Edgar Degas, c. 1880–84

Mary Cassatt *Born* 1844 Pennsylvania, USA

Died 1926

Cézanne, Paul

A Modern Olympia, 1873

Cézanne was one of the more eccentric of the original group of Impressionists and was prone to emotional outbursts. This may have been partly caused by frustration – the artist struggled initially with his paintings, unable to find a visual expression that relayed the concepts behind his works. It was not until later in his career that his paintings truly achieved the full extent of his extraordinary vision, and paved the way forward for modern art.

Cézanne shunned Paris, preferring the countryside, and at the time of this painting he was living in Auvers, not far from the charismatic Dr Gachet who would later look after Van Gogh. *A Modern Olympia* appears to parody Manet's *Olympia* of 1863, and in turn perhaps challenges the regimented sentiments of the conservative critics who had so slated the older artist's painting. The figure of the man is commonly attributed as a self-portrait of Cézanne who gazes up at the figure of Olympia. The work is wonderfully free in expression – much more so than was usual for the artist – with a refreshing measure of satirical humour.

CREATED

Auvers

MEDIUM

Oil on canvas

SIMILAR WORK

Olympia by Édouard Manet, 1863

Paul Cézanne *Born* 1839 Aix-en-Provence, France

Died 1906

Cézanne, Paul

The Card Players, 1885–90

© akg-images

In 1886 Cézanne's father died and the artist was left a considerable fortune thus resolving his financial problems. Shortly before the death of his father he married his long-term mistress Hortense Fiquet with whom he already had a son, and the family moved to Aix-en-Provence, Cézanne's hometown. It was also significantly the year that the artist finally came to blows with Emile Zola, the acerbic critic and his old school friend at whose wedding he had been best man. The row occurred over the publication of Zola's novel *L'Oeuvre*, a book about a struggling group of painters, whose hero was a failed and desperate artist, obviously modelled on Cézanne and Manet.

Cézanne increasingly removed himself from society and lived in semi-isolation, hardly exhibiting and developing his style in a progressively innovative manner. *The Card Players* was one of a series of five paintings on this subject and reflects the artist's accomplished manipulation of space, form and perspective. He was using large areas of solid, rich, earthy colours and building these into the spatially challenging forms of his figures. The painting produces a synthesis of abstract and natural, and is convincing as both.

CREATED

Aix-en-Provence

MEDIUM

Oil on canvas

SIMILAR WORK

Agostina Segatori in the Café du Tamborin by Vincent Van Gogh, 1887

Paul Cézanne *Born* 1839 Aix-en-Provence, France

Died 1906

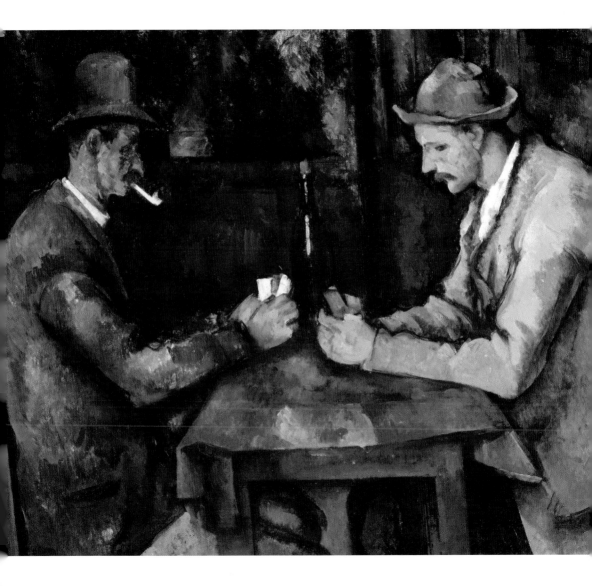

Cézanne, Paul

Sitting Peasant, c. 1900

Towards the end of the 1890s Cézanne's pictures started to command greater prices. This was particularly apparent at the sale of Victor Chocquet's collection in 1899. Chocquet had been a friend and patron to Cézanne since 1875 and had amassed a considerable collection of works by him and his contemporaries. Following his death and that of his widow his collection was sold and Cézanne's pictures finally sold for better prices.

It is ironic that whilst his work had finally started to be appreciated, Cézanne suffered in other areas of his life. From 1890 onwards he was increasingly debilitated by diabetes, and his relationship with his wife Hortense had begun to disintegrate. He isolated himself in Provence where he continued to work tirelessly, and was often plagued by a succession of young artists seeking his advice. This infinitely sad image of a Provence peasant evokes the weariness that the artist now felt. The figure shows Cézanne's abstraction of perspective seen in the oversized hands and the peasant's tools – something he frequently explored in his later works.

CREATED

Provence

MEDIUM

Oil on canvas

SIMILAR WORK

Old Man with a Pipe by Vincent Van Gogh, 1883

Paul Cézanne *Born* 1839 Aix-en-Provence, France

Died 1906

Impressionism

Places

Manet, Édouard

Argenteuil, 1874

By the second half of the nineteenth century, Argenteuil had become a popular destination for Parisians to escape for day trips and holidays. Situated around 12 km (7 miles) from the centre of Paris, the bustling town along the banks of the River Seine was also a favourite haunt for many young artists including Édouard Manet (1832–83), Claude Monet (1840–1926) and Pierre-Auguste Renoir (1841–1919).

Berthe Morisot (1841–95) is credited with introducing Manet to *en plein air* painting in around 1868, and in the summer of 1874 he painted scenes of the sparkling Seine at Argenteuil, alongside Monet. It provided him with the perfect subject to further explore the effects of light and atmosphere, and the influence of Monet in this respect was notable. Manet had bought a small house across the river at Gennevilliers and spent much of his time visiting Monet who had himself moved to Argenteuil in 1872. This famous depiction of a young couple courting by the river illustrates Manet's preoccupation with the figural content of his works. The landscape, though significant, is subsidiary to the two figures whose positioning in the foreground places the viewer almost within their space.

CREATED

Argenteuil

MEDIUM

Oil on canvas

SIMILAR WORK

Hide and Seek by Berthe Morisot, 1873

Édouard Manet *Born* 1832 Paris, France

Died 1883

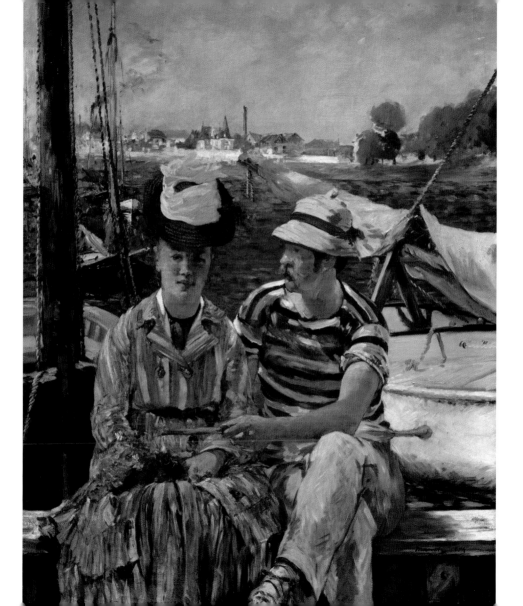

Manet, Édouard

In the Café, 1878

© akg-images

Manet was one of the first of the nineteenth-century artists to paint scenes of 'modern life'. He captured a rapidly changing world and although he is recognized as the father of Impressionism he never exhibited with the group. One aspect of life that Manet addressed was that of the café culture, as seen in this painting. The Parisian cafés were extremely popular and developed a reputation as boltholes for revolutionaries, based on meetings by radical factions, anarchists and those striving for social and political reform held in various cafés prior to the Commune. They were frequented by artists, critics, bohemians and writers and were the scene of many rowdy debates for Manet and his circle.

In 1878 he embarked on a series of paintings, of which this is one, depicting scenes of drinkers and waitresses at the cafés. The pictures are all based around a similar compositional form that throws the figures into the foreground so that the spectator becomes part of the busy scene. In this particular work the woman engages with her direct and level stare, paying more attention to the onlooker than the man beside her and drawing the spectator into her world.

CREATED

Paris

MEDIUM

Oil on canvas

SIMILAR WORK

Le Moulin de la Galette by Pierre-Auguste Renoir, 1876

Édouard Manet *Born* 1832 Paris, France

Died 1883

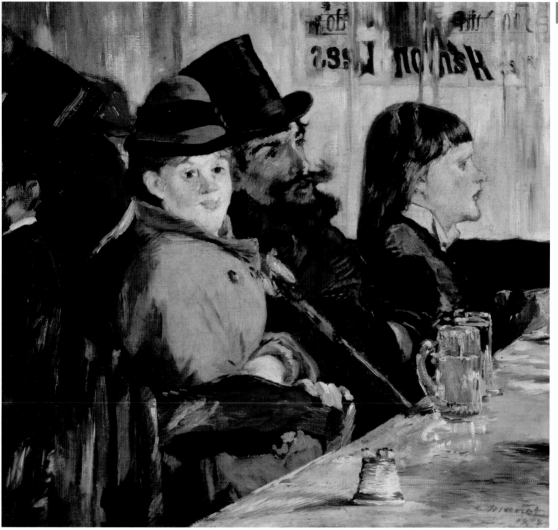

Manet, Édouard

The Rue Mosnier with Pavers, 1878

Another popular subject amongst the Impressionists and their circle was that of the urban street. In particular this was reflective of the changes to the city on a physical, social and political level following the 1870–71 Franco-Prussian war and the subsequent bloody Commune. Manet painted the Rue Mosnier several times, depicting the street from his second floor studio, which afforded him a bird's-eye view of the scene – a compositional device that several of the painters (especially Monet and Camille Pissarro (1830–1903)) employed.

In this painting workers labour away in the foreground repaving the road, though they are sketchily drawn and almost merge into the pale road itself. Behind them are several elegant carriages that suggest a juxtaposition between the working class road repairers and the middle class carriage occupants. Manet used a similar technique in his painting *The Rue Mosnier with Flags*, 1878, which depicts the street festooned with flags to celebrate a national holiday to mark France's recovery from the war. Here he uses a solitary figure on crutches (implying a war casualty) to contrast with another handsome horse and carriage.

CREATED

Paris

MEDIUM

Oil on canvas

SIMILAR WORK

Boulevard Montmartre by Camille Pissarro, 1897

Édouard Manet *Born* 1832 Paris, France

Died 1883

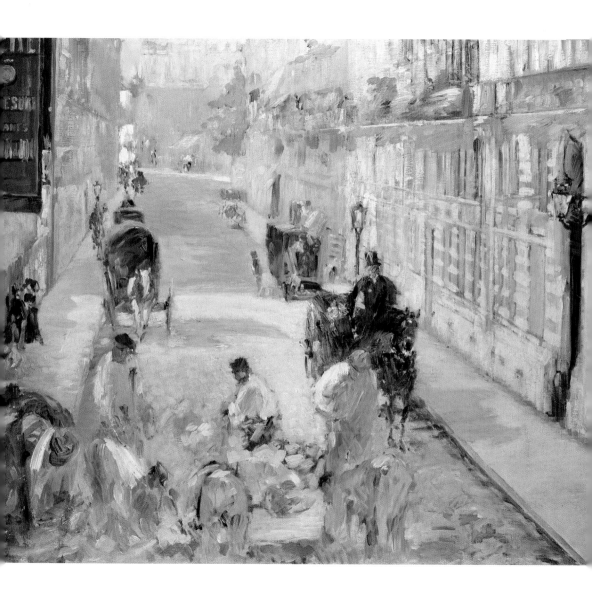

Bazille, Frédéric

The Family Reunion, 1867

Frédéric Bazille (1841–70) was born into a wealthy family that lived in Montpellier. It was here that Bazille first started to study medicine before moving to Paris where he continued his studies and also attended painting classes at Charles Gleyre's (1806–74) studio. His family supported him on the proviso that he continued his medical work, however, after failing his exams in 1864, he turned to painting full time. Luckily his family relented and continued their support. Their financial assistance allowed him to paint and also put him in a position to help his friends, namely Monet, Alfred Sisley (1839–99) and Renoir.

Bazille remained in close and affectionate contact with his family, and frequently returned to Montpellier during the summer to visit. It was on one such occasion in 1867 that the artist began the multi-figural composition seen here. The different members of his family are grouped on a large outdoor terrace with views across the countryside, and appear charmingly reserved. The composition reflects Bazille's still developing style and slight hesitance seen in the stiffness of his figures, but it is nonetheless a particularly appealing early work, especially poignant in the light of his death just three years later.

CREATED

Montpellier

MEDIUM

Oil on canvas

SIMILAR WORK

Terrace at the Seaside near Le Havre by Claude Monet, 1867

Frédéric Bazille *Born* 1841 Montpellier, France

Died 1870

Monet, Claude

Bathers at La Grenouillère (detail), 1869

© National Gallery, London, UK/The Bridgeman Art Library

La Grenouillère (meaning literally 'frog pond') was a popular bathing and socializing place on the Seine at Croissy, and was near enough to Paris to facilitate day-trippers. It provided a perfect subject for Monet at this time, with the shimmering, reflective water of the river and a constant bustle of fashionably dressed bourgeoisie promenading along her banks.

During the summer of 1869 Monet and Renoir painted the area, often working side by side and depicting the same motif. More than any of the other artists, these two worked most closely, yet their paintings remained highly individual. It was a period of great hardship for Monet – though this is quite unapparent in his iridescent paintings – and he was in a state of near poverty. Despite this, the works that he did here represent some of the first paintings of a truly impressionistic style, seen in particular in his (and Renoir's) treatment of the moving water. Interestingly Monet wrote to Bazille that he was unhappy with his pictures, describing them as 'bad'. This could have simply been a manifestation of his lack of self-confidence in the evolution of his new style.

CREATED

La Grenouillère

MEDIUM

Oil on canvas

SIMILAR WORK

La Grenouillère by Pierre-Auguste Renoir, 1869

Claude Monet *Born* 1840 Paris, France

Died 1926

Monet, Claude

Hyde Park, 1871

Monet was working at Le Havre in September 1870, and while there he saw hordes of people flooding onto boats and heading for England to escape the Franco-Prussian war. He decided to follow and avoid being conscripted into military service, so he too went to London leaving his new wife and child behind. While in London, still suffering financial hardships, Monet met Charles-François Daubigny (1817–78) while painting alongside the Thames, who introduced the artist to the art dealer Paul Durand-Ruel (1831–1922). Through Durand-Ruel Monet was reacquainted with his old friend Pissarro, neither artist being aware of each other's presence in the city.

Monet was enthusiastic about the new scenery and the motifs that the large city offered him. He painted scenes of the great London parks, such as this one, and views along the Thames. The heavy atmosphere and frequent fogs were a great inspiration to the artist who experimented with the depiction of different atmospheres. He also became familiar with the work of Joseph Mallord William Turner (1775–1851), John Constable (1776–1837) and John Crome (1768–1821), all of who had a significant effect on him, especially his use of colour.

CREATED

London

MEDIUM

Oil on canvas

SIMILAR WORK

Lordship Lane Station, Dulwich by Camille Pissarro, 1871

Claude Monet *Born* 1840 Paris, France

Died 1926

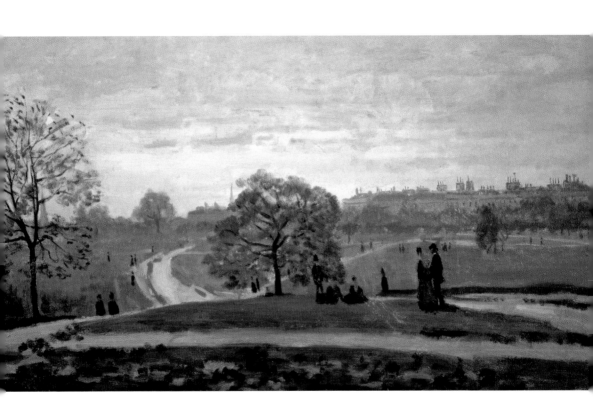

Monet, Claude

View of Le Havre, 1873

Monet moved with his family to the busy town of Le Havre in Normandy when he was just five years old, and it was here that he went to school and first started to draw. His obvious talent, especially apparent through his caricatures, won him schoolboy fame. He subsequently met Eugène Boudin (1824–98), who was painting along the Le Havre coastline. It was a fortuitous encounter and Boudin fostered Monet's talent, setting him on the path that would eventually make him one of the most famous of the Impressionists.

Following the Franco-Prussian war, Monet left London in 1871 and travelled to Holland, before returning to France. By 1872 he was back in Le Havre painting his familiar childhood territory, and producing amongst others, his famous painting *Impression: Sunrise*. At this time, as is demonstrated in this view of Le Havre, Monet was working in soft, subdued tones (in contrast to his earlier paintings) and evoking the sensation of sun shining through a heavy, wet atmosphere. Here the boats and reflective water are ephemeral, fleeting and buoyant against the solid, monumentality of the port's grand buildings behind.

CREATED

Le Havre

MEDIUM

Oil on canvas

SIMILAR WORK

Evening, Le Havre by Eugène Boudin, 1866

Claude Monet *Born* 1840 Paris, France

Died 1926

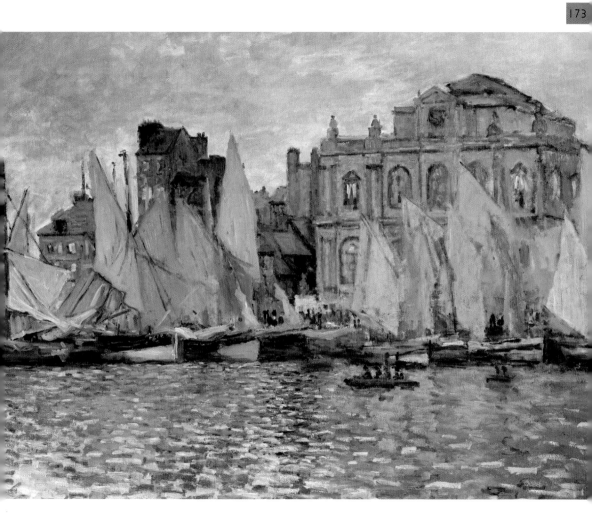

Monet, Claude

Rouen Cathedral, Sunlight, 1894

© akg-images

In 1891 Monet exhibited a series of 15 canvases depicting haystacks at different times of the day and they became an overnight success. His intense scrutiny of a single motif and multiple depictions of it formed a new departure in his style, and one that he would continue to work on until his death. The following year he travelled to Rouen, a city he was familiar with having visited his brother Léon there many times, and began a series of paintings of the Gothic Cathedral of Notre Dame. This again was a new development for the artist who until this point had never focused so intently on a single architectural structure, using instead landscape and natural motifs. Rouen Cathedral, which he went back to paint again in 1893, the year of this picture, was however a particularly significant subject for the artist, who saw the building as a symbol of France's historic medieval past and a national treasure. Monet, unlike many of his contemporaries, had a sharp head for business and depicting the Cathedral with its associations of patriotism and religious importance also afforded him a potentially popular subject in commercial terms.

CREATED

Rouen

MEDIUM

Oil on canvas

SIMILAR WORKS

The Louvre seen from the Pont Neuf, Winter by Camille Pissarro, 1902

The Church of Moret by Alfred Sisley, 1893

Claude Monet *Born* 1840 Paris, France

Died 1926

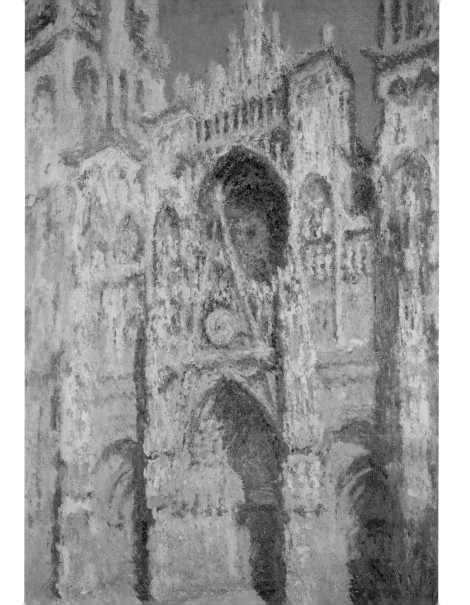

Monet, Claude

Les Nympheas Blancs (detail), 1899

© akg-images

In 1883 Monet rented a house in the village of Giverny alongside the River Seine, which was a convenient 80 km (50 miles) from Paris. He would live here for 43 years and paint some of his most famous canvases in the garden. By 1890 the artist had made a considerable amount of money and was in a position to purchase the house. Three years later bought a tract of land opposite the property and it was here that he created his lily garden, transforming the tired patch of land and small pond into an exquisite water feature of Japanese flavour. Throughout his life the artist had fostered a great love of gardening, spending money on his garden even when he could ill afford to.

Although Monet began to construct his lily pond in 1893, it was not until 1899 that he began to paint it in earnest. The series of paintings done at this time depicting the Japanese bridge revel in the beauty and primacy of nature. These are works that evoke wonder through their decorative and aesthetic form.

CREATED

Giverny

MEDIUM

Oil on canvas

SIMILAR WORK

Pine Tree at Saint Tropez by Paul Signac, 1909

Claude Monet *Born* 1840 Paris, France

Died 1926

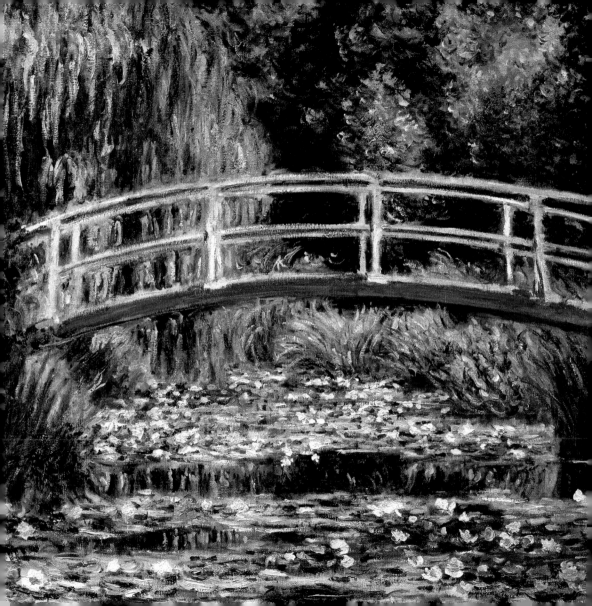

Monet, Claude

Santa Maria della Salute and the Grand Canal, 1908

© akg-images

In 1908 Monet visited Venice for the first time, ostensibly for a rest following a period of intense work on his paintings and in his beloved garden at Giverny. He was immediately entranced by the city on water that had captured the artistic souls of so many of his predecessors and contemporaries, and set about painting with renewed vigour. Monet had been against the trip, although he was enthusiastic once there, and it was due to the coercion of his wife Alice that he finally succumbed. Significant too was the publication in 1908 of a French translation of John Ruskin's (1819–1900) *The Stones of Venice*, which may also have tempted the elderly artist.

The trip, which had been planned to last a month, ended up lasting 10 weeks, with some time spent staying in the magnificent Palazzo Barbaro. Monet embarked on a staggering 37 paintings, though many of these were begun in Venice and later finished in his studio at Giverny. The works troubled him in the same way that some of his London paintings had and he lacked confidence in them.

CREATED

Venice

MEDIUM

Oil on canvas

SIMILAR WORK

Piazza San Marco by Pietro Fragiacomo, 1899

Claude Monet *Born* 1840 Paris, France

Died 1926

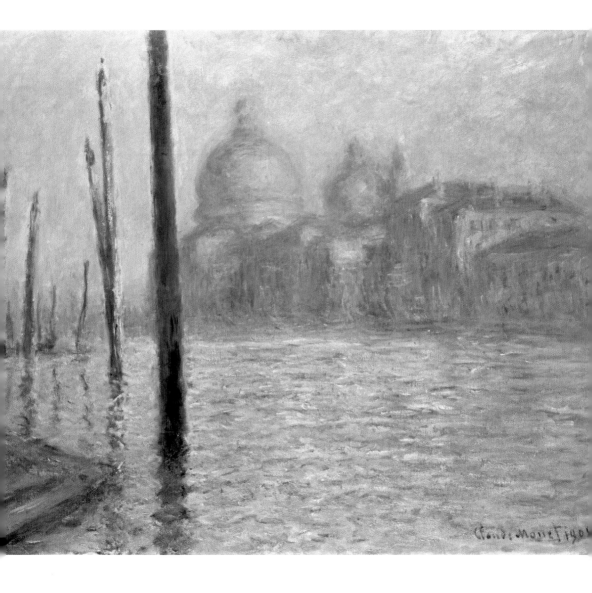

Sisley, Alfred

Vue du Canal Saint-Martin, Paris, 1870

© akg-images

Sisley is one of the least documented and most elusive of the Impressionists. There are few records pertaining to his early life, but what is known, rather surprisingly, is that the artist was an Englishman (though born in Paris) and retained English citizenship throughout his life. His father was a successful businessman and had moved to Paris around 1839 where he owned a warehouse importing luxury goods. Sisley grew up in Paris and was groomed to follow his father with a career in business. He is recorded as entering Gleyre's studio around 1860, apparently disenchanted with commerce and having decided to become an artist instead.

It was here that he befriended Bazille, Monet and Renoir and it is to this group of four friends that the birth of Impressionism can truly be attributed. This painting, executed in 1870, already demonstrates Sisley's preoccupation with capturing atmosphere and softly reflected light. Throughout his life he produced works in this vein, creating sincere evocations of a passing atmospheric moment. Of all his contemporaries he was the one artist who remained essentially honest to the original impressionistic style.

CREATED

Paris

MEDIUM

Oil on canvas

SIMILAR WORKS

The Mailcoach at Louveciennes by Camille Pissarro, 1870

Riverside Path at Argenteuil by Claude Monet, 1872

Alfred Sisley *Born* 1839 Paris, France

Died 1899

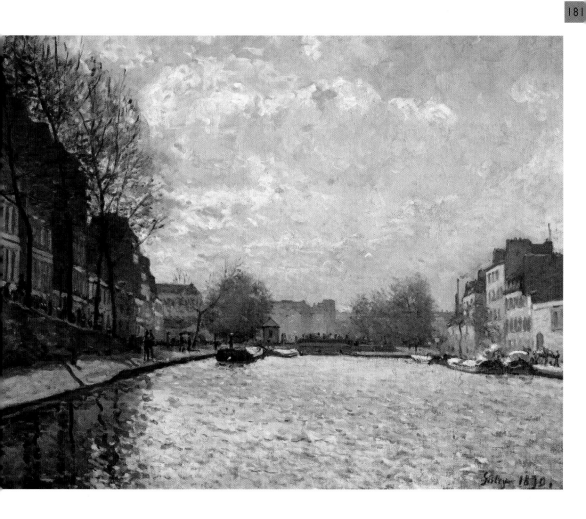

Sisley, Alfred

Molesey Weir, Hampton Court, 1874

Until the late 1860s Sisley was reasonably stable financially and received an allowance from his father. This was terminated sometime at the end of the decade, perhaps due to Sisley's relationship with Marie Louise Eugénie Lescouezec, and his father's business then crumbled following the Franco-Prussian war. Sisley struggled financially, perhaps more than any of his contemporaries, for the remainder of his life.

He exhibited at the first Impressionist exhibition in 1874 and afterwards travelled to England – his second trip to the country. The popular opera singer Jean-Baptiste Faure (1830–1914) had by this time started to help Sisley as well as being an important patron to others including Manet. It was through his support that Sisley made the trip where he painted 17 pictures of Hampton Court. Hampton Court, sitting alongside the Thames at East Molesey, provided the artist with the contrasting motifs of the rushing river, the stately old buildings and the startlingly modern Hampton Court Bridge. These works have a particularly light and fluid touch and demonstrate his use of strong geometric division through the compositions that greatly enlivens them.

CREATED

London

MEDIUM

Oil on canvas

SIMILAR WORK

The Crystal Palace, London by Camille Pissarro, 1871

Alfred Sisley *Born* 1839 Paris, France

Died 1899

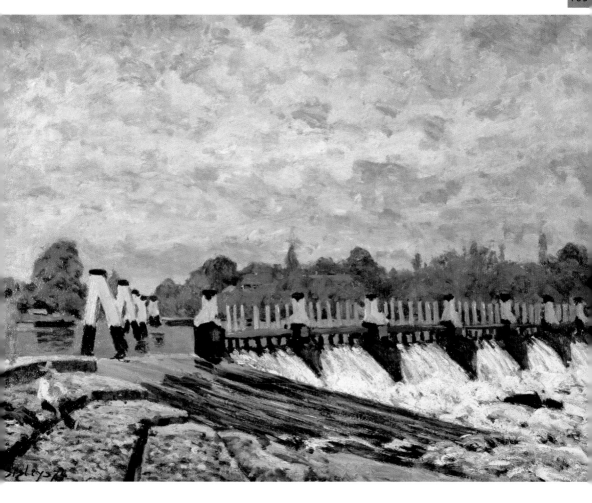

Sisley, Alfred

Snow in Louveciennes, 1878

© akg-images

Sisley first moved to the small village of Louveciennes with his mistress and children in 1871. It was here that he began to paint 'snow effects', with an early work being *Rue de Voisins, Louveciennes: First Snow*. This was a subject that he would return to over the years, often including one or two solitary figures bending into the weather conditions. He moved to Marly-le-Roi in the autumn of 1872 but continued to travel the short distance back to Louveciennes to paint.

He painted this view of the *Chemin de l'Etarché* first in 1874, and returned to the subject in 1878, creating the painting seen here. Despite the similarity in composition, right down to the inclusion of a woman braving the icy cold, there is a marked difference in his style between the two works. Here his brushstrokes have become longer, more fluid and rhythmic, and he has distilled his palette down to cool blue-grey tones. Seen in the distance, just discernible through the heavy, snow-laden atmosphere, are the houses that sat along the adjacent Rue de la Grand Fontaine, which appeared in an earlier painting, *Corner of the Village of Voisins*, 1874.

CREATED

Louveciennes

MEDIUM

Oil on canvas

SIMILAR WORK

Snow at Louveciennes by Camille Pissarro, 1872

Alfred Sisley *Born* 1839 Paris, France

Died 1899

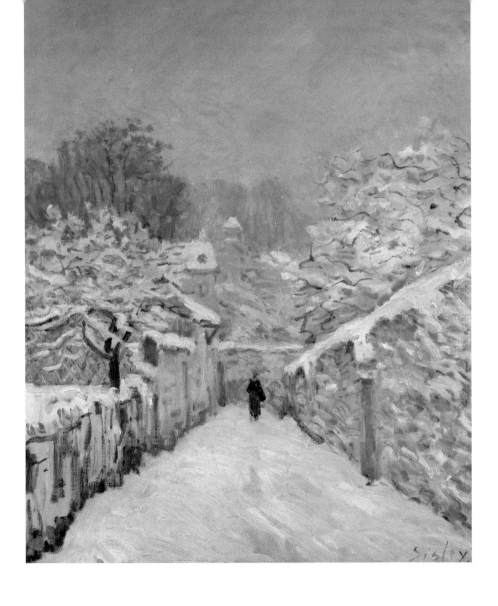

Sisley, Alfred

The Church at Moret, Frosty Weather, 1893

Sisley moved to Moret-sur-Loing sometime between 1888 and 1889 and lived there until his death in 1899 from cancer of the throat. The picturesque town situated next to the river is the site of a number of charming historic buildings as well as the magnificent Church of Notre Dame and provided the ailing artist with a choice of suitable subjects to paint. The time that Sisley lived at Moret was the longest period the artist lived in the same house, and by all accounts it was one that suited him. The house had a small garden and no immediate neighbours, which was appealing to the artist. He turned the attic rooms into a studio that became filled with his unsold works.

This painting of the church was one of a series Sisley made of the building and was the most significant example of him concentrating on a single motif. In all the paintings he depicted the church showing the southwest view, working on the canvases for over a year and capturing the façade under different light and at different times of the day. Monet had started his series of Rouen Cathedral paintings the year before, and inevitable comparisons are drawn between the two.

CREATED

Moret-sur-Loing

MEDIUM

Oil on canvas

SIMILAR WORK

Rouen Cathedral in the Morning by Claude Monet, 1894

Alfred Sisley *Born* 1839 Paris, France

Died 1899

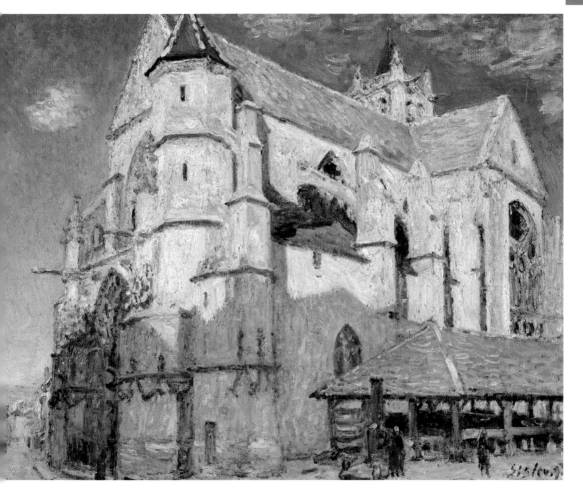

Pissarro, Camille

The Crystal Palace, London (detail), 1871

At the outset of the Franco-Prussian war Pissarro fled from Louveciennes to Brittany where he stayed with his friend and landscape painter Ludovico Piette (1826–77). Pissarro eventually left Brittany for London, England. While he was in London the Prussian military took over his studio in Louveciennes and turned it into a butcher's shop, destroying the majority of his paintings in the process.

By chance, Pissarro and his friend Monet met through the dealer Durand-Ruel in London and remained in close contact there. Pissarro concentrated on painting the suburbs of London around Lower Norwood where he was living, depicting the development of the city, the railway lines and the new buildings. In particular he was fascinated by a huge glass structure: the Crystal Palace built by Sir Joseph Paxton (1803–65) that can be seen here. One of the striking aspects of Pissarro's work was the way in which he embraced modern advancements – a genuine interest and celebration of that which was new. This was in contrast to many artists who deliberately chose not to depict scenes that referenced changes occurring in the nineteenth century.

CREATED

London

MEDIUM

Oil on canvas

SIMILAR WORK

Hyde Park, London by Claude Monet, 1871

Camille Pissarro *Born* 1830 St Thomas, West Indies

Died 1903

Pissarro, Camille

Snow at Louveciennes, 1872

© akg-images

While in England Pissarro married Julie Vellay, who was already the mother of his children, and at the end of June 1871 he moved back to his home in Louveciennes. England had been a disappointment to the artist and to Monet, both of whom found the art world unreceptive to their new style and had little success in selling their paintings. Pissarro found his Louveciennes home desecrated and many of his canvases destroyed. He remained there for a short time before moving on to Pontoise.

Undeterred, Pissarro threw himself into his painting and during the winter of 1871 produced some of his finest pictures of the winter landscape. This serene scene of Louveciennes is a study of chill light reflecting on the frosty snow. He has perfectly captured the atmosphere of early morning as a pale blue sky starts to unfold and the winter sun casts shadows on the nude trees. The strongly painted trees animate the composition, creating a certain geometry and pattern of line across the surface plane. During this period Pissarro was experimenting with the effects of shadow and their role in the structure of his composition.

CREATED

Louveciennes

MEDIUM

Oil on canvas

SIMILAR WORK

Snow in Louveciennes by Alfred Sisley, 1878

Camille Pissarro *Born* 1830 St Thomas, West Indies

Died 1903

Pissarro, Camille

Village near Pontoise, 1873

© Musée des Beaux-Arts, Basel, Switzerland/The Bridgeman Art Library

Pissarro had first moved to Pontoise in 1866, wishing to distance himself from the politics and frustrating aspects of living in Paris. He returned to Pontoise in 1872 following a short time at Louveciennes and settled here for some years. Paul Cézanne (1839–1906) had also moved to the area and it was during this period that the two worked side by side, the younger artist benefiting from 'Père Pissarro's' wisdom and experience. The artist Armand Guillaumin (1841–1927) was also living in the area, and the three artists remained good friends. The group was also friendly with the charismatic Dr Gachet (1828–1909), who lived at Auvers, close to Pontoise. Gachet proved an important patron for the artists.

Pontoise was an area of natural beauty that appealed to the artists, and while living here Pissarro painted many particularly lyrical canvases of the countryside and small surrounding villages. In this painting there is a great sense of unity, a common characteristic of Pissarro's work, with the small rustic cottages nestling back into the rolling landscape being as integral and harmonious to the scene as the figures and the trees.

CREATED

Pontoise

MEDIUM

Oil on canvas

SIMILAR WORK

View of Auvers by Paul Cézanne, c. 1874

Camille Pissarro *Born* 1830 St Thomas, West Indies

Died 1903

Pissarro, Camille

Paysage a Eragny (detail), 1895

By the early 1880s the Impressionists had largely fragmented as a group and this divergence in their stylistic developments was matched by their increasing geographic isolation from one another and from Paris. In 1884 Pissarro rented a house in the small town of Eragny-sur-Epte that was three times as far from Paris as his previous home in Pontoise. It was also around this time that Paul Signac (1863–1935) introduced Pissarro to Georges Seurat (1859–91). Seurat's rigorously ordered approach to colour and paint application immediately impressed Pissarro.

Although Pissarro produced a number of works in line with the scientific principles of Seurat, he found the style too restrictive and by the time of this painting had relaxed his approach to Pointillism. However this work reflects his still controlled handling of colour and brush strokes, which was in contrast to his early works. Here the mellow sunlight filters through a purple haze of cloud to soak the countryside around Eragny. It is a work of immeasurable tranquillity that again shows his interest in compositional structure through the lengthening shadows in the foreground.

CREATED

Eragny-sur-Epte

MEDIUM

Oil on canvas

SIMILAR WORK

The Railway at Bois-Colombes by Paul Signac, 1886

Camille Pissarro *Born* 1830 St Thomas, West Indies

Died 1903

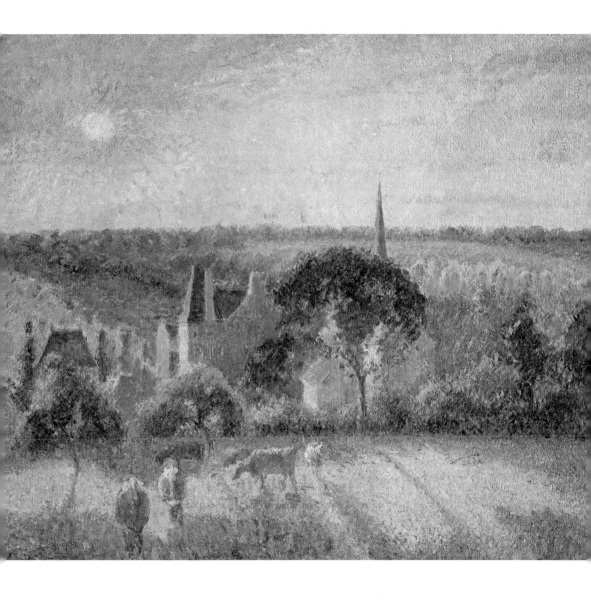

Pissarro, Camille

Place du Theatre Français, 1898

© akg-images

By the time of this painting Pissarro was suffering increasingly from a chronic infection in one of his eyes. It meant that he had to paint primarily in his studio, and he quickly tired of the scene that his window in the Eragny house offered. He spent the last years of his life travelling to find new motifs, painting in London again and staying for some time in Paris. Having lived away from the bustling city for most of his life, he was now attracted to its lively street scenes and activity, which provided such a sharp contrast to his primarily peaceful and still landscape paintings.

This scene, painted in Paris and viewed from Pissarro's studio window, offers a soaring perspective – the 'bird's-eye' view. It is alive with people, horses and cabs painted with small, short brushstrokes and dabs of colour that add to the activity. Sunlight filters down through the trees to dapple the pavement below, lending the scene a sense of shifting mottled light, flickering and animating the canvas further.

CREATED

Paris

MEDIUM

Oil on canvas

SIMILAR WORK

Paris, Place de la Concorde by Louis Hayet, 1888

Camille Pissarro *Born* 1830 St Thomas, West Indies

Died 1903

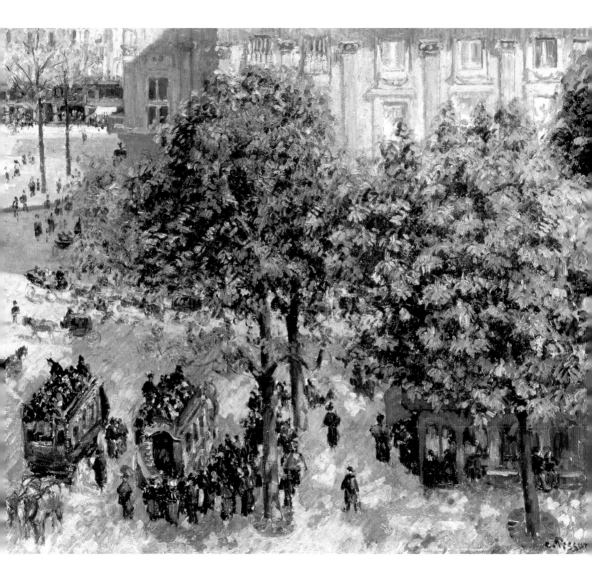

Renoir, Pierre-Auguste

La Grenouillère (detail), 1869

Renoir met Monet, Bazille and Sisley in the early 1860s at Gleyre's studio. The four quickly became friends and worked alongside each other on numerous occasions. Of particular note are the paintings that Renoir made at the fashionable bathing spot of *La Grenouillère*, which Monet also painted in the summer of 1869. La Grenouillère was a lively place – a café with outside dining and boating facilities, outside Paris on the Seine, and close to Bougival. It was also near to Renoir's parents' house at Louveciennes, which was where the artist was living at that time. Monet lived nearby, and the two would meet to paint. Unusually, La Grenouillère was a place that the bourgeoisie visited as well as the lower classes, and as such was a melting pot of society.

Renoir's delicate jewel-like palette is much in evidence in this work, which is a harmony of colour from the ladies in long dresses to the multi-faceted reflections in the water. Neither Monet nor Renoir submitted any of their paintings done here to the Salon, but the artist Ferdinand Heilbuth (1826–89) exhibited *By the Water's Edge* of La Grenouillère, which was well received.

CREATED

La Grenouillère

MEDIUM

Oil on canvas

SIMILAR WORK

Bathers at La Grenouillère by Claude Monet, 1869

Pierre-Auguste Renoir *Born* 1841 Limoges, France

Died 1919

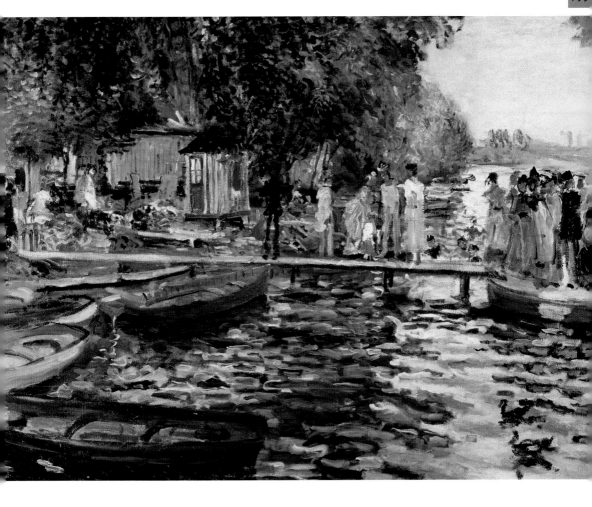

Renoir, Pierre-Auguste

The Grand Boulevards, 1875

During the Franco-Prussian war of 1870–71 Renoir spent some time with a regiment of Cuirassiers and fell seriously ill with dysentery. After he was demobilized he returned to Paris where he learnt of his great friend Bazille's death. He remained in Paris where he painted the busy cafés and streets. He also travelled out of the city, staying with Monet and his first wife Camille at Argenteuil and painting with Sisley. Along with Pissarro, Sisley and Monet helped the development of Renoir's style.

This can be seen in this hazy painting of the Grand Boulevard in Paris. Renoir's brushwork is lighter and more fluid than his works of the 1860s, and his evocation of atmosphere more astute. The street teems with life with a broad swash of sunlight falling from the right, while the distant purple sky in the background creates depth and continuity. This painting was done the year of the disastrous Impressionist auction in which works had sold for virtually nothing. However it was through the auction that Victor Chocquet became acquainted with the artists, and in particular Renoir, who later painted his portrait twice and a portrait of his wife.

CREATED

Paris

MEDIUM

Oil on canvas

SIMILAR WORK

Boulevard des Capucines by Claude Monet, 1873

Pierre-Auguste Renoir *Born* 1841 Limoges, France

Died 1919

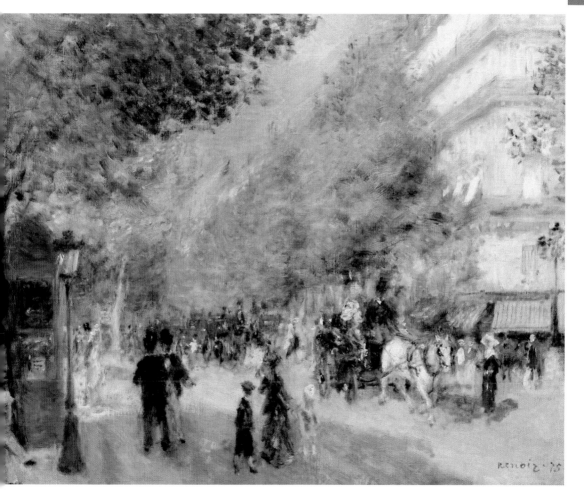

Renoir, Pierre-Auguste

The Mosque (Arab Festival) (detail), 1881

Early in 1881 the dealer Durand-Ruel began to buy Renoir's paintings in large quantities and the artist suddenly found himself enjoying a certain degree of wealth. His new funds enabled him to make two important trips abroad, to Italy and Algiers. Like the great colourist Eugène Delacroix (1798–1863), Renoir was absorbed by North Africa, although he later stated that it was his time in Italy that truly developed his style.

This painting is unique amongst those brought back from Algiers, since it is the only one that depicts a local custom. Precisely what the event is is unclear, but could relate to either a religious festival or a festival including dancers and entertainers. The scene is wonderfully impressionistic and jewel-like in colour. The artist has depicted the activity looking down onto the crowd, which has dissolved into an emotive flurry of colour. The strong Algerian sunlight that was so influential on Delacroix is also an important factor in this painting. The brilliance of the light further dissipates the actuality of the figures so that they appear to teem and flicker like dappled sunlight itself.

CREATED

Algiers

MEDIUM

Oil on canvas

SIMILAR WORK

The Old Market Place in Rouen by Camille Pissarro, 1898

Pierre-Auguste Renoir *Born* 1841 Limoges, France

Died 1919

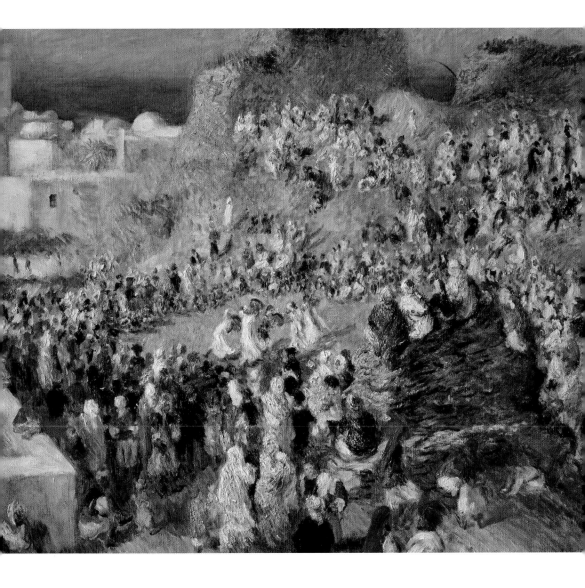

Renoir, Pierre-Auguste

Moulin Huet Bay, Guernsey (detail), *c.* 1883

The early 1880s saw the breaking up of the Impressionists, as the artists went in their different directions, both geographically and stylistically. This coincided with a lack of self-confidence in some as they struggled to maintain their new style and identity separate from the circle.

By Renoir's own admission in 1883, 'a sort of break occurred in my work'. The artist began to look back to the tradition of past masters, consciously removing himself from Impressionism. Ironically, however, in September 1883 Renoir made a short trip to Guernsey, and painted this charming picture of figures in the Moulin Huet Bay, that strongly harkens back to his Impressionist days. The ephemeral appearance of the scene, with the activity of the foreground figures merging into the reflective, moving waters, could not be described as anything but impressionistic. This was one of several studies the painter made here, and has the appearance of having been painted quickly, which gives it a particularly fresh and natural appeal unlike works done in the studio.

CREATED

Guernsey

MEDIUM

Oil on canvas

SIMILAR WORK

Cap Martin, near Menton by Claude Monet, 1884

Pierre-Auguste Renoir *Born* 1841 Limoges, France

Died 1919

Degas, Edgar

Racehorses in Front of the Stands (detail), *c.* 1866–68

© akg-images

Degas was born into a wealthy family in Paris, which is where the young man received his education. His father insisted that he attend law school, but Degas was uninspired and turned instead towards painting. He studied under a pupil of Jean-Auguste-Dominique Ingres (1780–1867) (Ingres himself would remain important to him throughout his career) for a short period and briefly enrolled in the *École des Beaux-Arts*. He travelled to Italy several times early in his career where he made copies of Old Masters — something that he continued to do later at the Louvre.

In 1861 he went to the races at Mesnil-Hubert with some friends and was immediately entranced. Horses became one of his few primary subjects, and the following year, in 1862, he began sketching scenes at the Parisian racetrack, Longchamps. This painting of around 1866–68 depicts one of his favourite moments, that of the tension before the start of the race. This was something that he frequently depicted, drawn by the excitement and restlessness of the horses and the crowds. He also characteristically cropped his scenes, providing an unusual view and implying that his painting was just a small part of a bigger event going on beyond the frame.

MEDIUM

Oil on paper on canvas

SIMILAR WORK

The Jockey by Henri de Toulouse-Lautrec, 1899

Edgar Degas *Born* 1834 Paris, France

Died 1917

Degas, Edgar

Musicians in the Opéra Orchestra (detail), 1868

© akg-images

Degas had been brought up in similar social circles to Manet, and had enjoyed an early introduction to the arts, music, opera, literature and painting — his father was keen on music and the family home was frequented by musicians. Degas became friendly with Désiré Dihau, a bassoonist in the Opéra orchestra and probably through this friendship was given permission to sketch in the wings and orchestra pit of the Opéra. Degas was welcomed into the Dihau home, and it was here that he was introduced to Henri de Toulouse-Lautrec (1864–1901), who would become one of his greatest admirers.

Dihau's portrait appears in several of the paintings Degas made of this subject, including this one where he is flanked by the cellist Pillet, the flautist Altès and the double-bass player Gouffé. The Opéra was the perfect subject for a painter of modern life, as was the ballet, which Degas also famously painted. Here he has taken a unique view of the scene, focusing on the musicians who are crowded in the foreground, while above their heads float the truncated and brilliantly lit bodies of the dancers.

CREATED

Paris

MEDIUM

Oil on canvas

SIMILAR WORK

The Box at the Mascaron Dore by Henri de Toulouse-Lautrec, 1893

Edgar Degas *Born* 1834 Paris, France

Died 1917

Degas, Edgar

The Pedicure, 1873

© akg-images

Late in 1872 Degas travelled to New Orleans with his brother René to visit his other two brothers who had established a cotton trading business in the city. Degas's mother was from New Orleans and he had strong family connections to the place, which might better explain his reasons for travelling there. He was drawn to the exotic flavour of the American city and to the diversity of its culture, especially in comparison to that of France. The colours and the atmosphere seemed brighter to him, and practically assailed his senses. He was in fact so overcome with the place that he felt unable to paint it, and instead concentrated on interior scenes and portraits of his family.

This painting is thought to be of 'Joe' Balfour, the young daughter of Degas's sister-in-law, Estelle, who had married René. Degas had a great affinity for Estelle who suffered from terrible eye problems resulting in near blindness. The picture of her daughter receiving a pedicure is a curious one, being rather melancholy and unsettling. The assumption being that the girl's mother was unable to clip her nails based on her sight, necessitating the doctor's intervention, but the girl too appears strangely languid and devoid of spirit.

CREATED

New Orleans

MEDIUM

Oil on paper on canvas

SIMILAR WORK

Mme-René De Gas by Edgar Degas, 1872–73

Edgar Degas *Born* 1834 Paris, France

Died 1917

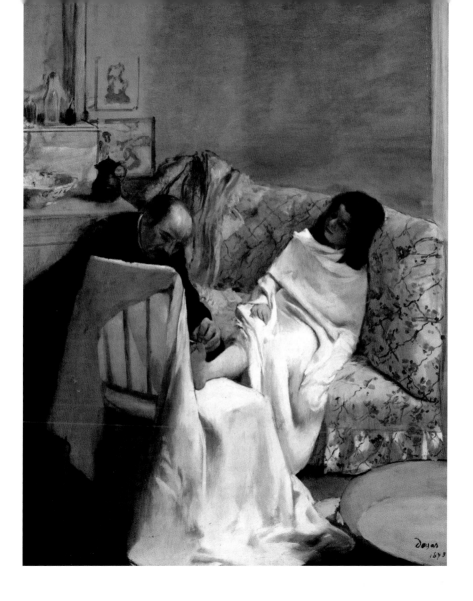

Caillebotte, Gustave

Le Pont de l'Europe, 1876

© akg-images

Following the death of his father in 1873, Caillebotte inherited enough money to make him financially independent for life. He graduated with a law degree before turning to art, and was sufficiently wealthy to indulge in a number of hobbies, including marine engineering, yacht building, rowing and stamp collecting. He came into contact with the Impressionists around 1873, and later became great friends with Monet, Renoir and Degas, but it is Degas's work that most influenced him. The artist lived mostly in Paris and his paintings document modern life around him, the streets of Paris and scenes from along the River Yerres, where his family had a second home. For many years Caillebotte was more famous as a collector of the Impressionists rather than as an artist, but recently his work has been rediscovered and now garners the acclaim it deserves.

This painting, with its plunging spatial depth, was one of two pictures the artist made of the same scene in Paris. Caillebotte's fascination with engineering and technology came to the fore here, and he made numerous meticulous studies of the bridge before starting to paint it.

CREATED

Paris

MEDIUM

Oil on canvas

SIMILAR WORK

Place de la Concorde by Edgar Degas, 1876

Gustave Caillebotte *Born* 1848 Paris, France

Died 1894

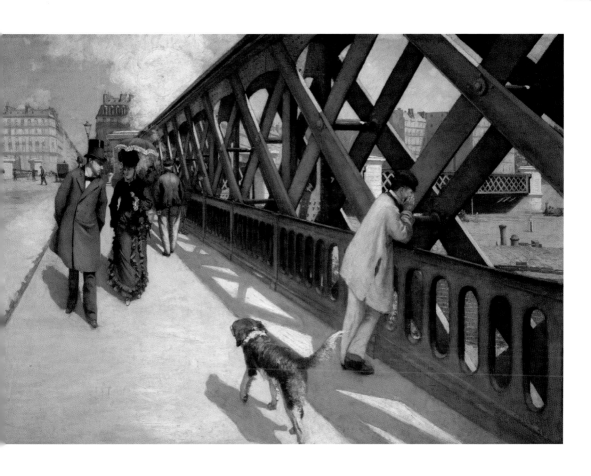

Morisot, Berthe

View of Paris from the Trocadero, 1872

© Museum of Art, Santa Barbara, California, USA/The Bridgeman Art Library

Morisot decided early in life to become a painter, as did her sister Edmé, and both were allowed to do so with the support of their wealthy family. It can be assumed that this was partly due to the fact that her great uncle was the prolific Rococo painter, Jean-Honoré Fragonard (1732–1806). Morisot began drawing lessons in 1857 and by 1860 had befriended the Barbizon painters and in particular Jean-Baptiste-Camille Corot (1796–1875), with whom she studied for two years. It was under his influence that she first began painting *en plein air*. Significantly, Morisot began admitting works to the Salon in 1864, and exhibited there for ten years before she joined forces with the Impressionists. She therefore had a history of producing accepted works and, even after entering the Impressionist circle, her paintings were often more readily accepted by the public and critics than those of her fellows.

She lived and worked in Paris in between travelling and later in life hosted weekly gatherings at her Paris home for her artist and literary friends. This view of Paris with its wide perspective is a characteristically charming painting, while also demonstrating Morisot's accomplished eye for clear spatial division and structure.

CREATED

Paris

MEDIUM

Oil on canvas

SIMILAR WORKS

The Quai des Paquis, Geneva by Jean-Baptiste-Camille Corot, *c.* 1842

The Garden of the Infanta by Claude Monet, 1867

Berthe Morisot *Born* 1841 Bourges, France

Died 1895

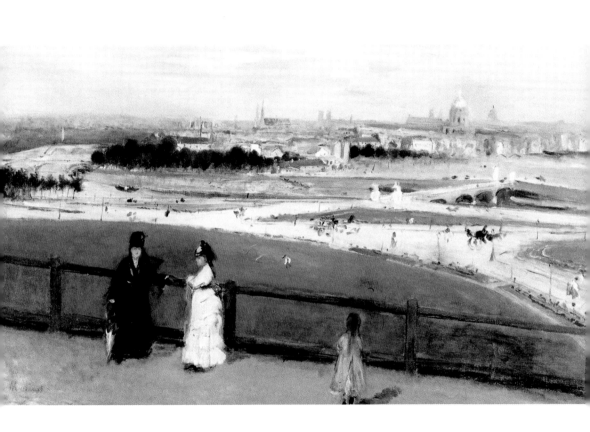

Morisot, Berthe

Eugène Manet and His Daughter in the Garden at Bougival, 1881

© akg-images

Morisot was introduced to Manet in 1868 and the two immediately became great friends. Morisot was impressed with Manet's painting, though her own style would become much freer in expression, and in turn Manet was entranced by her grace and charm. That winter she posed for his painting *The Balcony*, and he painted her again two years later in *Repose*. Through her friendship with the older artist, Morisot met his brother Eugène, an amateur painter and writer, and in 1874 the two married. They had one child, Julie, and she became one of Morisot's most frequently painted subjects. Between 1881 and 1883 Morisot and her husband built their house in Paris, and this would become a central meeting point for their circle of friends. This painting of Morisot's husband and daughter in the garden at Bougival – an especially beautiful area of Paris in the western suburbs – evokes a scene of tenderness, a moment of father and daughter interacting, caught unawares. Although Morisot's work was characteristically of domestic subject and in particular her daughter, her painterly expression and subtle use of colour prevented such paintings from becoming over-sentimentalized.

CREATED

Paris, Bougival

MEDIUM

Oil on canvas

SIMILAR WORK

Young Woman Sewing in the Garden by Mary Cassatt, *c.* 1880–82

Berthe Morisot *Born* 1841 Bourges, France

Died 1895

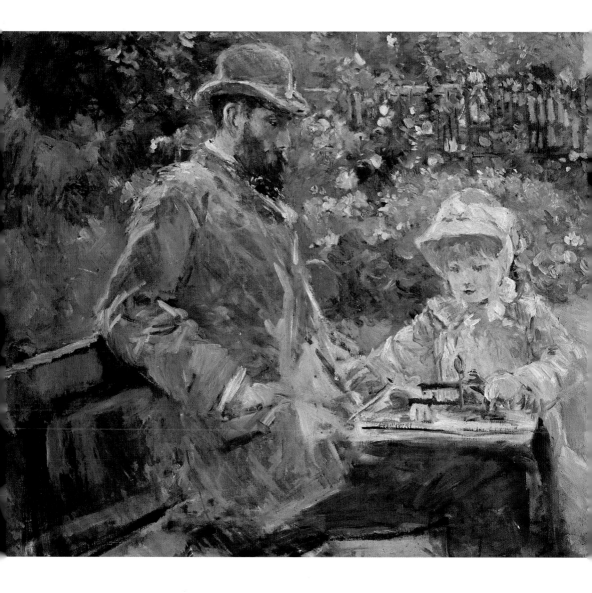

Morisot, Berth

The Port, Nice, 1882

Morisot had an extraordinarily strong character. She was working in a man's world and accordingly subject to restrictions, but she emerged as an artist whose work demanded attention and respect. During the Franco-Prussian war for example, when others were fleeing, Morisot remained in Paris and in so doing suffered substantial privation, which is thought to have contributed to her later health problems and early death. She travelled relatively widely during her life and her trips included Spain, Italy, England, the Isle of Wight and France.

In the winter of 1881 and into 1882 Morisot was in Nice, whose warm winters and brilliant Mediterranean sky were an undoubted draw. This painting completed during her stay is one of her most lyrical works of this time, and has the freshness and delicate palette so characteristic of her style. Her use of fine line to draw in the sails of the boats and the buildings of the harbour contrasts with the broadly impressionistic application of colour, and lends the work an almost watercolour feel. This was a medium that she also worked in, along with pastels, though she remains best known for her oil paintings.

CREATED

Nice

MEDIUM

Oil on canvas

SIMILAR WORK

Antibes by Claude Monet, 1888

Berthe Morisot *Born* 1841 Bourges, France

Died 1895

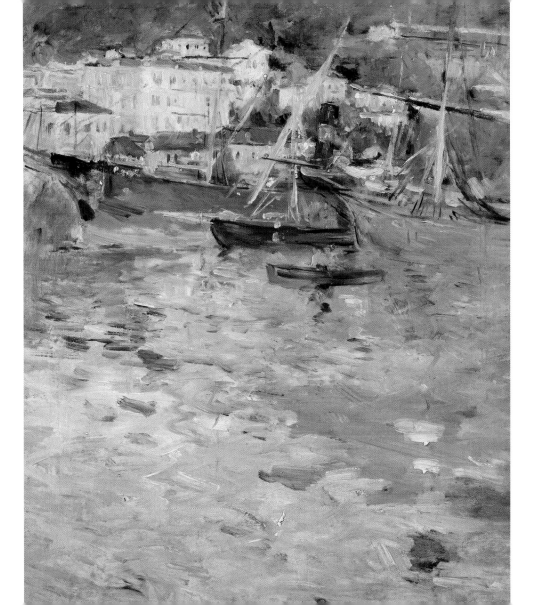

Cassatt, Mary

Woman in a Box with a Pearl Necklace (detail), 1879

The American artist Mary Cassatt moved from the United States with her family to Paris in 1851. Although they did not settle here for long, the busy, foreign city must have made a significant impact on the young girl. Cassatt travelled widely as a young woman, including studying art in Parma where she was influenced by the work of Antonio Allegri da Correggio (1489–1534) and Girolamo Francesco Parmigianino (1503–40), and visited the Netherlands, Belgium, Madrid and Seville. She moved to Paris in 1866, but returned to the United States at the outbreak of the war. She finally settled in Paris in 1873 and became friendly with Pissarro before meeting Degas, Renoir and other members of the Impressionist group. It was Degas however with whom she had the closest relationship, and similarly to him, she was greatly attracted to the theatre and opera of Paris.

This painting of a beautiful lady in a box at the theatre is an exquisite example of Cassatt's style at this time, and can be compared to Renoir's *La Loge*, 1874. The young lady in Cassatt's painting looks obliquely out of the canvas, blushing slightly and perhaps engaging with a suitor or lover.

CREATED

Paris

MEDIUM

Oil on canvas

SIMILAR WORK

La Loge by Pierre-Auguste Renoir, 1874

Mary Cassatt *Born* 1844 Pennsylvania, USA

Died 1926

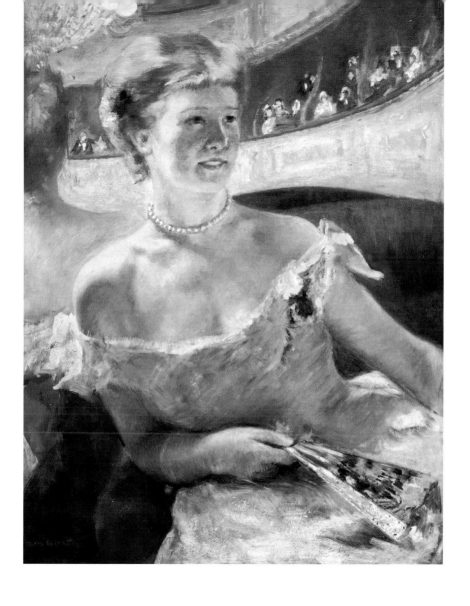

Cézanne, Paul

The Quai de Bercy in Paris, c. 1873

© akg-images

Cézanne was born in Aix-en-Provence to a wealthy family, and maintained a strong affinity for the south of France and his hometown throughout his life. He studied law in Aix from 1859–60, and around this time also began to paint, mostly scenes in and around his family's substantial estate, Jas de Bouffan. From 1862–65 he practised his art in Paris at the Académie Suisse, and became friends with Monet, Renoir, Pissarro, Sisley, Bazille and Guillaumin. Cézanne was never particularly attracted to Paris, though by necessity had to maintain a presence there in order to further his artistic endeavours. His career however was blighted by disappointments, including his continual rejection by the Salon. During the 1870s he divided his time between Paris and Pontoise and Auvers where he had become acquainted with Dr Gachet.

This painting done in the early 1870s is characteristic of this period, being dark and somewhat sombre in tone, which reflected the artist's frame of mind. He was financially struggling, especially since the birth of his son Paul in 1872, and was suffering self-doubt and depression because of his work.

CREATED

Paris

MEDIUM

Oil on canvas

SIMILAR WORK

The Peat Boat by Vincent Van Gogh, 1883

Paul Cézanne *Born* 1839 Aix-en-Provence, France

Died 1906

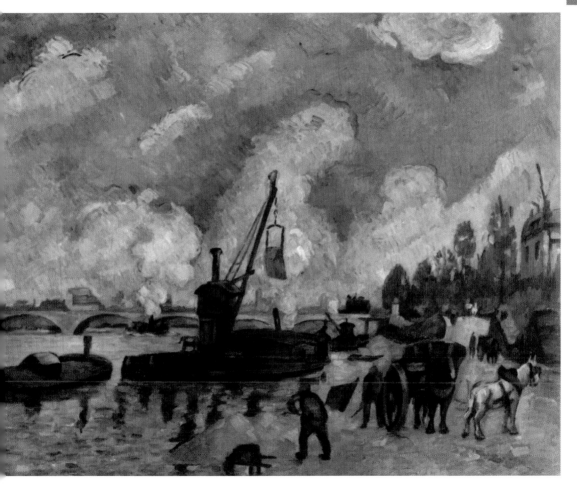

Cézanne, Paul

Small Houses at Auvers (detail), *c.* 1873–74

In 1872 Cézanne moved to Pontoise close to where Pissarro was living. Pissarro reputedly urged Cézanne to move to Pontoise with his family so that the two might paint together. Pissarro's influence on Cézanne was profound and is evident by a brightening of the younger artist's palette. In 1873 Cézanne moved to nearby Auvers-sur-Oise, though he continued to paint regularly with Pissarro. Cézanne became acquainted with the enigmatic Dr Gachet, who was also friends with Pissarro, and who lived at Auvers. The doctor bought several of Cézanne's works and entertained the artist at his house on many occasions. It was at this time that Pissarro introduced Cézanne to Père Tanguy, who owned an art supplies shop. Tanguy subsequently became a great supporter of Cézanne and provided him with paint and canvases in exchange for paintings.

This painting is one of a number Cézanne made of the small village of Auvers with its simple rustic houses and surrounding countryside. These paintings and in particular *View of Auvers-sur-Oise, c.* 1873, reflect Cézanne's increased use of geometric form and spatial structure that would be seen in his later works.

CREATED

Auvers-sur-Oise

MEDIUM

Oil on canvas

SIMILAR WORK

Chestnut Trees at Louveciennes by Camille Pissarro, 1872

Paul Cézanne *Born* 1839 Aix-en-Provence, France

Died 1906

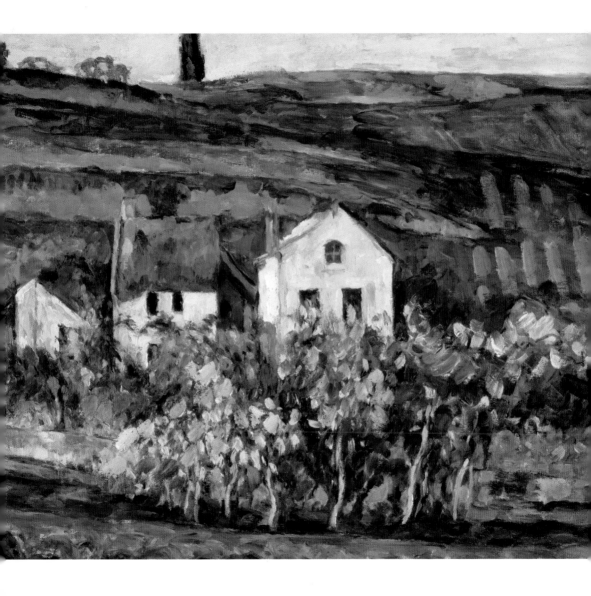

Cézanne, Paul

Landscape on the Bank of the Oise (detail), 1875

© akg-images

Cézanne left Auvers early in 1874 and returned to Paris. Later that year he showed three paintings, all of which had been painted at Auvers, at the first Impressionist exhibition. Following the exhibition he returned briefly to Aix-en-Provence and was visited by the director of the town's museum who wished to understand why the Impressionists had received so much media attention. Unfortunately for Cézanne he was unimpressed with his work and commented, 'I shall be able to appreciate much better the dangers now threatening painting after seeing your attempts on its life.' Cézanne returned to Auvers and painted this picture in 1875, the same year that he was introduced to the important collector Victor Chocquet.

The rural Auvers was a much smaller village than nearby Pontoise, and this was particularly attractive to Cézanne who was able to set his easel up and paint undisturbed by the residents who were well used to a succession of artists and intellectuals making their way to Dr Gachet's door. Here the village is seen nestled down along the great river Oise, while behind it the land sweeps up to meet a heavy bank of rain-filled cloud.

CREATED

Auvers-sur-Oise

MEDIUM

Oil on canvas

SIMILAR WORK

The Farm at Osnay by Camille Pissarro, 1883

Paul Cézanne *Born* 1839 Aix-en-Provence, France

Died 1906

Cézanne, Paul

La Montagne Sainte-Victoire, Vue de Bellevue (detail), 1882–85

© akg-images

This painting is one of a group that Cézanne made of Mount Sainte-Victoire, that now form amongst the most famous views of the area. This was the landscape of Cézanne's youth, and quite possibly his favourite place. There is a familiarity and an assurance in these works that denotes both his matured and highly individual style and an increasing self-confidence, which can be partly attributed to his sense of ease within these surroundings. The countryside around Aix-en-Provence was his childhood home and somewhere he would return to continuously throughout his life. He again returned to painting views of the mountain in 1901, and continued to work on these paintings until his death in 1906. Bellevue was a farm owned by his sister Rose and her husband, and was situated to the southwest of Aix. Cézanne would walk to the farm and set up from sites around it that offered a panoramic view across the valley to the mountain in the distance. He chose similar vantage points looking east towards the mountain, and often included dominant pine trees in the foreground, as seen here.

CREATED

Aix-en-Provence

MEDIUM

Oil on canvas

SIMILAR WORK

View of Agay by Armand Guillaumin, 1895

Paul Cézanne *Born* 1839 Aix-en-Provence, France

Died 1906

Cézanne, Paul

Chestnut Trees at Jas de Bouffan, Winter, 1885–86

© akg-images

Jas de Boffan was the impressive estate that belonged to Cézanne's family, and included a substantial eighteenth-century manor house set amidst beautiful grounds. The artist painted numerous views of the estate with its tall chestnut trees and ornamental pond through much of his career. Even after he stopped painting the house itself in the late 1880s, he continued to paint within its environs working on still life motifs. He was allegedly extremely upset when his family sold the estate in 1899.

This painting shows part of the house seen from the south side of the ornamental pond and looking through the chestnut allée – a path of chestnut trees leading to the house. In the distance is the omnipresent Mount Sainte-Victoire, although in actuality the view to the mountain would probably have been partially obscured by the buildings of Aix. The dominant bare trees in the foreground form a lattice-like screen, and were a motif that he used frequently at this time. Set against their verticality is a series of horizontal bands, seen in the grass strip, the blonde path, the wall and behind in the green swathe of hillside.

CREATED

Aix-en-Provence

MEDIUM

Oil on canvas

SIMILAR WORKS

L'Estaque by Andre Derain, 1906

The Olive Grove by Vincent Van Gogh, 1889

Paul Cézanne *Born* 1839 Aix-en-Provence, France

Died 1906

Impressionism

Influences

Courbet, Gustave

After Dinner at Ornans, 1848

Gustave Courbet (1819–77) can be considered one of the most important and influential painters of the early nineteenth century and was instrumental in the development of Realism. He was also a highly charismatic man with fervent Socialist ideals and believed that art should reflect the pursuit of truth. Courbet was the portrayer of modern life, not the whirling life of Paris, but rather that of the worker and labourer. He believed in painting nature and life as it was, in all its roughness, and so challenged the accepted doctrines of the academy. His antagonism against conventional attitudes made Courbet strive to paint 'modern' subjects in a particularly expressive and real manner – these elements were the foundations for the work of the Impressionists, although their subject matters differed in content.

Courbet often returned to his hometown of Ornans to paint, producing amongst others this picture of a group of workers relaxing after a hard day at work. This was one of the first paintings to win him wide acclaim, and he was awarded a gold medal for it at the Salon of 1849.

CREATED

Ornans

MEDIUM

Oil on canvas

SIMILAR WORK

At the Inn of Mother Anthony, Marlotte by Pierre-Auguste Renoir, 1866

Gustave Courbet *Born* 1819 Doubs, France

Died 1877

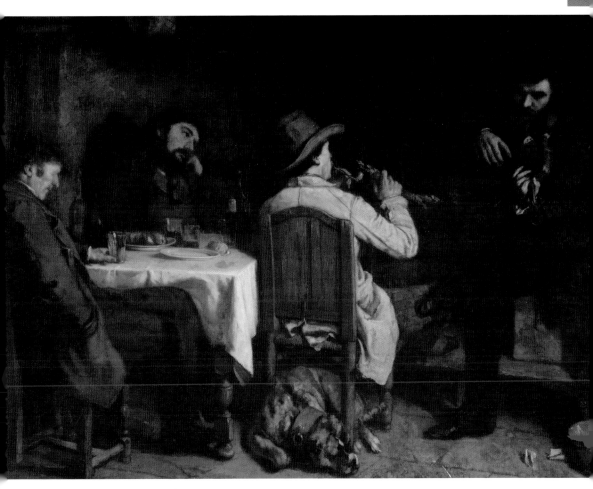

Courbet, Gustave

Ladies at the Seine, 1856

© akg-images

Although generally Courbet concentrated on scenes outside Paris, or those with a political message, he made some exceptions, of which this is one. *Ladies at the Seine* depicts what were probably two prostitutes, one lying provocatively in her petticoats while her friend gazes languidly into the distance. It is a minor genre scene that he has escalated in importance to that of a history painting by conceiving it on such a grand scale. This was a technique that the artist frequently used and one that was adopted by the Impressionist group. Interestingly the faintly sexual undertone of this painting was something that Courbet returned to more forcefully in the 1860s when he produced a number of erotic paintings that were banned from public display due to their content.

Comparisons can be made between *Ladies at the Seine* and Édouard Manet's (1832–83) *Le Déjeuner sur l'Herbe*, painted seven years later. Courbet's use of thick, dark and earthy background colours, often applied with a palette knife, was something that Manet also experimented with, and was also reminiscent of the Spanish and Dutch Masters.

CREATED

Paris

MEDIUM

Oil on canvas

SIMILAR WORK

Le Déjeuner sur l'Herbe by Édouard Manet, 1863

Gustave Courbet *Born* 1819 Doubs, France

Died 1877

Courbet, Gustave

Sunset, Trouville, c. 1865–70

In the mid to late 1860s Courbet was painting alongside Eugène Boudin (1824–98) on the Normandy coast at Trouville. He had seen and admired Boudin's paintings some years previously during a trip to Le Havre, and had become acquainted with the artist, who was one of the formative influences on Claude Monet (1840–1926). Boudin and Courbet were joined by James Abbott McNeill Whistler (1834–1903) and by Monet, and for the first time Monet painted side by side with Courbet. It was an experience that would greatly influence the young artist, who was drawn towards Courbet's expressive, broad technique and his use of large canvases. Monet adopted a similar regard for huge canvases, and occasionally used a palette knife to apply his paint the way Courbet did. He was not however taken with Courbet's method of preparing his canvas with a dark tonal base, and preferred a white base that enhanced his depiction of light and colour.

Courbet appears to have been a popular guest while staying at Trouville and had a succession of visitors to his studio, including the artist Charles-François Daubigny (1817–78), whom Monet also met for the first time that summer.

CREATED

Trouville

MEDIUM

Oil on canvas

SIMILAR WORKS

Deauville by Eugène Boudin, 1893

Cliffs and the Port d'Amont, Morning Effect by Claude Monet, 1885

Gustave Courbet *Born* 1819 Doubs, France

Died 1877

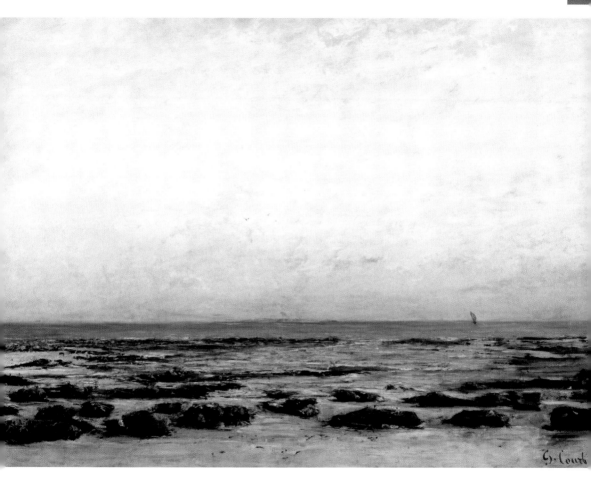

G. Court

Corot, Jean-Baptiste-Camille

Dardagny, Morning (detail), *c.* 1853

© National Gallery, London, UK/The Bridgeman Art Library

Jean-Baptiste-Camille Corot (1796–1875) was one of the leading painters of the Barbizon School and one of the most influential landscape artists to precede the Impressionists. His work significantly influenced many of the Impressionist group, including Camille Pissarro (1830–1903), Alfred Sisley (1839–99), Monet and Berthe Morisot (1841–95). Corot trained under a neo-classical artist, and three trips to Italy established his style more than his formal education had. He often worked in and around Fontainebleau Forest and painted *en plein air* – later the Impressionists would follow in his and the footsteps of other Barbizon School painters, and would again paint the natural beauty of the area. Corot's work is defined by an overwhelming lyrical charm. His landscapes, though drawn from nature, combine their very real qualities with a nostalgia and classical repose. He did not take pupils as such, but lent his advice and time freely to younger artists, and in particular to Pissarro and Morisot, dining with the latter every Tuesday night at her parents' house.

This painting was done while the artist was on his second trip to Switzerland, and is set outside the small village of Dardagny, not far from Geneva.

CREATED

Dardagny

MEDIUM

Oil on canvas

SIMILAR WORK

The Four Seasons, Autumn by Camille Pissarro, 1872

Jean-Baptiste-Camille Corot *Born* 1796 Paris, France

Died 1875

Corot, Jean-Baptiste-Camille

Recollections of Mortefontaine, 1864

Corot was one of the leading proponents for painting landscape scenes *en plein air*, but from the mid-1860s to the end of his life he changed his approach and frequently painted in the studio. Significantly and particularly with reference to this painting, he had a considerable collection of early landscape photographs many of which were slightly blurred, and from which he would paint. The blurring was due to a lack of technical ability in early cameras, but it lent itself perfectly to the hazy effect that is seen in so many of his late paintings. This poetic and serene picture of the mirror-like pond at Mortefontaine was painted in the studio, and probably based on photographs and sketches he would have made at the location. It is considered one of his masterpieces and was bought in 1864 on behalf of Napoleon III to hang at Fontainebleau, later being moved to the Louvre.

His use of a pared down palette here and his evocation of a melancholy, dewy atmosphere is a precursor to later experiments with colour and atmospheric effects that characterized much of the Impressionists' work, and especially that of Monet.

CREATED

Mortefontaine

MEDIUM

Oil on canvas

SIMILAR WORKS

Antibes seen from the Salis by Claude Monet, 1888

Moret-sur-Loing, Sunset by Alfred Sisley, 1892

Jean-Baptiste-Camille Corot *Born* 1796 Paris, France

Died 1875

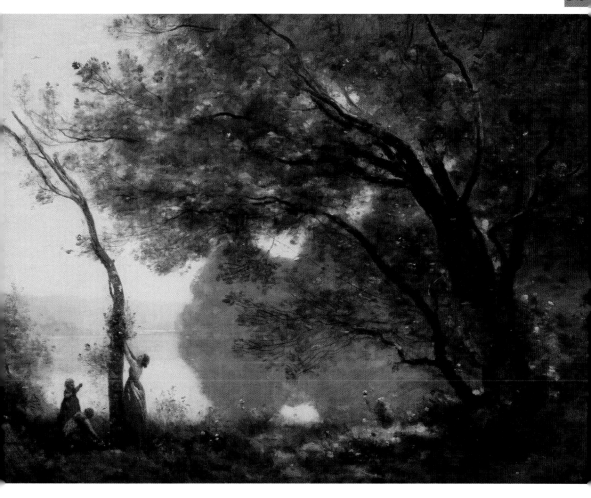

Delacroix, Eugène

Liberty Leading the People, 28 July 1830

© Louvre, Paris, France/The Bridgeman Art Library

In 1845 the influential French poet Charles Baudelaire (1821–67) described Eugène Delacroix (1798–1863) as, 'the most original painter of ancient or modern times'. He was certainly to be of enormous influence in the development of modern art, not just through the work of the Impressionists, but also the Post-Impressionists and beyond. He is one of the few artists of his time whose work spanned the gap between traditional and 'modern' art, seen through his synthesis of old master influences Rubens (1577–1640), Rembrandt (1606–69), Titian (c. 1488–1576) and Veronese (1528–88), with a radically new approach that fired the Romantic movement in France.

This was one of his most famous paintings and is fiercely patriotic in spirit. He was inspired by contemporary events, and painted a number of works with political messages that in essence rallied for freedom from oppression and tyranny. Here defiant Parisians march under the Tricolore that represents liberty – the work commemorates the Revolution of 28 July 1830 that brought Louis-Philippe to the throne. The figures that are almost hyper-realistic and depict a cross-section of society are sombre in tone, while the red of the flag is vibrant and focal to the work.

CREATED

Paris

MEDIUM

Oil on canvas

SIMILAR WORK

The Execution of Maximillian by Édouard Manet, c. 1867

Eugène Delacroix *Born* 1798 Rhône-Alpes, France

Died 1863

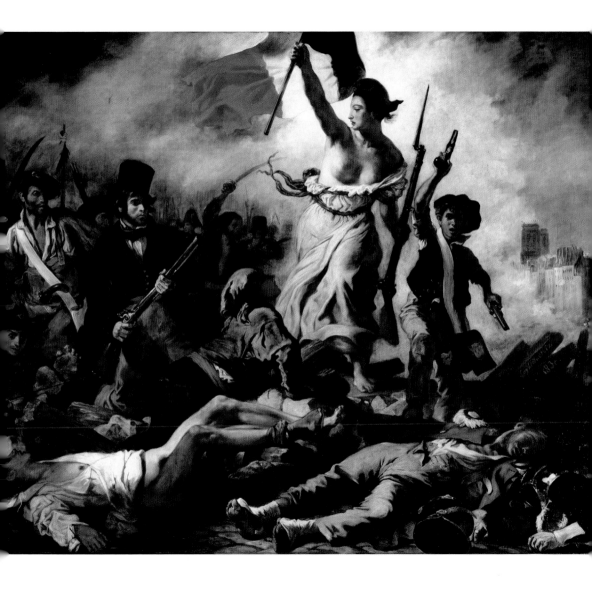

Delacroix, Eugène

The Moroccan Chief, 1845

© Musée des Augustins, Toulouse, France/The Bridgeman Art Library

Delacroix travelled to Spain and North Africa in 1832 and was greatly influenced by the exoticism of both countries, but in particular North Africa. The brilliant sunlight was quite different from what he was used to, and it had the effect of highlighting and purifying the colours around him so that everything appeared more dazzling and opulent. After his return to Paris, he continued to paint scenes from North Africa working from the hundreds of sketches he had made. He was particularly captivated by the Algerian and Moroccan costumes and the people with their elegant stance, and equated them with his interpretation of how the Romans and Greeks of antiquity may have appeared.

Delacroix's use of colour influenced Pierre-Auguste Renoir (1841–1919) and Paul Cézanne (1839–1906) perhaps more than their contemporaries. In 1881 Renoir made two trips to Algeria, following in the great colourist's footsteps. Although initially enthusiastic about the people and their costumes, he painted mostly landscapes. It seems he may have had some difficulty persuading the locals to pose for him.

CREATED

Paris

MEDIUM

Oil on canvas

SIMILAR WORKS

The Mosque (Arab Festival) by Pierre-Auguste Renoir, 1881

Life in the Fields by Paul Cézanne, 1876–77

Eugène Delacroix *Born* 1798 Rhône-Alpes, France

Died 1863

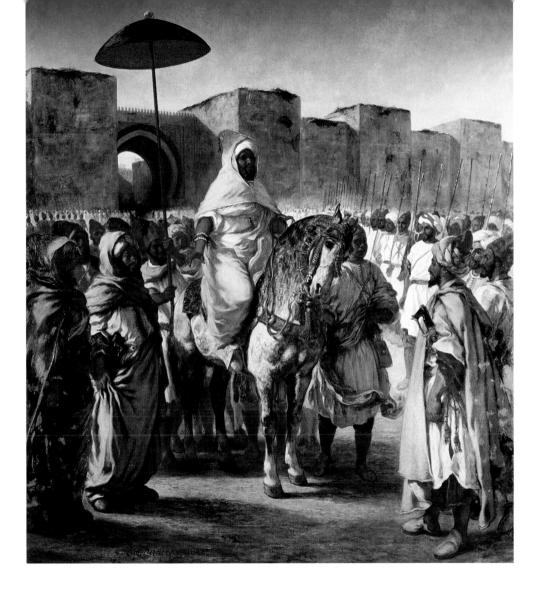

Daubigny, Charles-François

The Confluence of the River Seine and the River Oise, 1859

Daubigny was a leading painter of the Barbizon School, along with Corot, Jean-François Millet (1814–75) and Théodore Rousseau (1812–67), and his work was an important precursor to that of the Impressionists. He painted his many landscape pictures on site, and was a great advocate of painting *en plein air*. His work had the greatest influence on Monet, who had greatly admired Daubigny's work at the Salon of 1859.

Daubigny frequently painted river scenes along the Seine and the Oise, concentrating on the reflective surface of the water. His love of these settings prompted him to turn his boat, *Botin*, into a floating studio, which was something Monet would do some years later. The artist would then travel along the river, often rowed by his son, and paint the banks from his boat. The arrangement caused Daubigny's friend Corot great amusement, and he later painted the artist working in his boat. He was also joined on occasion by the artist Antoine Guillemet (1843–1918), who was an admirer of Daubigny and Corot, and was friends with Emile Zola (1840–1902), Pissarro and Cézanne.

CREATED

Outside Paris

MEDIUM

Oil on canvas

SIMILAR WORK

Argenteuil, The End of the Afternoon by Claude Monet, 1872

Charles-François Daubigny *Born* 1817 Paris, France

Died 1878

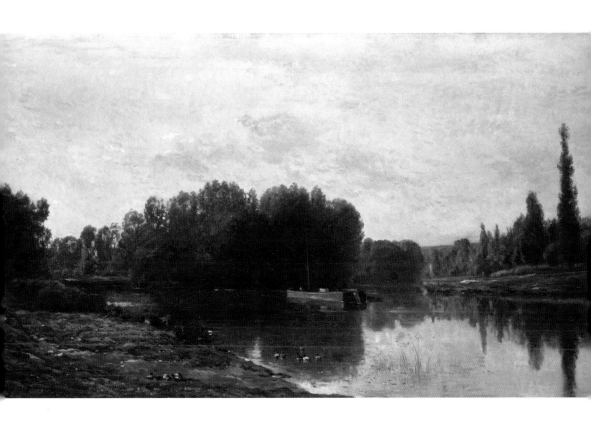

After Daubigny, Charles-François

The Coming Storm, Early Spring, 1874

Quite apart from Daubigny's influence on the development of Impressionism and his evocation of atmosphere (which can be seen in this work), he was of great help to the Impressionists and extended a long arm of friendship. He campaigned on their behalf as a member of the Salon jury in 1866 and again in 1868 when he wrote to Pissarro and Monet to notify them of the acceptance of their work. In 1870 when Monet's work was rejected, Daubigny resigned his position as a jury member out of disgust.

In 1871, while in London sheltering from the Franco-Prussian war, Daubigny and Monet met by chance alongside the river Thames. The older artist introduced Monet to Paul Durand-Ruel (1831–1922), an art dealer, who subsequently bought many paintings from Monet and other artists of the Impressionist circle. Daubigny is believed to have accompanied Monet on a trip to Holland before returning to France following the end of the war, and certainly paintings done by Monet during this period reflect the influence of his friend. Pissarro too was influenced by Daubigny's synthesis of Realism and Impressionism, as was Cézanne.

CREATED

Outside Paris

MEDIUM

Oil on panel

SIMILAR WORKS

Mont Sainte-Victoire by Paul Cézanne, 1890

Path at Le Chou by Camille Pissarro, 1878

Charles-François Daubigny *Born* 1817 Paris, France

Died 1878

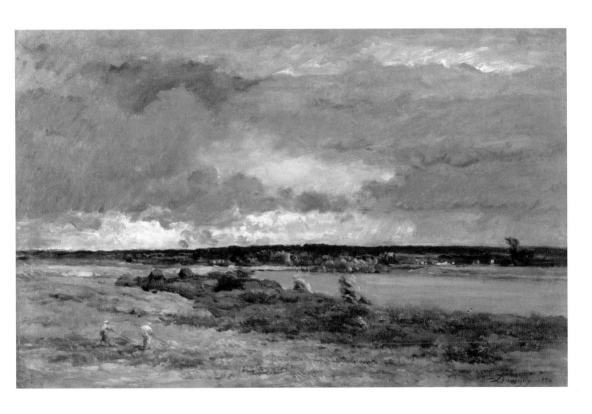

Jongkind, Johan Barthold

The Banks of the Isere, 27 September, 1863

Dutch artist Johan Barthold Jongkind's (1819–91) work is characterized by his quick, light and expressive touch and his paintings (particularly his watercolour sketches) had an immediacy that appealed to the Impressionists. His oeuvre is widely overlooked, but his importance as a precursor of Impressionism and his influence on Monet are without question.

When Monet first became acquainted with Jongkind's work at the Salon of 1859 he wrote to his friend Boudin: 'the only seascape painter we have, Jongkind, is dead to art; he is completely mad'. Monet would dramatically alter his opinion of the Dutchman just three years later. By chance Jongkind was working in Le Havre in 1862 at the same time as Monet, and the younger artist was greatly impressed with the animated and evocative nature of his work. Monet then introduced Jongkind to Boudin, and the three artists became close friends. Jongkind did not paint his finished works in the open, but made watercolour sketches, such as this, that he then worked on in the studio. He was greatly concerned with creating the 'impression' of a moment – of atmosphere, time or weather – and in this respect helped to pave the way for true Impressionist works.

CREATED

Along the banks of the Isere

MEDIUM

Watercolour on paper

SIMILAR WORK

The Seine at Vetheuil by Claude Monet, 1879

Johan Barthold Jongkind *Born* 1819 Lattrop, The Netherlands

Died 1891

Jongkind, Johan Barthold

A Canal in The Hague, 1868

Jongkind was born in The Netherlands close to the border with Germany and received his artistic training at the Academy in The Hague. He moved to Paris in 1846, but continued to travel back to his home country often, and travelled widely within The Netherlands. This impressionistic watercolour was made on a visit to The Hague in the late summer of 1868, when he also travelled to Delft, Dordrecht and Rotterdam. He painted his numerous watercolours on site, and would then create his oil paintings in the studio based on his watercolour sketches. There is an immediacy and freshness to these watercolours that render them amongst the best of his work.

Jongkind and Boudin were both important in Monet's early development, but similarly both artists encouraged him to find his own expression, which ultimately became the voice of Impressionism. There is little documentation about Jongkind in comparison to his contemporaries, but it is recorded that he lived in the same building as Cézanne for a period during the early 1870s. This is interesting, especially when comparing watercolours such as this and Cézanne's landscape paintings of the 1870s, which echo Jongkind's fluid, immediate approach.

CREATED

The Hague

MEDIUM

Watercolour on paper

SIMILAR WORKS

Landscape, Study after Nature by Paul Cézanne, 1876

The Dam at Zaandam, Evening by Claude Monet, 1871

Johan Barthold Jongkind *Born* 1819 Lattrop, The Netherlands

Died 1891

la Haye ? sept 68

Millet, Jean-François

The Gleaners, 1857

Millet was born in a small village in Normandy to a poor family. In 1838 he left for Paris, but his humble upbringing would stay with him throughout his life, and he would later become famous for his paintings of peasants and labourers. He received his artistic training with Paul Delacroche (1797–1856) but two years later fell under the influence of Honoré Daumier (1808–79) and started to develop his own style. In 1849 Millet moved to Barbizon where he painted his most famous works and lived in near poverty. He is recognized today as one of the leading Barbizon artists and his works led the way towards Realism and Naturalism. His paintings of peasants and farm labourers, like *The Gleaners*, elevated those people from the lowest echelons of society to monumental heroic figures, and were painted reverentially, with an almost religious feel and a social message. Millet's serene and atmospheric paintings were of enormous influence to the younger generation of artists, especially Pissarro and later Vincent Van Gogh (1853–90). It was also Millet who encouraged Boudin to become an artist, although he stressed it was not an easy path to follow.

CREATED

Barbizon

MEDIUM

Oil on canvas

SIMILAR WORKS

A Cowherd at Pontoise by Camille Pissarro, 1874

The Sower by Vincent Van Gogh, 1888

Jean-François Millet *Born* 1814 Gruchy, France

Died 1875

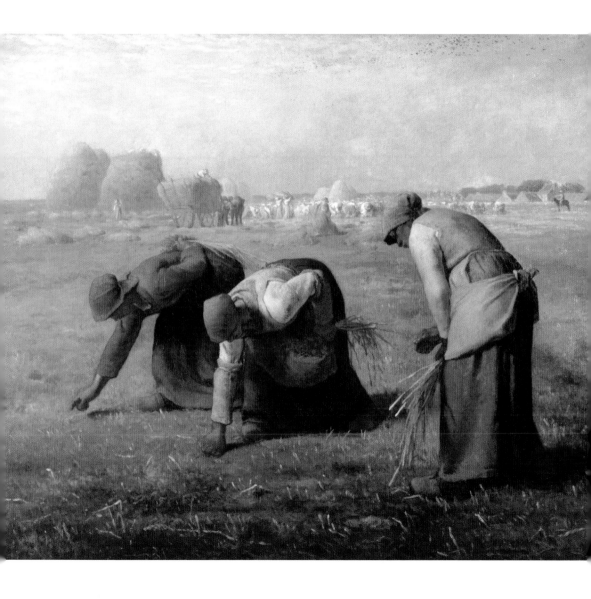

Gleyre, Charles

The Evening, 1865–67

The Swiss artist Charles Gleyre (1806–74) was orphaned while a young boy and was subsequently sent to an uncle in Lyon, France. He moved to Paris while still a teenager and studied art for four years before going on extended travels, visiting Italy, Greece, Nubia and Syria. He returned to Paris and began to paint again, receiving some success with his *Apocalyptic Vision of St John* that was exhibited at the 1840 Salon. In 1843 he took over Paul Delaroche's (1797–1856) studio and the same year painted this work, which was awarded a second-class medal at the Salon. His studio was popular amongst students, primarily because he refused to accept payment for his advice, charging them only rent and model's fees. The students were allowed to choose their subjects, and appear to have been left largely to their own devices; Gleyre's one preoccupation being that drawing over colour was all-important.

It was from these rather unlikely beginnings, however, that some of the most important artists of the Impressionist group emerged. Monet, Frédéric Bazille (1841–70), Renoir and Sisley were all pupils at Gleyre's studio, and it was here that the four artists met.

CREATED

Paris

MEDIUM

Oil on canvas

SIMILAR WORK

Semiramis Founding a Town by Edgar Degas, 1860–61

Charles Gleyre *Born* 1806 Loiret, France

Died 1874

Couture, Thomas

The Romans of the Decadence, 1847

Thomas Couture (1815–79) studied at the *École des Beaux-Arts* in Paris and established a reputation as an important history painter. He was a difficult and pompous character, whose self-belief eclipsed his ability to recognize the talents of others, and especially of those who worked in a way that differed from his own. He was vitriolic about Courbet, Millet and Rousseau, all leaders of the Barbizon School and important in the development of Impressionism. He considered his own abilities to outshine those of Jean-Auguste-Dominique Ingres (1780–1867) and Delacroix. He taught a number of students, and among those he taught were three important young artists, Manet, Henri Fantin-Latour (1836–1904) and Pierre Puvis de Chavannes (1824–98).

Couture advocated precise and careful drawing with equally controlled use of colour, and above all the practice of idealizing the figure to produce a balanced and harmonious finished work. In essence he could not have been further removed from the young artists of the Impressionist circle, with Monet writing to Boudin in 1859 and describing Couture's work as simply bad. There is however something of Couture's influence evident in Manet's work, which reflects his accomplished and accurate drawing, and his use of clearly defined areas of colour.

CREATED

Paris

MEDIUM

Oil on canvas

SIMILAR WORK

The Spanish Guitar Player by Édouard Manet, 1860

Thomas Couture *Born* 1815 Senlis Oise, France

Died 1879

Rousseau, Théodore

Oak Trees near Apremont, 1855

© akg-images

Rousseau battled throughout his life for acceptance from the Salon, which continually disregarded his works in favour of those in a Neo-Classical style that remained the 'officially' recognized art. He first studied business, but turned to art and trained in Paris with his family's support. In 1836 the Salon rejected his painting *La Descente des Vaches*, and, tired of the art circles in Paris, Rousseau moved to Barbizon. For the next few years he travelled between the two places before settling in Barbizon for good in 1848. He was one of the first artists to set up in the tiny village surrounded by beautiful countryside and forest, but was quickly joined by Millet, Narcisse-Virgile Diaz (1808–76), Charles-Emile Jacque (1813–94), Corot and Daubigny. Some years later Monet, Renoir, Pissarro and their circle would also make painting trips there where they were influenced by their predecessors.

During this period at Barbizon, Rousseau painted some of his finest works, and had a growing circle of admirers. His paintings are characteristically lyrical, nostalgic in feel and beautifully painted, reflecting his enormous attention to draughtsmanship.

CREATED

Barbizon

MEDIUM

Oil on canvas

SIMILAR WORK

Le Pavé de Chailly by Claude Monet, *c.* 1866

Théodore Rousseau *Born* 1812 Paris, France

Died 1867

Fantin-Latour, Henri

Homage to Delacroix, 1864

© akg-images

The influential artist Fantin-Latour was born in Grenoble and studied with his father who worked in pastels, before moving to Paris and entering the *École des Beaux-Arts*. He took lessons with Paul Lecoq de Boisbaudran (1838–1912) who practised unusual teaching methods based on developing his students' pictorial memory. Fantin-Latour moved to Couture's studio for a short period where he met Manet and Puvis de Chavannes and around the same time became friendly with Edgar Degas (1839–1917), Delacroix, Ingres, Corot, Whistler and Courbet amongst others. His friendship with Whistler was particularly important and led to him settling in England for a period, where he gained some success. There is something in Whistler's early work that echoes Fantin-Latour's sombre palette and elegant figures, and this is seen also in the work of Manet and Degas.

He is perhaps best known for his group portraits of his Parisian friends and his still life paintings. *Homage to Delacroix* was painted following the great colourist's death in 1863. It depicts Fantin, Whistler, Manet, Alphonse Legros (1837–1911), Louis Edmond Duranty (1833–80), Felix Bracquemond (1833–1914), Baudelaire and the art critic Champfleury (1820–89) surrounding a portrait of the artist.

CREATED

Paris

MEDIUM

Oil on canvas

SIMILAR WORK

Victorine Meurent in the Costume of an Espada by Édouard Manet, 1862

Henri Fantin-Latour *Born* 1836 Rhône-Alpes, France

Died 1904

Fantin-Latour, Henri

Atelier des Batignolles, 1870

© akg-images

By the late 1860s there was a circle of artists, intellectuals, writers and critics who lived and revolved around the Batignolle area of Paris, and more specifically the Café Guerbois. This café became the scene of lively debates and raucous socializing, it was a place where like-minded and forward-thinking bohemians could meet, share ideas and argue the difference. For want of a better name they were collectively labelled *le groupe des Batignolles*, and the name stuck.

In 1870 Fantin-Latour finished his large group portrait, *A Studio in the Batignolles Area*, which included the key members of the group centred round Manet who is seated in front of an easel painting a portrait of Astruc (1835–1907). There are two notable omissions from the painting, firstly Fantin-Latour himself, who invariably included a self-portrait, and more significantly Pissarro, who was the oldest of the group. The painting was conceived in a similar spirit to *Homage to Delacroix*, and acknowledges the importance of Manet as an artistic influence. Astruc is seated in the fore, with standing from left to right, Otto Scholderer (1834–1902), Renoir, Zola, Maitre (an amateur musician), Bazille and Monet.

CREATED

Paris

MEDIUM

Oil on canvas

SIMILAR WORK

The Artist's Studio by Frédéric Bazille, 1870

Henri Fantin-Latour *Born* 1836 Rhône-Alpes, France

Died 1904

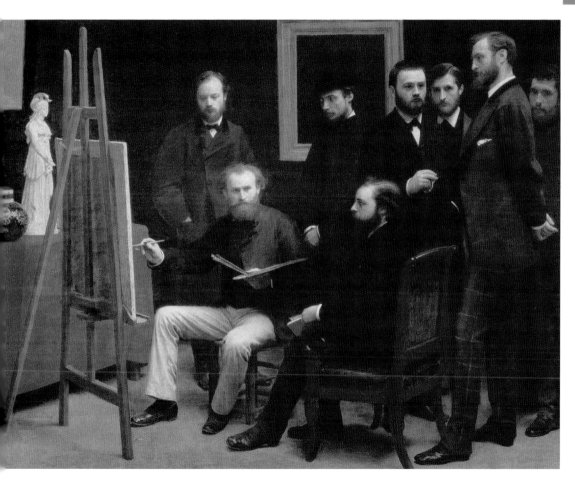

Boudin, Eugène

Beach Scene near Trouville, c. 1863–66

Boudin was an important artist in the later development of landscape painting, although he did not see himself as an innovator. He concentrated on seascapes and beach scenes, painting charming works whose great appeal was emphasized through his subtle and brilliant handling of colour. Boudin's works reflect his admiration for Dutch seventeenth-century Masters, especially seen in his characteristic low horizon and expansive sky, and it was with great enthusiasm that he befriended the young Dutch painter Jongkind when the two met at Le Havre.

Le Havre, Boudin's hometown, was also the home of the young Claude Monet, who had shown an early aptitude for drawing. Monet saw Boudin's works in a shop window and instantly took an aversion to the congenial artist, refusing even to meet him. It was by chance that the two were later introduced, and they went on to become close friends. Boudin can be considered Monet's early teacher, and his work had a great formative influence on the young artist, while also encouraging the development of Monet's own form of expression.

CREATED

Trouville

MEDIUM

Oil on canvas

SIMILAR WORK

The Beach at Sainte-Adresse by Claude Monet, 1867

Eugène Boudin Born 1824 Honfleur, France

Died 1898

Boudin, Eugène

The Jetty at Deauville, 1869

Boudin first worked as a cabin boy on boats travelling between Honfleur and Le Havre, before his family moved to Le Havre and his father opened a stationery and frame-making shop. Boudin entered the business and then opened his own shop, which brought him into contact with various artists including Constant Troyon (1810–65), Millet and Couture. He became interested in art, and with the encouragement of these artists began his career as a painter travelling to Paris and Flanders. He later settled in Paris for three years from 1850, but continued to make extended trips back to Le Havre and the Normandy coastline for painting excursions. He met Monet in 1857 and Monet, then only 17 years old, quickly became his pupil, and much later in life spoke of Boudin's influence on him.

Boudin firmly believed that in order for paintings to achieve immediacy and vibrancy they had to be painted in front of the motif, and that the study of the simple beauty of nature was the way forward. Both of these were doctrines that Monet took to immediately, and though he later worked in the studio, his career is defined through his depictions of nature painted *en plein air*.

CREATED

Deauville

MEDIUM

Oil on panel

SIMILAR WORK

The Regatta at Saint-Adresse by Claude Monet, 1867

Eugène Boudin *Born* 1824 Honfleur, France

Died 1898

Boudin, Eugène

Plougastel-Daoulas (detail), *c.* 1870–73

© Private Collection/The Bridgeman Art Library

Boudin occupied an unusual position within the ranks of nineteenth-century artists: he bridged the gap between the accepted works of the Salon and the Academy, and the 'revolutionary' style of the new generation of artists. He exhibited at the Salon throughout much of his career, and gained a certain degree of success within this circle. At the same time, his paintings can be seen as a precursor to the Impressionists, and in 1874 he exhibited simultaneously at the first Impressionist exhibition and the Salon. Stylistically too his delicate and illuminating touch and fresh depiction of the motif marked something of a transition between Corot and the Impressionists. Boudin, with his self-effacing character, never acknowledged the tremendous effect his work had on the emergence of Impressionism, and was often gripped by self-doubt over his abilities. One of his greatest frustrations was that he felt unable to truly depict the magnificence of nature – at times he felt it was simply beyond his reach.

This painting was characteristic of his work at this time. He had moved from depicting the bourgeoisie, and was concentrating on coastal scenes and landscapes, often painting them at different times of the day and under different light effects.

CREATED

Plougastel-Daoulas

MEDIUM

Oil on canvas

SIMILAR WORK

Impression, Setting Sun by Claude Monet, 1872

Eugène Boudin *Born* 1824 Honfleur, France

Died 1898

Gauguin, Paul

Nude, 1880

© akg-images

The irascible artist Paul Gauguin (1848–1903), who would become one of the leading painters of the Post-Impressionists, had a late and inauspicious start to his artistic career. After finishing his education in Orléans he worked as a sailor for six years before settling in Paris in 1870 and becoming a stockbroker. Gauguin's guardian was Gustave Arosa, a successful businessman and an art collector who was a patron of Pissarro. Arosa introduced Gauguin to Pissarro, and around the same time Gauguin began to paint in his spare time. It is significant that as Gauguin was beginning to turn to art, the Impressionists were assuming their relatively rapid rise and decline as a cohesive circle that saw the group largely fragmented by the 1880s. His first exposure to the art world, and that of the Impressionists, was through Pissarro. This exposure formed the basis for his later extraordinary style, but he quickly moved on from the Impressionists incorporating what he had learnt and emerging with an entirely new visual language.

Pissarro took Gauguin on as a student, and through him he met Cézanne, whose work would be of particular influence on the younger artist.

CREATED

Paris

MEDIUM

Oil on canvas

SIMILAR WORK

Woman at her Toilet by Edgar Degas, c. 1876–80

Paul Gauguin *Born* 1848 Paris, France

Died 1903

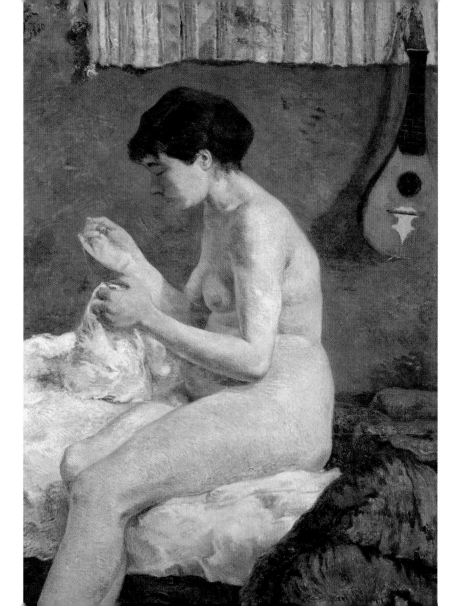

Gauguin, Paul

Still Life with Mandolin and Flowers, 1885

© akg-images

While still painting part-time, and occasionally attending the Atelier Colarossi, Gauguin exhibited a landscape at the Salon of 1876, and from 1879 contributed to the Impressionist exhibitions. He had also begun to collect works from his friends, and by the 1880s owned paintings by Monet, Pissarro, Sisley, Renoir, Guillaumin, Manet, Cézanne and Jongkind. In 1883 there was a financial crisis at the bank where Gauguin worked and he was forced to leave, something he considered a happy turn of events. He now relied on his painting for income, and shortly afterwards travelled to Rouen with his Danish wife and five children to live and work close to Pissarro. His wife soon returned to Denmark taking the children, and Gauguin followed reluctantly. By 1885, the year he painted this picture, he had returned to Paris with one son leaving the rest of his family behind.

Gauguin first started to develop his individual style during his time in Rouen, and this was furthered while he was in relative artistic isolation in Copenhagen. This period allowed him the opportunity to evolve his own particular expression, experimenting with bold colour and simplifying his forms.

CREATED

Paris

MEDIUM

Oil on canvas

SIMILAR WORK

The Blue Vase by Paul Cézanne, 1889–90

Paul Gauguin *Born* 1848 Paris, France

Died 1903

Gauguin, Paul

The Road to Rouen, 1885

© akg-images

This painting recalls Gauguin's early brush with Impressionism and in particular with Pissarro and Cézanne, but it was painted at a time when he was on the brink of moving in an entirely different direction. Gauguin had tired of the Impressionists and was about to make a conscious decision to distance himself from Pissarro, and look instead towards Degas. This decision was in some part based on Pissarro's experimentation with scientific colour theories and his adoption of a Pointillist approach that Gauguin did not appreciate. He then met Van Gogh, whom he would later paint with for some weeks, and the artist Émile Bernard (1868–1941) who would prove to be another decisive influence on his style.

The last Impressionist exhibition was in 1886, and it clearly indicated the division within the circle of artists. Following the exhibition Gauguin, like Cézanne, felt he needed to isolate himself and went to Pont-Aven in Brittany, where he subsequently met Bernard and Charles Laval (1862–94). In 1887 he travelled with Laval to Panama and Martinique – a trip that would again significantly affect his style.

CREATED

Rouen

MEDIUM

Oil on canvas

SIMILAR WORK

Poplars by Paul Cézanne, 1879–80

Paul Gauguin *Born* 1848 Paris, France

Died 1903

Gauguin, Paul

The Yellow Haystacks (detail), 1889

© akg-images

Increasingly towards the end of his career Gauguin moved towards Synthetist Symbolism and away from the precedents of his Impressionist teachers. By the time of this work (also reflective of Van Gogh's influence) he had become friendly with Bernard who worked in a manner referred to as 'Cloisonnism', the term being taken from an enamelling technique. He worked with broad areas of flat colour, delineated with a heavy outline and created images that were entrenched in Symbolism. Gauguin later wrote in a letter to a friend that, 'Art is an abstraction: derive it from nature by indulging in dreams in front of nature'. His words clearly indicate the direction in which his work was moving, and was suited to the exotic and mysterious environs of Tahiti where he spent his last years.

The influence of Gauguin's late style of simplified forms, symbolic elements and colour, and emotive use of colour was enormous on emerging art circles, from the Symbolists, to the Nabis, the Pont-Aven School, the Fauves and the Expressionists, and as such he paved the way for the transition towards modern and abstract art.

CREATED

Pont-Aven

MEDIUM

Oil on canvas

SIMILAR WORK

Breton Women in the Shade by Émile Bernard, 1892

Paul Gauguin *Born* 1848 Paris, France

Died 1903

Seurat, Georges

Sunday Afternoon on the Island of La Grande Jatte, 1884–86

Georges Seurat (1859–91) studied at the *École des Beaux-Arts* in 1878 and 1879, where he avidly absorbed the classical linearity of Ingres and became interested in Delacroix's use of colour. It was around this time that he first became aware of Eugène Chevreul (1786–1889) and Charles Blanc (1813–82) who had both written about scientific colour theories and optical illusion. In 1879 Seurat attended the fifth Impressionist exhibition and was greatly taken with Renoir's work, amongst others, and works made at Barbizon. He later followed in the Impressionists' footsteps by painting the landscape around Barbizon and Fontainebleau Forest. Interestingly for an artist now famous for his approach to colour, he spent several years working in black and white, creating a technique of building mass and form through graduated intensity of small brush strokes. This formed the foundation for his later approach to paintings such as this one: the monumental *Sunday Afternoon on the Island of La Grande Jatte*.

The work took him two years to finish and was based on a series of sketches he made on site that were Impressionist in technique. He then used these to paint the huge canvas in his studio.

MEDIUM

Oil on canvas

SIMILAR WORK

Woman wth a Parasol by Paul Signac, 1893

Georges Seurat Born 1859 Paris, France

Died 1891

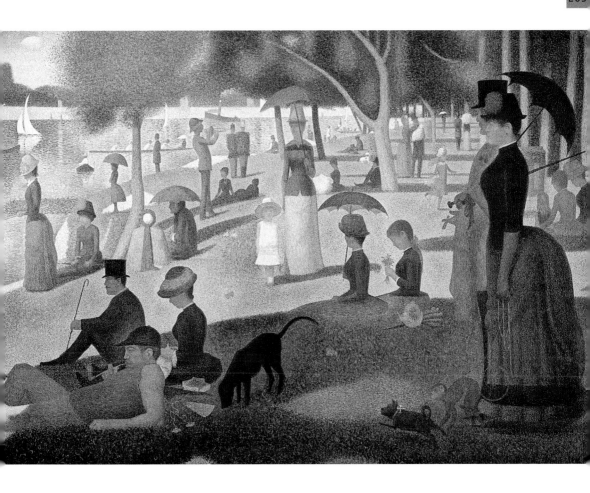

Seurat, Georges

The Circus, 1891

In 1884 Seurat's large painting *Une Baignade* was rejected by the Salon and the same year he, along with the Symbolist artist Odil Redon (1840–1916) and Paul Signac (1863–1935), were instrumental in founding the *Société des Indépendants* whose first exhibition was in December. The following year Pissarro met Signac and later Seurat, and was immediately drawn to their new technique. Consequently the older artist's style underwent a radical change in line with Seurat's colour theories, although Pissarro's work later reverted to a more impressionistic approach. Rather typically Pissarro wrote to his son Lucien that although he no longer felt able to paint with such divisionism he regarded Seurat's innovations as being of the 'utmost importance to art'.

Seurat can be regarded as one of the leaders of the avant-garde, and although his scientific approach to painting was widely copied by younger artists, it was never surpassed. This work was left unfinished after he died suddenly in 1891, and was exhibited in its unfinished state at the seventh *Salon des Indépendants*. The seated figure in the first row of seats wearing a silk top hat is the artist Charles Angrand (1854–1926) who was a friend of Seurat's.

CREATED

Paris

MEDIUM

Oil on canvas

SIMILAR WORK

Portrait of Félix Fénéon in front of an Enamel of a Rhythmic Background of Measures and Angles, Shades and Colours by Paul Signac, 1890

Georges Seurat *Born* 1859 Paris, France

Died 1891

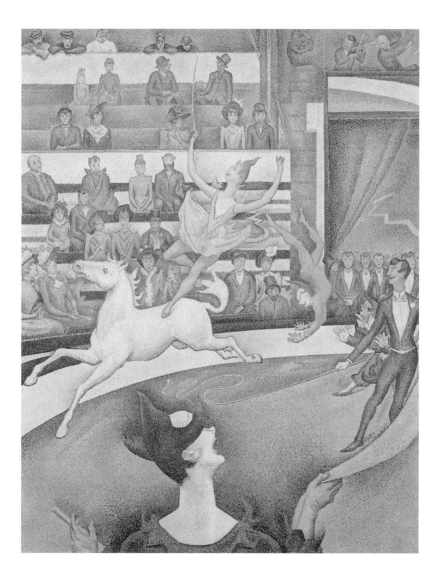

Signac, Paul

The Railway Junction at Bois-Colombes (La Route Pontoise), 1886

© Leeds Museums and Galleries (City Art Gallery) UK/The Bridgeman Art Library

In contrast to Seurat's reticence and very private life, Signac was more vociferous, and following Seurat's early death he became the spokesman for Neo-Impressionism. Signac first trained in architecture before turning to painting, and was also a keen sailor with many of his subjects including seascapes or boats. He had strong political beliefs and was an anarchist like many of his friends, including Pissarro, Henri-Edmond Cross (1856–1910) and Maximilien Luce (1858–1941).

As a young artist, Signac was most impressed by Monet's work and even wrote to him asking for his advice, stating that his paintings were the only model from which he would work. He later became friendly with Guillaumin, and the two worked side-by-side painting in a broad impressionistic style using bold colours. He did not become familiar with Seurat's work until he saw *Une Baignade*, and by 1884 a close friendship had developed between the two. It was under Seurat's influence that Signac abandoned his earlier impressionistic style and began to assimilate scientific colour theories into his work. At this time there were enormous advances within scientific rationalization of colour and optical illusion and many papers were being published on the topic.

MEDIUM

Oil on canvas

SIMILAR WORK

Lacroix Island, Rouen, in Fog by Camille Pissarro, 1888

Paul Signac *Born* 1863 Paris, France

Died 1935

Signac, Paul

Woman at her Toilette Wearing a Purple Corset (detail), 1893

Pissarro's friendship with Seurat and Signac and his subsequent change of style caused consternation amongst the original Impressionist group, though by the mid-1880s the group had all but fragmented. In 1886, when Pissarro insisted that Seurat and Signac be included in the eighth and final Impressionist exhibition, it caused huge ructions and eventually the three artists were relegated to a room on their own. Monet chose not to exhibit at all, which is ironic given that Signac's earliest influences had been his work.

Signac travelled along the French coast, and many of his paintings are coastal scenes and landscapes, in contrast to Seurat who concentrated on Paris and urban settings. This painting of a woman wearing a corset is one of the few exceptions, and was strongly influenced in subject and style by Seurat's work, *Young Woman Powdering Herself*, c. 1889–90. Signac constantly experimented with different media and continued to explore colour theories throughout his life. From 1908 until his death he presided over the *Société des Artistes Indépendants*, and promoted and encouraged young artists. He had a particular influence on Henri Matisse (1869–1954) and André Derain (1880–1954) and was important in the emergence of the Fauves.

MEDIUM

Oil on canvas

SIMILAR WORK

Young Woman Powdering Herself by Georges Seurat, c. 1889–90

Paul Signac *Born* 1863 Paris, France

Died 1935

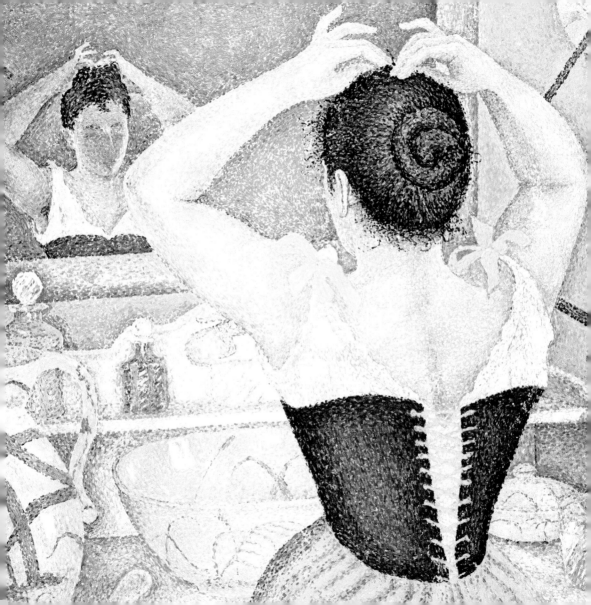

Van Gogh, Vincent

Restaurant de la Sirène at Asnières, 1887

© Giraudon, Musée d'Orsay, Paris, France/The Bridgeman Art Library

The Dutch artist Van Gogh arrived in Paris in March 1886. His style immediately underwent an enormous change. Initially Van Gogh had been sceptical about the Impressionists and their use of colour, but after becoming friends with Pissarro who advised him on colour theories, his palette brightened considerably. Relatively quickly after his arrival in Paris, Van Gogh became acquainted with several avant-garde painters including Toulouse-Lautrec, Signac, Bernard and Gauguin. He was also exposed to the works of Seurat, Cézanne and the Impressionists through his brother Theo and Durand-Ruel's gallery, as well as at the various exhibitions at which they were shown.

This painting was done at Asnières, a popular northwest suburb of Paris and a favourite haunt. During mid-1887 Van Gogh would paint here, often with Bernard and Signac, the three walking the considerable distance from central Paris to Asnières armed with their paints and easels. His style reflects the influence of the Impressionists and his Neo-Impressionist friends, particularly in his treatment of colour. Colour would become definitive in Van Gogh's work and he went on to have an indelible influence on the emergence of modern art.

CREATED

Asnières

MEDIUM

Oil on canvas

SIMILAR WORKS

Garden at Asnières by Paul Signac, 1883

The Boulevard de Clichy Under Snow by Paul Signac, 1886

Vincent Van Gogh *Born* 1853 Groot-Zundert, The Netherlands

Died 1890

Van Gogh, Vincent

Portrait of Père Tanguy, 1887–88

Shortly after his arrival in Paris, Van Gogh met Père Tanguy, the elderly owner of a paint and art supplies shop in Montmartre. Tanguy also bought and sold works of the Impressionists and Post-Impressionists and through his generosity and benevolence garnered a reputation as a father figure amongst the artists. He had a large number of paintings on display, especially those by Cézanne, and subsequently bought canvases by Van Gogh.

This painting shows Van Gogh's interest in Japanese prints, which were popular at this time in Paris. Since the opening of trade routes with Japan in 1854, there had been a steady flow of Japanese artefacts into Europe and the US, and there was a vogue for all things Japanese. Many artists including Monet, Degas, Gauguin, Whistler and Toulouse-Lautrec were attracted to Japanese wood-block prints, and Van Gogh himself collected a number of them. The strong and vibrant colours in this work reflect Van Gogh's increasing experiments with colour, and in particularly colour in relation to mood. The artist had a sincere and deep friendship with Tanguy and this is apparent through his depiction of the serene, paternal man.

CREATED

Paris

MEDIUM

Oil on canvas

SIMILAR WORKS

Portrait of Marie Lagadu by Paul Gauguin, 1890

Père Tanguy by Émile Bernard, 1887

Vincent Van Gogh *Born* 1853 Groot-Zundert, The Netherlands

Died 1890

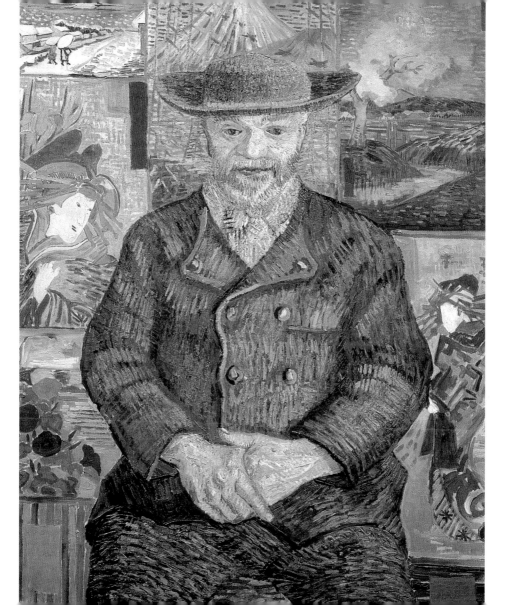

Cross, Henri-Edmond

The Excursionists, 1894

© Petit Palais, Geneva, Switzerland/The Bridgeman Art Library

Cross was born in Douai and grew up in Lille. He had a traditional start to his artistic career, studying art at the *École des Beaux-Arts* and moving to Paris in 1878. His early style was in a Realist vein with a sombre palette, and was influenced by his friend Francois Bonvin (1817–87) and by the work of Jules Bastein-Lepage (1848–84). He exhibited at the Salon in 1881, but by 1883 he became particularly influenced by Monet and the works of the Impressionists and their extended circle. Trips to the south of France where the strong sun illuminates the scenery, also inspired his palette to become bold and bright. In 1884 he joined Seurat and Signac and thereafter adhered to their vibrant Pointillism. That same year he exhibited at the first show of the *Salon des Artistes Indépendants*, and in 1891 was elected Vice-President of the *Société des Artistes Indépendants*.

By the time of this painting, Cross had moved to the Mediterranean coast where he concentrated on mystical, evocative landscapes such as this one, evolving a decorative and slightly surreal harmony.

CREATED

Mediterranean coast

MEDIUM

Oil on canvas

SIMILAR WORKS

In the Time of Harmony by Paul Signac, 1894

Luxe, Calme et Volupté by Henri Matisse, 1904

Henri-Edmond Cross *Born* 1856 Douai, France

Died 1910

Cross, Henri-Edmond

Coastal View with Cypress Trees (detail), 1896

© Petit Palais, Geneva, Switzerland/The Bridgeman Art Library

This melancholic painting with its spiritual air and Symbolist elements was probably based on a literary source, a scene from a play by Dujardin. The painting depicts the scene from *Le Chevalier du Passé* where four Floramyes weep over their departure from Antonia's Island. The muted colours and the strangely luminous pale pinks of the foreground add to the unearthly, surreal atmosphere of the painting.

In 1904 Cross spent some time in Saint-Tropez working alongside Signac and Matisse, and started to further brighten his colours and paint more broadly. This period was significant to Matisse, who under the influence of Cross and Signac started to develop a more pointillist manner of working, and it was at this time that he painted *Luxe, Calme et Volupté*. In his later years Cross's style continued to develop with his use of colour becoming increasingly vibrant and expressive, with a refined use of colour contrasts. His work naturally progressed towards the emergence of the Fauves and the Expressionists, while also contributing to the Nabis and Symbolists.

CREATED

Mediterranean Coast

MEDIUM

Oil on canvas

SIMILAR WORKS

Luxe, Calme et Volupté by Henri Matisse, 1904

The Shell Gatherer by Jan Toorop, 1891

The Bathers by Maurice Denis, 1899

Henri-Edmond Cross *Born* 1856 Douai, France

Died 1910

Van Rysselberghe, Théo

Alice Sethe (detail), 1888

© akg-images

The Belgian artist Théo Van Rysselberghe (1862–1926) studied art at the *Ghent Académie des Beaux-Arts* and later at the Academy in Brussels. He developed an enthusiasm for North Africa and Morocco, and between 1882 and 1888 made three extended trips to the countries. These were significant to his developing style that was broadly impressionistic at first. In 1883 he became a founding member of *Les XX* – a group of radical young artists that included Signac and Auguste Rodin (1840–1917). Rysselberghe's participation in *Les XX* brought him into contact with the main avant-garde artists of the day including Monet, Pissarro, Whistler, Seurat, Renoir and others, and their work was to have a profound impression on him. In 1888, after seeing Seurat's *La Grande Jatte*, Rysselberghe adopted a pointillist approach, and in that same year he painted *Alice Sethe*, introducing Pointillism to Belgium.

This monumental painting expresses Rysselberghe's evolving new style and also the influence of Whistler in the full-length elegant figure and restricted palette. It marked the beginning of a period during which Rysselberghe painted numerous portraits in an increasingly vibrant pointillist manner. By 1903 however he had adopted broader brush strokes again, and by 1910 had abandoned Pointillism.

CREATED

Belgium

MEDIUM

Oil on canvas

SIMILAR WORKS

Young Woman Powdering Herself by Georges Seurat, 1889

Théo Van Rysselberghe Born 1862 Ghent, Belgium

Died 1926

Anquetin, Louis

The Walk (Woman with an Umbrella), 1891

© Private Collection/The Bridgeman Art Library

Louis Anquetin (1861–1932) was an innovative artist whose unique vision contributed towards the development of the Fauves, and beyond to abstract and modern art. However this flush of vibrancy was relatively short-lived, and, after starting on the path to a new expression in the arts, he then swiftly left it and spent the second half of his career working in a Baroque style of monumental painting of Rubenesque feel.

He moved to Paris in around 1882 and joined the Atelier Cormon where he met and befriended Van Gogh, Toulouse-Lautrec and Bernard, and established himself as a leader within the lively café culture of Paris's nightspots. He became interested in Japanese prints, possibly having seen Van Gogh's collection, and was influenced at first by the work of Monet. From around 1887, however, he had started to develop his own unique style based on the study of these Japanese prints and of stained glass windows. He started to work with areas of broad flat colour, heavily delineated and with a flattened surface perspective. The critic Dujardin coined the term 'Cloisonnism' – an enamelling technique that describes Anquetin's and also Bernard's work.

CREATED

Paris

MEDIUM

Oil on canvas

SIMILAR WORKS

Portrait of My Sister Madelaine by Émile Bernard, 1888

On the Bois de Boulogne by Henri de Toulouse-Lautrec, 1901

Louis Anquetin *Born* 1861 Etrepagny, France

Died 1932

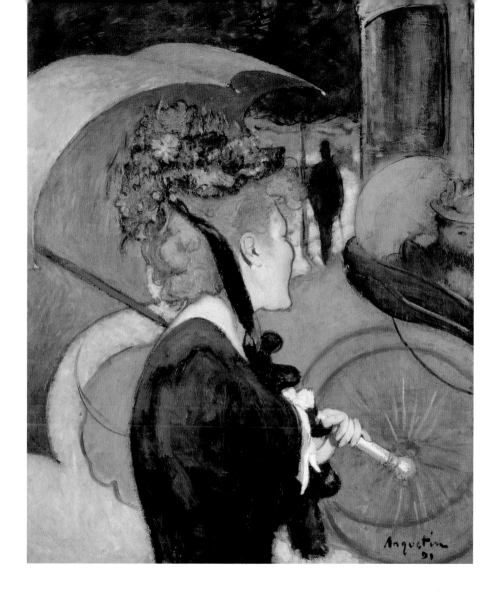

Bernard, Émile

Landscape, Saint-Briac, 1889

Bernard, like Anquetin, was another highly original artist whose work had a profound influence on, amongst others, Gauguin and Van Gogh. He studied at the *École des Arts Décoratifs* and later joined the Cormon's Atelier where he met Anquetin, Toulouse-Lautrec and Van Gogh. Van Gogh and Bernard would go on to develop a close friendship, and many letters sent between them have survived. Bernard developed a method of working that was similar to Anquetin and involved the use of broad, flat areas of colour and heavy outline. Furthermore, Bernard's works reflect strongly symbolic elements and were often spiritual in feel, while his actual compositions had a geometric quality, which may have been in part influenced by Cézanne. Bernard travelled to Normandy and Brittany, and met Gauguin at Pont-Aven. His influence on Gauguin, seen primarily in his increasing use of Symbolism and flattened areas of colours, was substantial, and it was a disappointment to Bernard that Gauguin never acknowledged it.

This landscape, painted while staying in Brittany, reflects Bernard's highly refined use of colour, and foreshadows the colour experiments that the Fauves and Expressionists explored through their work.

CREATED

Saint-Briac

MEDIUM

Oil on canvas

SIMILAR WORKS

Landscape at Collioure by Henri Matisse, 1905

The Seine at Le Pecq by Maurice de Vlaminck, 1907

Émile Bernard *Born* 1868 Lille, France

Died 1941

Impressionism

Styles & Techniques

Manet, Édouard

The Balcony (detail), 1868–69

© akg-images

The Balcony established Édouard Manet's (1832–83) position as a controversial painter of modern life. Scenes of the bourgeoisie were popular at this time, but he approached the painting in a totally unconventional manner. The figures are pressed to the fore of the canvas, frozen in a moment of inconsequential time. They relate no story or purpose, and are lacking in any emotional response. The seated figure is Berthe Morisot (1841–95), who became one of Manet's favourite models, and beside her is the violinist Fanny Claus, while behind them stands Antoine Guillemet (1841–1918), and barely visible against the dark background is Leon, Manet's son. Against the dark interior Manet used touches of brilliant colour, the green of the shutters, the blue of Guillemet's tie and the white of the dresses, in a manner that was widely criticized. He also inverted traditional pictorial values by applying more detail to the flowerpot and lace of the dress sleeves than to the faces of the subjects themselves. The painting was exhibited at the Salon of 1869 and was poorly received by the critics.

CREATED

Paris

MEDIUM

Oil on canvas

SIMILAR WORKS

Majas on the Balcony by Francisco de Goya, *c.* 1810–15

Musicians in the Opéra Orchestra by Edgar Degas, 1868

Édouard Manet *Born* 1832 Paris, France

Died 1883

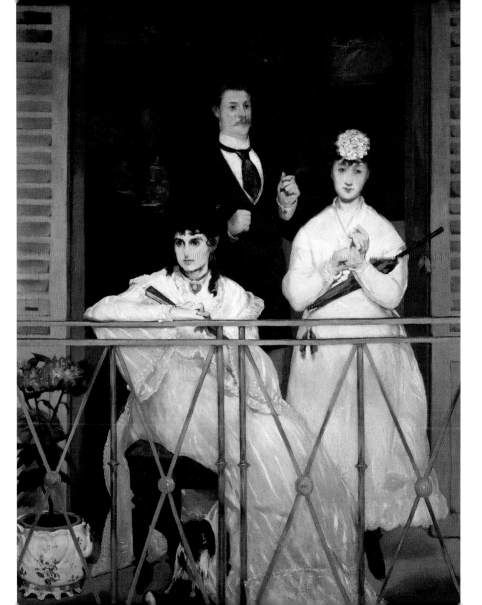

Manet, Édouard

The Barge, 1874

It is in no small way ironic that Manet was looked upon as a leader of the group of artists who were developing a new visual language and challenging the deeply embedded traditions of academic art. His innovations in art, in subject and style were at the forefront of the emerging new voice of art, yet he never exhibited at any of the Impressionist exhibitions.

This painting, which reflects the Impressionist way in which Manet was working at this time, was painted in the summer of 1874 at Argenteuil. While visiting Claude Monet (1840–1926) and his family Manet produced some of his most Impressionist *plein air* paintings, here capturing the younger artist painting in his studio boat. His palette is particularly rich with vibrant use of purples and deep blues reflective of the effect of sunlight. His brush strokes are broad, especially in his painting of the water, and his composition structured around strong verticals and horizontals. In a characteristic manner, he has placed the focus of the scene, the boat and artist, to the front of the canvas – so close in fact that its form is truncated by the strictures of the canvas itself.

CREATED

Argenteuil

MEDIUM

Oil on canvas

SIMILAR WORK

The Studio Boat by Claude Monet, 1874

Édouard Manet *Born* 1832 Paris, France

Died 1883

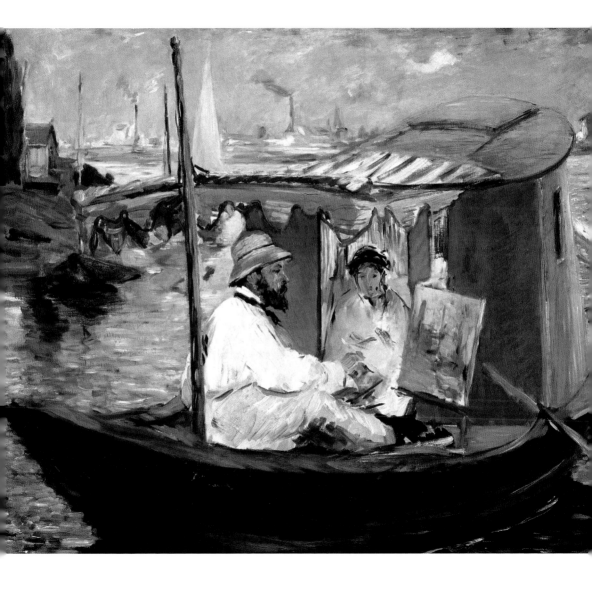

Bazille, Frédéric

View of the Village (detail), 1868

© akg-images

Frédéric Bazille (1841–70) studied at Charles Gleyre's (1806–74) studio, and when the studio closed in 1864 he began taking trips out to the countryside to paint. Bazille and Monet visited Honfleur where they worked alongside Eugène Boudin (1824–98) and Johan Barthold Jongkind (1819–91). It was during this period of painting outside, in front of the motif, that Bazille's style really evolved.

This portrait of a young woman seated in the foreground with an expansive view of Castelnau-le-Lez behind her reflects Bazille's bold and increasingly assured use of colour and his innovative approach to compositional structure. Here strong sunlight bathes the background, which has been painted broadly and impressionistically, while the young woman is exquisitely modelled with highly refined detailing seen especially in her earring and face. Bazille had been particularly impressed with Ruben's work, and frequently made copies and drawings at the Louvre, and there is something of the Old Master in his painting of the young girl. Bazille had painted a similar picture four years earlier, and this provides a useful comparison to the later work that demonstrates his growing self-confidence as an artist.

CREATED

Castelnau-le-Lez

MEDIUM

Oil on canvas

SIMILAR WORKS

The Pink Dress by Frédéric Bazille, 1864

The River Bennecourt by Claude Monet, 1868

Frédéric Bazille *Born* 1841 Montpellier, France

Died 1870

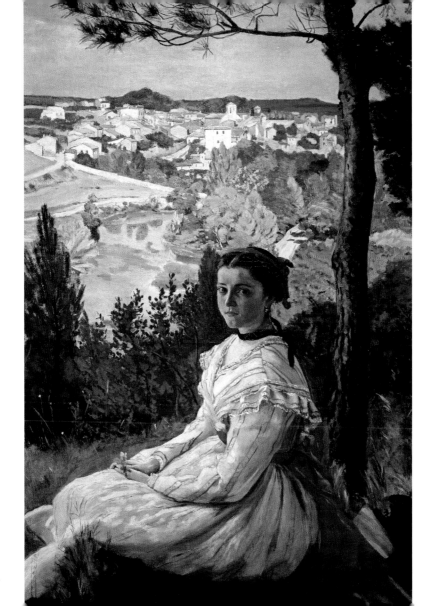

Monet, Claude

The Beach at Sainte-Adresse, 1867

In the summer of 1867 Monet visited his parents' home on the Normandy coast and undertook a number of beach scenes, of which this is one. Earlier that year, his large work *Women in the Garden* had been rejected at the Salon, and these smaller paintings of the beach, fishermen and the middle classes promenading seem to have been conceived with a more commercial purpose. Much of Monet's early career was blighted by financial deprivation and it was essential that he was able to sell his works; of particular importance in 1867 because it was the year his mistress Camille Doncieux gave birth to their first child.

This painting reflects the influence of Boudin and Jongkind, who both specialized in coastal scenes. He has used short, loaded brushstrokes in his depiction of the beach and the clouds, contrasting these textures with a smoothly painted translucent green/blue sea and quite finely painted buildings in the distance. Unlike some of his contemporaries, Monet painted onto a white canvas, which contributed to the lightness and translucent quality of his colours that can be seen to great effect in the water.

CREATED

Sainte-Adresse

MEDIUM

Oil on canvas

SIMILAR WORK

Fishing Boats at Trouville by Eugène Boudin, 1874

Claude Monet *Born* 1840 Paris, France

Died 1926

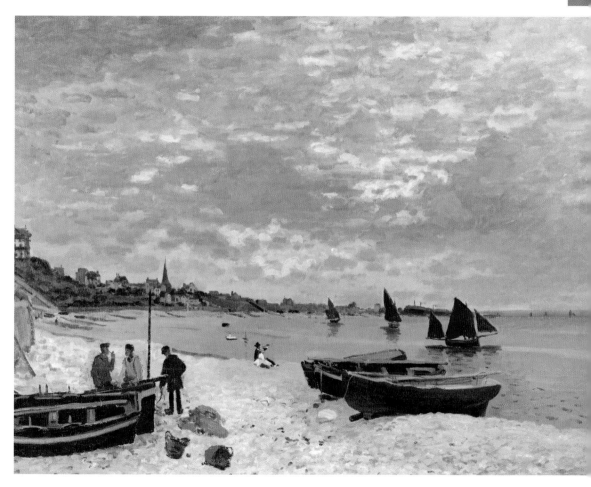

Monet, Claude

Poppies, 1873

© akg-images

Monet had moved to Argenteuil in 1872 and was frequently visited there by Pierre-Auguste Renoir (1841–1919), Alfred Sisley (1839–99) and Manet. An important place for Impressionists, primarily due to Monet being based there, it was painted frequently. By now Monet was regarded as something of a figurehead amongst his contemporaries, a position that remains today, with Monet being widely acclaimed as the leader of the Impressionists.

He painted this beautifully idyllic picture in the summer of 1873, at a time when he was painting numerous scenes of his wife and young son in the garden and surrounding countryside. His technique of small dots of pure, brilliant colour seen especially in the rendering of the poppies, was characteristic of his style during this period. By using these accents of swiftly applied colour across a broader base of green he created the impression of the flowers as though seen through a sunlit haze. The flatly painted figure of the mother and whispered image of the child appear to float down through the long grasses and add to the sense of transience – a fleeting moment, captured.

CREATED

Argenteuil

MEDIUM

Oil on canvas

SIMILAR WORK

Country Footpath in the Summer by Pierre-Auguste Renoir, c. 1875

Claude Monet *Born* 1840 Paris, France

Died 1926

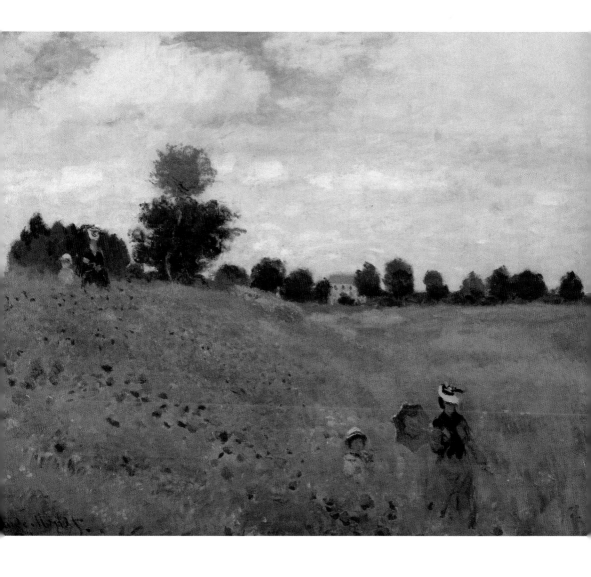

Monet, Claude

Lavacourt Under Snow (detail), *c.* 1878–81

Monet moved to the village of Vétheuil late in the summer of 1878 and lived there for three years. Vétheuil and the surrounding area that included Lavacourt afforded Monet a more rural subject matter – being an area that was still largely unaffected by the growth of industry and had retained its rustic appeal. It was also near enough to Paris to allow Monet easy access to the studio he had retained in the capital and to the galleries and exhibitions. The time that he spent in Vétheuil was highly productive and resulted in almost 300 paintings.

This painting was done at Lavacourt, a village smaller even than Vétheuil, which spread along the banks of the Seine. The cool palette and vigorous brushwork evoke the moisture-heavy, snow-filled sky, and demonstrates his growing preoccupation with the depiction of specific atmospheres. His use of sharp pale blues and pinks in the distance create the sensation of sun filtering down through the clouds and reflecting off a frosty landscape, while the single darkly painted boat draws the eye into the painting and towards the light.

CREATED

Lavacourt

MEDIUM

Oil on canvas

SIMILAR WORK

Snow in Louveciennes by Alfred Sisley, 1878

Claude Monet *Born* 1840 Paris, France

Died 1926

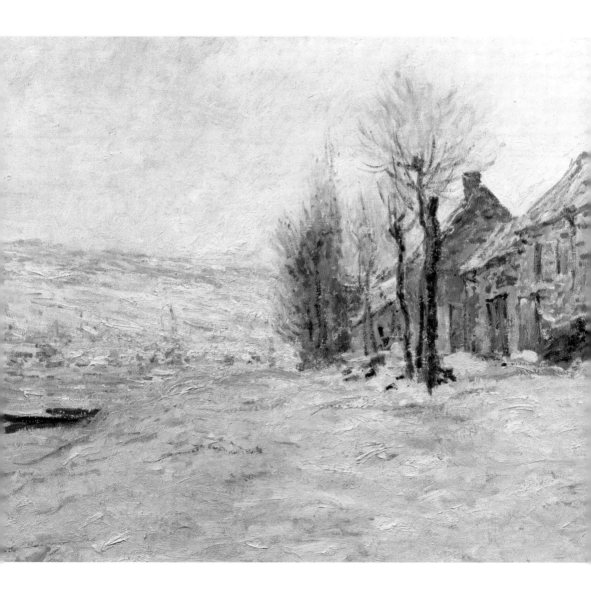

Monet, Claude

The Parliament, Sunset (detail), 1904

© akg-images

When Monet fled to London in 1870 to avoid the Franco-Prussian war it sparked what would become a long love affair with the city. He did not stay long in the capital and he did not return for any significant amount of time for many years, but between 1899 and 1904 he embarked on a series of extended stays that resulted in an enormous number of paintings. In 1904 he exhibited 37 London paintings at Paul Durand-Ruel's (1831–1922) gallery in Paris, winning wide acclaim.

One of the problems facing Monet during his massive series of London paintings was the frustratingly rapid rate at which the light and atmosphere over the Thames changed. This in part led to him starting canvas after canvas, in an attempt to accurately capture the exact impression. In this painting the Houses of Parliament loom up out of the river as a dark shadow, the building's verticality reiterated through the upwards sweep of strong brushstrokes, while the glowing oranges and reds of the sunset, real and reflected, shimmer with an intensity increased through his use of pale highlights in thick, heavy paint.

CREATED

London

MEDIUM

Oil on canvas

SIMILAR WORKS

Waterloo Bridge by Andre Derain, 1906

Dudley, Worcester by Joseph Mallord William Turner

Claude Monet *Born* 1840 Paris, France

Died 1926

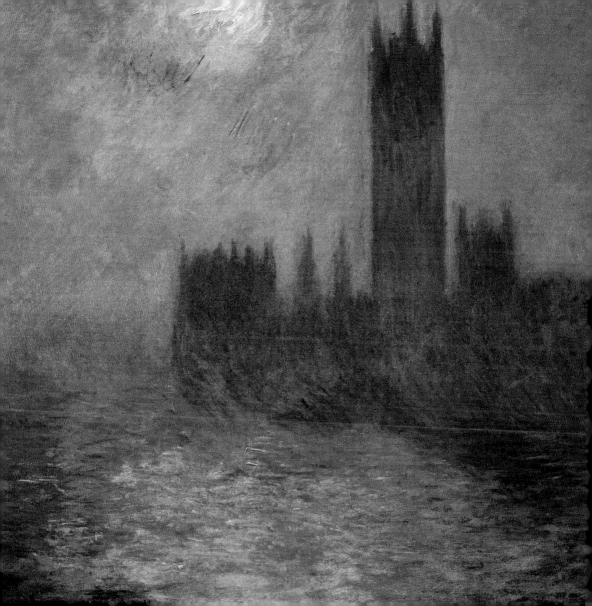

Sisley, Alfred

Chestnut Avenue in La Celle-Saint-Cloud, c. 1865–67

© akg-images

Sisley mainly painted landscape scenes throughout his career, and was not interested in large figural pictures or scenes of urban life. Before pursuing a career in art, he spent two years in England and then studied at Gleyre's studio in Paris with fellow students Monet, Renoir and Bazille. As a landscape artist during the 1860s, his most significant influence was in the form of the realist work of the Barbizon artists, Charles-François Daubigny (1817–78), Théodore Rousseau (1812–67), Jean-Baptiste-Camille Corot (1796–1875) and, to some extent, Gustave Courbet (1819–77).

 This painting reflects these influences but also demonstrates Sisley's use of impressionistic brushstrokes – short, sharp daubs of pale highlights to create the effect of dappling sun and broadly painted ground – and his work would become increasingly impressionistic as his artistic self-confidence grew. The composition is also interesting and creates the effect of being part of a larger continuing scene. The subject of the scene, the chestnut trees, are elusively in the middle ground and separated by the large expanse of rocky foreground. It was a clever technique that encouraged the viewer to look more closely towards the avenue and beyond to the brightly lit field.

CREATED

La Celle-Saint-Cloud

MEDIUM

Oil on canvas

SIMILAR WORKS

Clump of Oaks, Apremont by Théodore Rousseau, 1852

Orchard in Blossom by Camille Pissarro, 1872

Alfred Sisley *Born* 1839 Paris, France

Died 1899

Sisley, Alfred

The Fog, 1874

Sisley exhibited at the Salon three times prior to 1874, although his works seem to have elicited very little comment. During this period he was beginning to work in an increasingly impressionistic manner, and the concept of an 'impression', that is the evocation of atmosphere, weather conditions or time of day, was becoming more central to his work.

Between 1872 and approximately 1875, Sisley lived mostly at Louveciennes, a village to the west of Paris that was the subject of paintings by a number of the Impressionists including Renoir, Camille Pissarro (1830–1903) and Monet. He painted numerous scenes of the pretty village and surrounding landscape during this period, including this painting of a solitary figure stooped and working in a heavy mist. Sisley's paint handling here is similar to Monet's at this time, and he has used small dabs of light paint – white, pinks and yellows – to suggest the bank of flowers in the foreground. His brushwork is short and blocky in the treatment of the leaves and foliage, with broad washes of pale blue and mauves covering the surface of the canvas and creating the sensation of heavy, wet air.

CREATED

Louveciennes

MEDIUM

Oil on canvas

SIMILAR WORKS

Poppies by Claude Monet, 1873

Harvesters by Pierre-Auguste Renoir, 1873

Alfred Sisley *Born* 1839 Paris, France

Died 1899

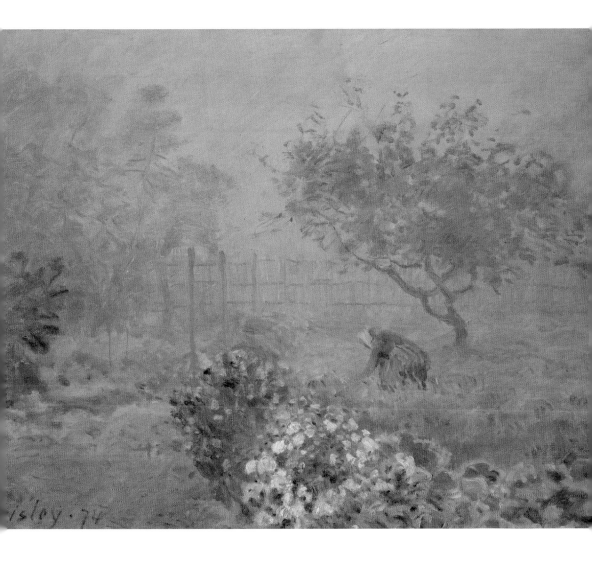

Sisley, Alfred

Spring in Moret-sur-Loing, 1890

© akg-images

By the 1880s the Impressionists as a group had started to fragment, their art developing in different directions, which in part was the natural evolution of their style, but was also reflective of a drop in confidence brought about by continued rejection and in particular by the criticism of their former friend and ally, Emile Zola (1840–1902). Sisley of all the artists however, remained the essential Impressionist, and, though his style matured, it stayed firmly within the precepts of his original objectives.

Sisley's paintings from the last decade of his life are amongst his best works and reflect the culmination of a life spent studying nature. Here the canvas is alive with flickering light reflecting from the trees and water, which itself is contrastingly mirror-like. He has used brilliants points of white, yellow and green to create the dappled effect in a manner reminiscent, or at least aware, of the recent works by Neo-Impressionists and Pissarro. The whole canvas has been reduced to a minimal palette of light green/yellow base with faint mauve underlay and darker brown tones that lend the work a unifying consistency, harmony and balance.

CREATED

Moret-sur-Loing

MEDIUM

Oil on canvas

SIMILAR WORKS

Poplars on the Banks of the Epte by Claude Monet, 1891

Lacroix Island, Rouen, in Fog by Camille Pissarro, 1888

Alfred Sisley *Born* 1839 Paris, France

Died 1899

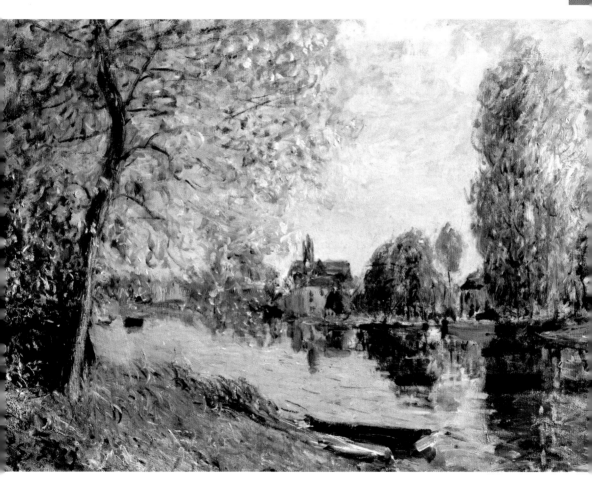

Pissarro, Camille

Hoar Frost, 1873

© akg-images

Pissarro, who was the only one of the Impressionist circle to exhibit at all eight exhibitions, did not pursue any serious artistic training, and instead made sporadic use of the facilities at Académie Suisse. This was run by Charles Suisse, who, for a small fee, provided art students with a model and use of his studio. Pissarro met Monet, Armand Guillaumin (1841–1927) and Paul Cézanne (1839–1906) here and quickly discovered that with regards to their artistic aims, they had much in common.

In 1872 Cézanne moved to Pontoise where Pissarro was living. He wanted to be near to the older artist, and there followed a period in which both artists greatly benefited from the experience of shared ideas. This painting was done during this time and reflects Pissarro's heightened sense of compositional structure, with great spatial depth achieved through graduating colour values. The painting is strongly geometric, with the dark furrows of the land making a dramatic vertical and gradually diagonal statement that is counterbalanced through the diagonal swathes of frost. It is an extraordinary painting, and is one that in many ways was before its time.

CREATED

Pontoise

MEDIUM

Oil on canvas

SIMILAR WORK

Landscape: Study After Nature by Paul Cézanne, 1876

Camille Pissarro *Born* 1830 St Thomas, West Indies

Died 1903

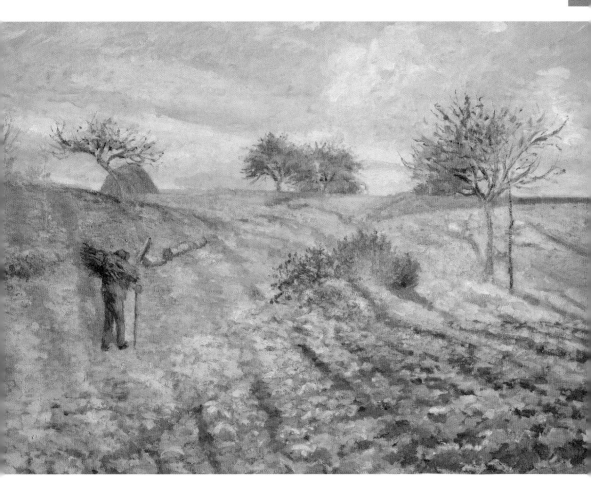

Pissarro, Camille

Kitchen Garden at L'Hermitage, Pontoise (detail), 1874

This painting was completed in the same year as the first Impressionist exhibition, and during the time when Pissarro was still absorbing elements of Cézanne's work (and vice versa), the two artists living and working in close proximity. One of the overriding considerations with Pissarro was his openness to new ideas, and his readiness to experiment with new techniques. This became particularly obvious later in his life, but throughout his career he consistently used different methods, changing his brushstrokes, varying structural and compositional elements and altering the tonal qualities of his palette.

He produced a number of paintings of gardens, as did many of his contemporaries, but this one is especially striking in its geometric composition created through the straight lines of the flowerbeds and paths that contrast with the organic forms of the trees in the foreground, and the roundness of the broadly painted cabbages. His broken brushwork and use of bright colours with vivid accents seen in the chimney pots, enlivens the scene and lends it a sense of almost hyper-reality while the actuality of life has become greatly concentrated.

MEDIUM

Oil on canvas

SIMILAR WORK

The Fields by Alfred Sisley, 1874

Camille Pissarro *Born* 1830 St Thomas, West Indies

Died 1903

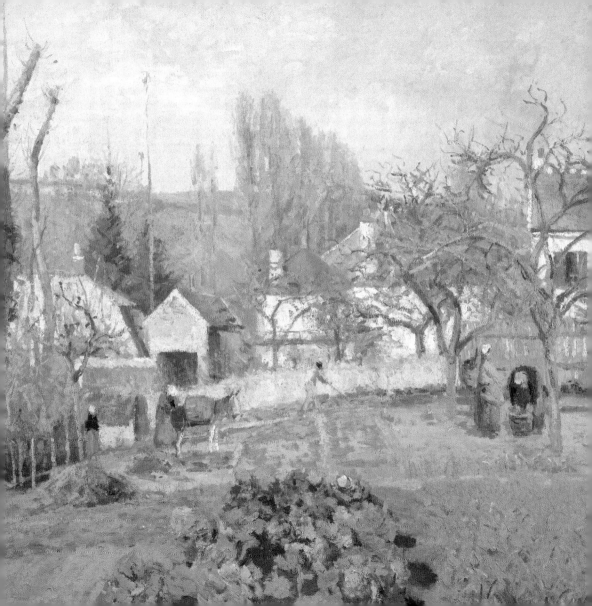

Pissarro, Camille

The Cote des Boeufs at L'Hermitage, Pontoise (detail), 1877

© National Gallery, London, UK/The Bridgeman Art Library

The year that Pissarro painted this picture, 1877, was the year of the third Impressionist exhibition. The show was largely organized and financed by Gustave Caillebotte (1848–94), helped by Renoir, with Pissarro and Monet joining them to form the hanging committee. Only 18 artists took part, but these included all the key Impressionist painters with the exception of the American artist Mary Cassatt (1844–1926) who joined the group after the exhibition. It is considered that this exhibition was the most cohesive in terms of representing Impressionism as a movement, and included over 230 paintings. Perhaps unsurprisingly works by Caillebotte, Renoir, Monet and Pissarro dominated, with Pissarro showing 22 landscapes of Pontoise, Auvers and Montfoucault.

This painting of red-roofed houses peeping from behind a grill of trees was painted in the village of L'Hermitage just outside Pontoise, and was one of several paintings that Pissarro made of the same subject. It is characteristic of his style at this time, with its heavily textured surface and thickly applied short daubs of paint. The short strokes of broken, bright colour across the canvas lend the painting its atmospheric and highly impressionistic feel, with the two small figures fleetingly emerging from the landscape surrounding them.

MEDIUM

Oil on canvas

SIMILAR WORK

Landscape, Louveciennes, Autumn by Alfred Sisley, *c.* 1875

Camille Pissarro Born 1830 St Thomas, West Indies

Died 1903

Pissarro, Camille

Woman in the Meadow at Eragny, Spring, 1887

© Giraudon, Musée d'Orsay, Paris, France/The Bridgeman Art Library

By the mid-1880s Pissarro had become frustrated with his style and was searching for a different expression. In 1885 he met Paul Signac (1863–1935) and later Georges Seurat (1859–91), and was particularly taken with the younger artists' radical scientific approach to their painting. Based on the colour theories propounded by Eugène Chevreul (1786–1889) and other investigations into the scientific analysis of colour and optical illusion, Seurat had devised a method of painting with tiny dots of pure primary colours, that when aligned in certain ways would produce different effects of colour, and levels of intensity. The basis for the theory was in essence founded on the principles of complementary colours.

Pissarro began to work along these lines, replacing his fluid brushstrokes with controlled daubs and points of colour. Durand-Ruel and others received his first paintings in this manner with surprise, but Pissarro quite quickly tired of this regimented and controlled manner of painting, and by 1888 had reverted back to a more Impressionist approach. This painting reflects his use of careful brushwork combined with brilliant colour, but also shows a certain rebellion against the strictures of Neo-Impressionism with his brushstrokes gradually starting to gain fluidity again.

CREATED

Eragny

MEDIUM

Oil on canvas

SIMILAR WORK

The Railway at Bois-Colombes by Paul Signac, 1886

Camille Pissarro *Born* 1830 St Thomas, West Indies

Died 1903

Renoir, Pierre-Auguste

Portrait of Blanche Marie Renoir, 1870

Renoir had trained and worked as a porcelain painter, before entering Gleyre's studio where he met and befriended Monet, Bazille and Sisley. From the outset Renoir was a 'colourist' – it was colour that he concentrated on and it was of primary importance to him. This was in direct opposition to Gleyre, for whom line and draftsmanship were of utmost importance. Renoir also spent many hours in the Louvre copying French Masters of the eighteenth century, and this affinity with eighteenth-century French art is something that hovers in the background of his 'modern day' paintings. From joining Gleyre's studio in 1862 to 1868 Renoir experimented with a number of different styles, influenced by Courbet and the Barbizon painters, and by his friends Monet and Sisley, all the while searching for his own expression.

In 1868 he painted two large portraits, *Alfred Sisley and His Wife* and *Lise*, who was Renoir's mistress. For the first time there is evidence of his maturing style and his visual language had suddenly become his own. Two years later he painted this portrait, which shows his prowess at achieving form through modelling, with the figure emerging from an interplay of coloured shadow into half-illumination.

CREATED

Paris

MEDIUM

Oil on canvas

SIMILAR WORK

Portrait of Madame Pontillon by Berthe Morisot, 1871

Pierre-Auguste Renoir *Born* 1841 Limoges, France

Died 1919

Renoir, Pierre-Auguste

Path Climbing up Through the Tall Grass, 1876–77

© akg-images

At the time of this painting, Renoir was living in Paris and supplementing his income through portraiture. Monet, with whom Renoir was close friends, was living at Argenteuil and it was here that Renoir would go to paint landscapes alongside his friend. Renoir is primarily associated with figurative works, but during the 1870s he produced a number of paintings similar to this that feature small figures set within a landscape, a motif that allowed him the opportunity to experiment with impressionistic renderings of nature.

He has used a white ground here, which was a technique that Monet also used, because it brightened the colours and added luminosity. Over this Renoir applied broad areas of greens and yellows, with broken brushstrokes overlaid to create the effect of the moving grass and shimmering poppies. He painted the figures themselves, the trees, fence posts and shadow in a dark, near black, tone that contrasts sharply with the surrounding scenery and provides an obvious vertical note in the composition. The composition and the spatial arrangement are quite traditional, using the path to lead from the foreground to the horizon – a trick used by both Sisley and Monet.

CREATED

Argenteuil

MEDIUM

Oil on canvas

SIMILAR WORK

Poppies by Claude Monet, 1873

Pierre-Auguste Renoir *Born* 1841 Limoges, France

Died 1919

Renoir, Pierre-Auguste

Female Nude in the Sun, c. 1876

© akg-images

In the mid-1870s, Renoir became preoccupied with depicting the effect of sunlight on figures, particularly that of dappled sunlight filtering through the leaves of trees. He painted a number of pictures to such effect, posing models (often friends) in the garden of his house in Paris or in the large park area behind. In these works it is the effect of the sunlight on the figures that absorbed Renoir, rather than the figures themselves. This meant they become de-objectified, which can be seen clearly in this study. The model's face is blurred as the brilliant light causes a hazy effect, and her nude body patterned with purple and green shadows has assumed an organic state making her appear part of the natural surroundings in which she sits. The study was particularly unconventional, with its background of almost abstract, highly lit foliage, stippled light patterns and vivid colouring. He used rapid, fluid brushstrokes in the foliage and softly modelled the female form, contrasting the two types of expression and contributing to the uniqueness of the image.

CREATED

Paris

MEDIUM

Oil on canvas

SIMILAR WORK

Camille in a Garden, Springtime by Claude Monet, c. 1875

Pierre-Auguste Renoir *Born* 1841 Limoges, France

Died 1919

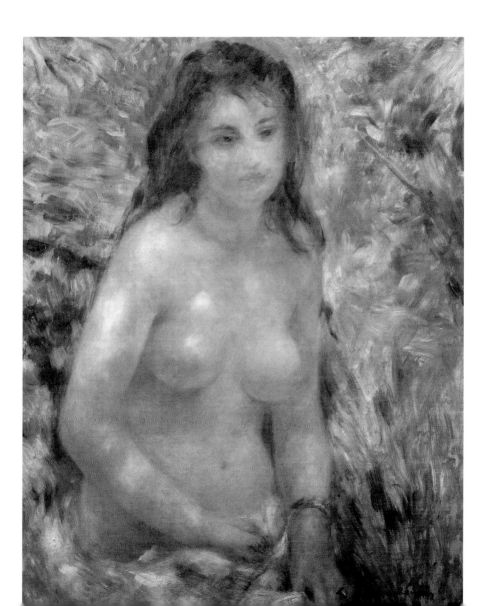

Renoir, Pierre-Auguste

Two Sisters (On the Terrace), 1881

Two Sisters was painted in 1881, something of a definitive year for Renoir. He had just finished his monumental *Luncheon of the Boating Party* and had finally achieved a degree of financial stability.

The painting reflects Renoir's use of brilliant, jewel-like colour, which he has used across the surface of the canvas in a pattern of vibrant contrasts. The pure red notes of the girl's hat and fruit are characteristic of his work during this period, and are used here to focus the eye to the central pyramidal grouping of the girls and the fruit. The composition is unusual, with the sisters pressed into the foreground and the railings of the balcony behind increasing the sense of their proximity. Renoir treated the background with fluid, Impressionist brushstrokes and earthy, organic tones that contrast with both the colouring and the treatment of the foreground. Perhaps most interesting of all is Renoir's inverted focus on the sisters. He has painted the youngest girl, who is nearest to the fore, in an Impressionist manner, with her facial features suggested rather than defined, whereas the older girl, who is further away, has been painted in a closer focus with greater detailing.

CREATED

Paris

MEDIUM

Oil on canvas

SIMILAR WORK

Summer Day by Berthe Morisot, 1879

Pierre-Auguste Renoir *Born* 1841 Limoges, France

Died 1919

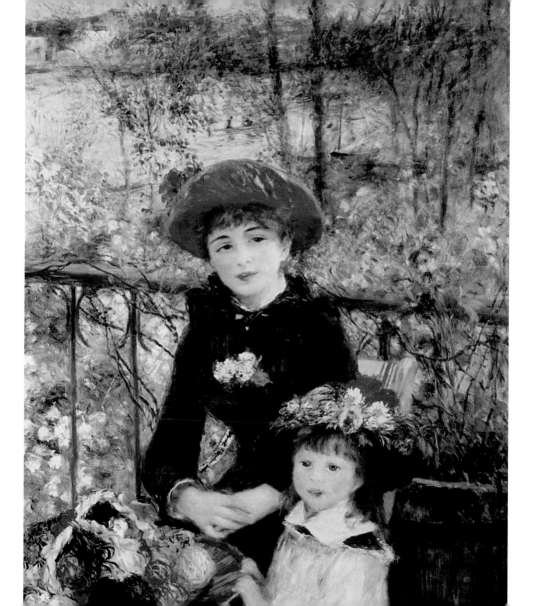

Renoir, Pierre-Auguste

Motherhood (Nursing Mother), 1886

Renoir was able to travel to Italy and Algiers in 1881 and both places had a profound impact on his art. Italy particularly reaffirmed his long-held interest in the Renaissance Masters, especially Raphael (1483–1520) and he followed in the footsteps of Jean-Auguste-Dominique Ingres (1780–1867) in studying the Classical Masters. Algeria had a similar effect on him, as it had on the colourist Eugène Delacroix (1798–1863).

Subsequent to this trip, Renoir had begun to reject Impressionism in favour of works with a timeless, monumental significance. At around the same time, he placed more emphasis on drawing and line, making numerous preliminary sketches, and at times drawing his composition onto the canvas first. This painting of his mistress Aline Charigot nursing their first son Pierre, has a sense of the Italian Renaissance depictions of the Madonna and Child. It is a strangely disquieting combination of the formal, seen in the clean lines of the central group, and the informality of the setting and sketchily painted background. He used a thick, white ground and painted the background thinly, so that the white shines through and adds luminosity. In contrast to this, the two figures are precisely painted with opaque paint and a smooth finish.

CREATED

Paris

MEDIUM

Oil on canvas

SIMILAR WORKS

Portrait of Two Children by Berthe Morisot, 1893

Mother and Boy by Mary Cassatt

Pierre-Auguste Renoir *Born* 1841 Limoges, France

Died 1919

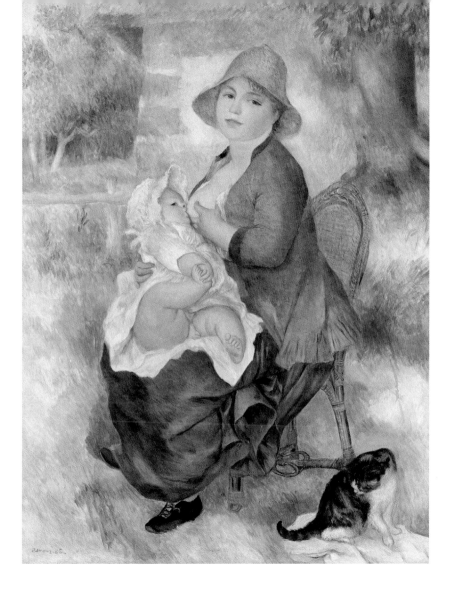

Renoir, Pierre-Auguste

The Bathers, 1887

This painting was the result of three years of studies, sketches and experiment as Renoir struggled to find a new means of expression through following the changing perceptions surrounding his art. The work was entirely done in his studio, a departure from his early Impressionist days, and reflects his attempts to produce a monumental figural composition within a landscape setting. He was preoccupied with creating an air of timeless significance on the scale of the Masters of the Italian Renaissance.

There is no play of light or atmosphere here; instead the scene is flooded with the brightness of artificial studio lighting. The figures, which appear contrived in posture, owe something to the influence of Ingres in this careful drawing and clear linear quality, but Renoir combined this with his continued love of colour. At the time of painting this he was experimenting with his oil paints, which he found too fluid, and was removing much of the oil medium to produce a matt surface more like that of frescos. Unfortunately, with the oil being the binding agent, the paintings done in this manner, of which this is one, have suffered deterioration.

CREATED

Paris

MEDIUM

Oil on canvas

SIMILAR WORKS

The Turkish Bath by Jean-Auguste-Dominique Ingres, 1863

Le Concert Champetre by Titian, c. 1510

Pierre-Auguste Renoir *Born* 1841 Limoges, France

Died 1919

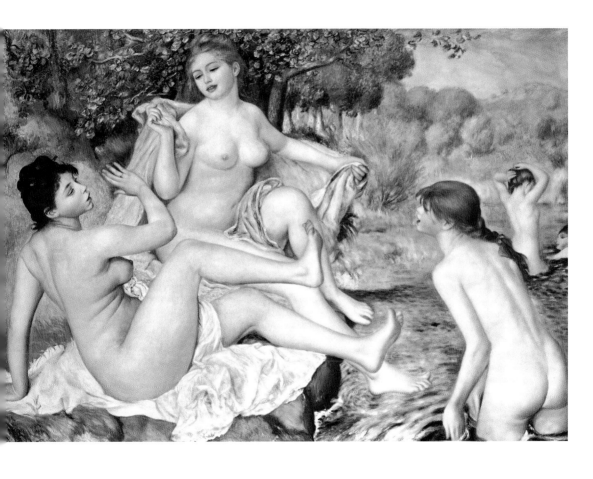

Guillaumin, Armand

Paysage, c. 1872

© akg-images

Guillaumin met Cézanne and Pissarro at the Académie Suisse where he used the facilities and models, in between working a full-time job. He was from a poor family who were unable to offer him financial support to pursue his artistic career. Consequently for much of his career he worked and painted in his free time, although in 1891 he won a prize in the National Lottery that made him financially independent.

He remained close friends with Cézanne and Pissarro throughout his life, and the three artists benefited from their shared artistic ideas. In the early 1870s, the three spent some time painting together in and around Pissarro's home at Pontoise, and the painting that was done around this time reflects elements of both Cézanne's and Pissarro's influence. Guillaumin was also developing his own personal language however, and here his brilliant colouring and strongly modelled form predict the manner in which his style would develop. Here he has used vibrant blue and purple as his basic colours, with a gradation of these two across the canvas to create a unifying scene of drama and a heavy, wet atmosphere.

CREATED

French coast

MEDIUM

Pastel on paper

SIMILAR WORK

L'Estaque at Dusk by Paul Cézanne, 1863

Armand Guillaumin *Born* 1841 Paris, France

Died 1927

Guillaumin, Armand

The Creuse in Summertime, 1895

Guillaumin concentrated on landscapes, and worked in an impressionistic manner using rapid, broad brushstrokes and painting in front of the motif. He was unaffected by the growing interest in Neo-Impressionism during the late 1880s, although he defended his friend Pissarro when he began to work in this manner. Instead, Guillaumin remained an essential colourist throughout his career and, as his style matured, his interest in colour and expressive colour increased. This painting was done during a period when his use of colour would seem to anticipate the work of the Fauves. Significantly, Guillaumin had also been friendly with Van Gogh prior to his death in 1890, and there is something of Van Gogh's voice present in this painting. Guillaumin has used short, broken brushstrokes loaded with vibrant colour to depict the rippling river Creuse with its fragmented reflections, while the hills behind are more broadly painted with deep tonal purples and greens forming shadows across the ground surface. It is a richly evocative work that sees the relatively mundane view of a river and hill with no particular focus, turned into something deeply moving and enigmatic through the clever use of colour.

CREATED

Creuse

MEDIUM

Oil on canvas

SIMILAR WORKS

La Côte, Collioure by Henri Matisse, *c.* 1905–06

Bend in the Forest Road by Paul Cézanne, 1902

Armand Guillaumin *Born* 1841 Paris, France

Died 1927

Degas, Edgar

Gentlemen Race (Before the Departure), 1862

© Lauros/Giraudon, Musée d'Orsay, Paris, France/The Bridgeman Art Library

Degas studied at the *École des Beaux-Arts* under a follower of Ingres, and received a traditional artistic education that could have seen him progress as a history painter. He painted several history pieces and exhibited at the Salon early in his career, but his diary, published in 1921, shows entries dating back to 1859 that list modern subjects he considered important to study. This shows the artist developing his unorthodox and unique approach at the same time as continuing his conventional education. Degas, along with Manet, was one of the first artists to address the subject of modern urban life, and as such he was one of the pivotal figures in the Impressionist movement.

This painting of racehorses depicts a subject he first addressed in around 1861 after a trip to the races, and it was one he continued to paint for the majority of his career. Here he has used a fairly conventional frieze-like composition, unlike many of his later racehorse paintings, and has included smoking factory chimneys in the distance, acknowledging the growth of industry in and around Paris.

CREATED

Paris

MEDIUM

Oil on canvas

SIMILAR WORK

Race Course at Longchamps by Édouard Manet, 1864

Edgar Degas *Born* 1834 Paris, France

Died 1917

Degas, Edgar

The Song of the Dog, c. 1876–77

© akg-images

Unlike many of his contemporaries, Degas did not often paint landscapes and rarely, if ever, painted *en plein air*. His subjects focused on modern life in Paris, the café culture, dance, races and women. He was interested in the juxtaposition of figures and their surroundings to create an oblique or truncated view, or one that created confusing perspective, raised questions and challenged the viewer. He increasingly worked in pastels, as in this picture, due in part to his failing eyesight. The pastels allowed him to work more quickly and freely than oil paint, and gave his works a softness of outline that lent them an evocative, atmospheric feel. The pastel medium has a certain textured surface quality that creates a different sensation to paint – a sense of immediacy that is lost through the labour of oils. This is particularly present in this work where the singer Emma Valadon (1837–1913) mimics a dog singing in one of Degas's favourite night-time haunts. It is a humorous subject and he has captured perfectly Valadon's slightly whimsical expression, with the glowing globes of light behind the singer lending the work a somewhat surreal edge.

CREATED

Paris

MEDIUM

Gouache and pastel on monotype

SIMILAR WORKS

Jane Avril Dancing by Henri de Toulouse-Lautrec, 1892

Café Concert Singer by Édouard Manet, 1879

Edgar Degas *Born* 1834 Paris, France

Died 1917

Degas, Edgar

Woman Washing Herself, 1886

© akg-images

From around 1877 onwards Degas increasingly began to depict women washing and in various stages of undress. The women in his pictures, such as here, are unaware of the viewer, which lends them a voyeuristic quality that has caused debate over Degas's motivations and opinion of women ever since. These images, which he did in pastels, charcoal, oil and sculpted, were approached with an almost obsessive intensity, matched only by the vigour with which he depicted his ballet dancers.

In this picture he has used a startling composition and spatial organization with a distorted perspective. The whole arrangement is broken into simple geometric shapes, the rectangular shelf, circular bath and elliptical form of the woman, which creates an almost abstract quality, heightened by the distortion of the perspective. The hairbrush balanced on the edge of the shelf is a further note of discord. It is a scene of tension, although many of these images created different subtle emotional states such as relaxation or agitation. He has used pastels in sombre tones that have been applied sketchily in places to allow the colour of the base to show through, which gives it a warm, soft quality.

CREATED

Paris

MEDIUM

Pastel on card

SIMILAR WORK

Woman Putting on her Stocking by Henri de Toulouse-Lautrec, *c.* 1894

Edgar Degas *Born* 1834 Paris, France

Died 1917

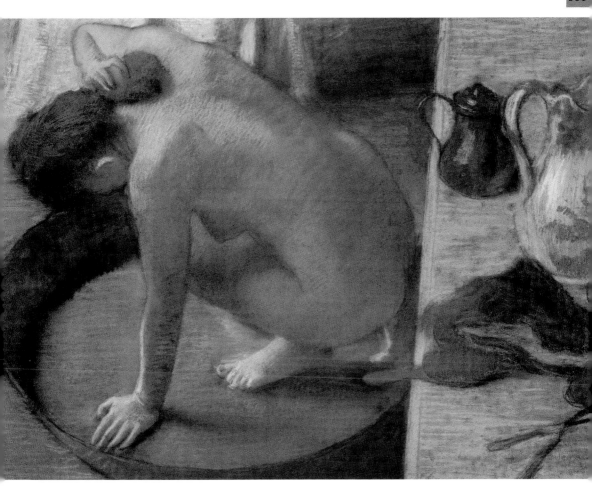

Degas, Edgar

Green Dancers (detail), 1900

© akg-images

Degas increasingly isolated himself from his colleagues in the Impressionist circle from the late 1880s, and instead worked and lived in Paris, surrounded by just a few friends. He exhibited only once following 1886 and, struggling with his deteriorating eyesight, took up sculpting wax figures of ballet dancers and horses.

In these last years of his working life, his output consisted almost entirely of pastels and drawings (and wax figures) of dancers. Due to his failing sight, his works tended to become more vibrant in colour, with colour and surface texture becoming more important than preciseness of form. However his work off 1900 shows an incredible lightness of touch, with the impressionistic rendering of the dancers' skirts creating an astonishingly realistic image of the net and toile material. He has used a combination of pastel and gouache, applied thinly and rapidly over the surface, and softened and blurred around the dancers to evoke the sense of movement. The use of outline in his principal figures is quite evident here – something seen in many of these late works – while the dancers in the background are more impressionistic in style.

CREATED

Paris

MEDIUM

Pastel and gouache

SIMILAR WORK

Quadrille at the Moulin Rouge by Henri de Toulouse-Lautrec, 1892

Edgar Degas *Born* 1834 Paris, France

Died 1917

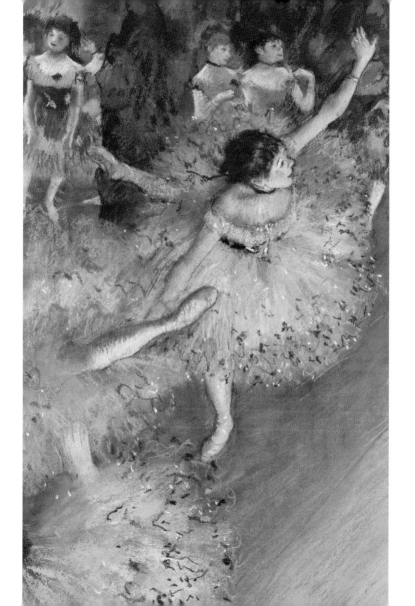

Caillebotte, Gustave

Paris, a Rainy Day, 1877

© Giraudon, Musée Marmottan, Paris, France/The Bridgeman Art Library

The independently wealthy Caillebotte became an important member of the Impressionists, for his work and also because he bought many of his friends' paintings, helping them financially. He eventually bequeathed his collection to the nation, although it was poorly received at the time!

He met Degas in around 1874, and he along with Manet would become the most significant influence on Caillebotte's art. He was drawn to the idea of capturing a moment of passing time, but brought to his work a vivid realism, bordering almost on the photographic. This can be seen in *Paris, Rainy Day*, a picture that combines Realism and Impressionism in one fluid sweep. Caillebotte characteristically used unusual perspectives and viewpoints in his work, and this is no exception. His figures here have a purpose, they are all doing something other than promenading and are trying to get somewhere – the man in the foreground appears on the verge of stepping out of the picture frame. He has used tight brushwork, in contrast to the technique used at this time by his contemporaries, and solid areas of colour, while still achieving the effect of a rainy atmosphere.

CREATED

Paris

MEDIUM

Oil on canvas

SIMILAR WORK

Place de la Concorde by Edgar Degas, 1876

Gustave Caillebotte *Born* 1848 Paris, France

Died 1894

Caillebotte, Gustave

Bathers, 1878

© akg-images

Caillebotte often used plunging spatial depths and unusual perspectives that placed the viewer within the scene of his painting. This can be seen here: the diving plank looms out of the canvas and the viewer becomes a participant. He also worked in a manner that combined Realism and Impressionism, giving his works a highly three-dimensional, photographic quality, which was widely derided by the critics. He has used a combination of broken brushwork, seen in the river, foreground and foliage and solid areas of colour which can be seen in the figures and tree trunk. His palette is bright and based on purple and green tonalities throughout the canvas, which creates the effect of summer light and the slight haze from light reflecting off water.

Caillebotte painted the full range of Impressionist subjects and produced a large number of works during his career. Because he did not need to sell his paintings, many of them remained within his family, not entering the art markets, and as such he became one of the 'forgotten' artists of the Impressionists. More recently his work has enjoyed something of a revival and is now receiving the attention it deserves.

CREATED

Along the River Yerres

MEDIUM

Oil on canvas

SIMILAR WORK

Boating by Édouard Manet, 1874

Gustave Caillebotte *Born* 1848 Paris, France

Died 1894

Morisot, Berthe

In the Cornfields, 1875

© akg-images

Morisot studied art with her sister Edmé under the watchful eye of the Barbizon artist Corot. Her contemporaries amongst the Impressionists – Monet, Renoir, Pissarro, Sisley and Bazille – had also travelled frequently to Barbizon in the footsteps of the Realist painters before them, and were divided in their admirations between Corot, Millet and Courbet. It seems however that the Barbizon painters themselves were not especially receptive to the new group of artists, with Millet in particular maintaining a distance. Being taught by Corot (especially in the art of *plein air* painting) put Morisot in a sound position regarding her future emergence as a distinguished artist.

This work reflects Morisot's highly impressionistic method. She has used broad, swift brushstrokes, contrasting horizontals with the vertical strokes of the grass and the figure. The composition is broken into several horizontal planes defined through colour: the foreground, the vibrant band of grasses, the buildings on the horizon. The sense of horizontality is furthered through the relatively uniform buildings and trees in the distance, and the low sky that emphasizes the enormous spatial recession from foreground to background.

CREATED

Gennevilliers

MEDIUM

Oil on canvas

SIMILAR WORK

The Four Seasons, Summer by Camille Pissarro, 1872

Berthe Morisot *Born* 1841 Bourges, France

Died 1895

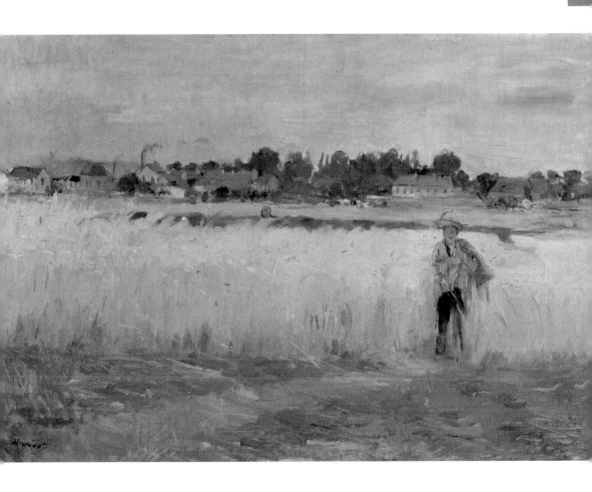

Morisot, Berthe

Eugène Manet on the Isle of Wight, 1875

Morisot had enjoyed a close relationship with Manet from the late 1860s, and in 1874 married his brother Eugène who appears in this painting. Manet is often cited as Morisot's teacher and mentor, but in actuality the two shared a more reciprocal relationship, and exerted a certain amount of influence on each other. Morisot worked in an Impressionist manner throughout her career, although her style developed within this framework. Here she has used an interesting composition with the figure of Eugène in the immediate foreground and pushed up to the front of the canvas, which was a technique deployed by many of the Impressionists at this time. The rest of the scene then unfolds through the window, with the female figure's head being rather unsettlingly separated from her body through the lower window frame. She has used thick paint with a combination of sketchy and broad brushstrokes, and points of brilliant colour, as in the flowers of the garden. She characteristically painted scenes of domestic interiors, like this one, and her family, both of which were subjects within her reach as a female artist of the nineteenth century.

CREATED

Isle of Wight

MEDIUM

Oil on canvas

SIMILAR WORKS

Argenteuil by Édouard Manet, 1874

Two Sisters (On the Terrace) by Pierre-Auguste Renoir, 1881

Berthe Morisot *Born* 1841 Bourges, France

Died 1895

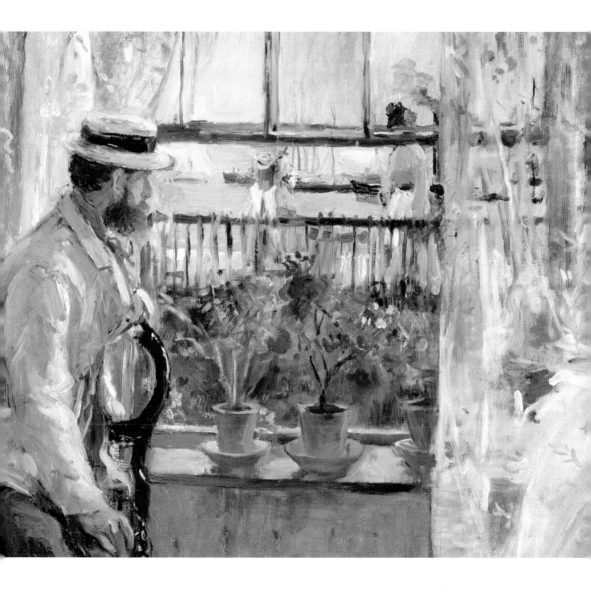

Cassatt, Mary

Girl in the Garden, c. 1880–82

© akg-images

The American artist Mary Cassatt (1844–1926) was, along with Morisot, one of the leading female painters of the Impressionists, and was also instrumental in promoting and introducing the Impressionists' work to America. She studied with Pissarro in Paris before meeting Degas in 1877. The two would become close friends, and his work had something of an influence on her. However, Cassatt, more than Morisot, continually experimented with different styles and techniques, and moved away from Impressionism towards the end of her career.

In 1879 Cassatt exhibited at the fourth Impressionist exhibition after being invited to do so by Degas. This picture, of a girl in a garden, was painted some time after this, and it shows her impressionist approach. She chose an unusual angle for the composition, which was something that Degas also used, and painted the girl's dress sketchily, allowing the green behind to show through and become part of the colour of the material. There is a soft, blurred quality to her handling of paint that creates an atmospheric image, and is almost pastel-like in rendition – pastels were a medium that she used frequently, especially from the 1890s onwards.

CREATED

Paris

MEDIUM

Oil on canvas

SIMILAR WORKS

Seated Woman by Edgar Degas, 1887

Summer by Pierre-Auguste Renoir, 1875

Mary Cassatt *Born* 1844 Pennsylvania, USA

Died 1926

Cassatt, Mary

Clarissa with a Fan, c. 1895

In the early 1890s Cassatt's style underwent a dramatic change and she concentrated her efforts on pastels and printmaking. Her colours had strengthened and become bolder and she had started to use a clearly defined outline. This, combined with her use of a flattened pictorial space, was reminiscent of Japanese prints, of which she had become a great admirer. In this pastel she has combined strong draughtsmanship with soft colouring, the medium of pastel being conducive to a grainy, soft, blurred effect. The figure and composition is flattened, and falls between a realistic depiction and one of a stylised nature. The woman's face is gently rounded and convincing, while her body is quite two-dimensional, an effect that has been emphasised by the flatness of the fan she holds to her. This, added to the narrow pictorial space that she occupies, lends the work a unique appeal that entices the viewer to question what they are seeing. In 1891 Cassatt exhibited a series of lithographic prints that were highly original with their bold colouring, outline and flattened perspective. This pastel of some years later recalls these earlier prints while furthering Cassatt's experiments in pastels.

CREATED

Paris

MEDIUM

Pastel

SIMILAR WORK

Woman Ironing by Edgar Degas, 1892

Mary Cassatt *Born* 1844 Pennsylvania, USA

Died 1926

Cézanne, Paul

Portrait of Victor Chocquet, 1875

Cézanne first met Pissarro when the two artists were using the facilities at the Académie Suisse in Paris, and Pissarro immediately recognized the younger artist's talent. Later the two worked side by side at Pontoise where Pissarro lived, and mutually helped and influenced each other. Cézanne was perhaps one of the most important artists within the Impressionist group in terms of moving artistic expression along and into the twentieth century. His visual language was so unique and so expressive that it became a springboard for the next generation of artists, and saw the development of Cubism, Abstraction, the Fauves and Modern Art.

This portrait of one of Cézanne's main patrons, Victor Chocquet, was shown at the third Impressionist exhibition and was widely mocked. It is typical however of Cézanne's unorthodox and expressive rendering. He has used thick, strong brushstrokes that appear to 'build' the three-dimensionality of the face creating a rough and tactile surface quality. The brushstrokes build on one another at different angles and with different strength and size creating a collage of intermingled brushwork that greatly enlivens the face and lends it mobility and verve.

CREATED

Paris

MEDIUM

Oil on canvas

SIMILAR WORK

Old Peasant by Vincent Van Gogh, 1888

Paul Cézanne *Born* 1839 Aix-en-Provence, France

Died 1906

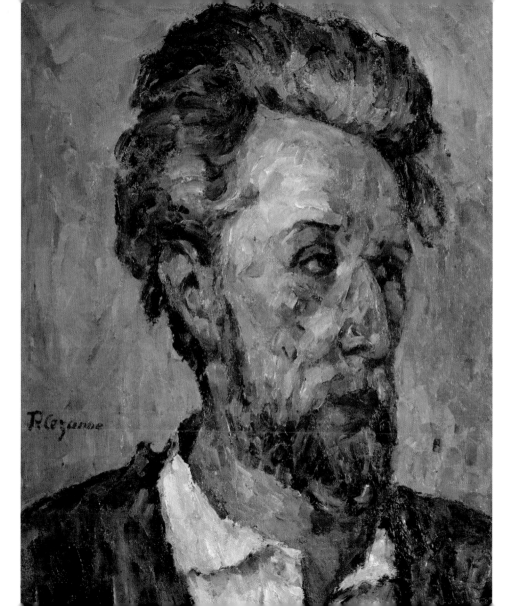

Cézanne, Paul

Three Bathers, 1879–82

This image is one of a series of scenes by Cézanne which depict nudes bathing. Henri Matisse owned an almost identical version. He bought it in 1899 and it stayed in his collection for 37 years before it was donated to the Petit Palais. It has since become one of the most famous bathing scenes of the nineteenth century due to the extent of its influence on Matisse in the way he modelled his figures and his use of colour.

There is a sense of timelessness, history and classical past in the depiction of a bathing scene such as this. The monumental figures themselves appear as icons of female nudity, while the image was rendered in a characteristically Cézanne manner, with thick, rapid and intense brushwork and vibrant colour. The explosion of colour in the background foliage lends the work a surreal, expressive edge that was taken up by the Fauves in their landscapes. The heavy outlines of the figures have a sculptural quality to them. An earlier painting of the same subject was bought by Henry Moore, who made a set of sculptures modelled on the three figures.

CREATED

France

MEDIUM

Oil on canvas

SIMILAR WORKS

Pastoral by Henri Matisse, 1905

Nude in a Wood by Henri Matisse, 1906

Paul Cézanne *Born* 1839 Aix-en-Provence, France

Died 1906

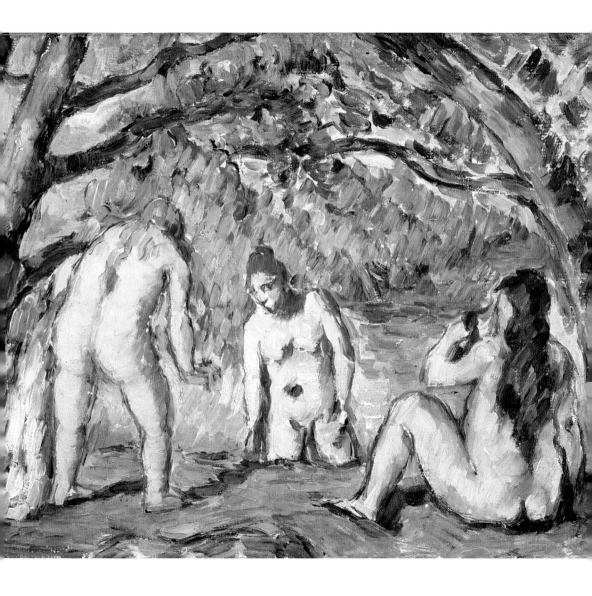

Cézanne, Paul

Still Life with Apples (detail), *c.* 1899

Of the six related still life paintings that included the same jug, drapery and fruit, this is the most vividly rendered and lavishly coloured. In this picture Cézanne has used a close focus and arranged the composition so that the eye is drawn first to the bottom of the canvas, and then travels slowly upwards towards the heap of oranges in the china stand. This was a technique used by many of the Dutch Masters of still life, and was one that Cézanne used in several of his paintings of Mont Sainte-Victoire. The focus here is so close that the drapery extends beyond the frame, lending the picture a great sense of immediacy. He has treated the drapery with opulent colour and pattern suggested through thick brushstrokes on the left and contrastingly fine painting on the right. The brilliant white cloth in the front stands out against the fabric of the background and he has sensationally created the sense of soft reflection on the white through careful light blue-white and white-beige tones, while the deep folds create a sense of geometric pattern.

CREATED

France, Paris or Aix-en-Provence

MEDIUM

Oil on canvas

SIMILAR WORK

Still Life with Blue Tablecloth by Henri Matisse, 1906

Paul Cézanne *Born* 1839 Aix-en-Provence, France

Died 1906

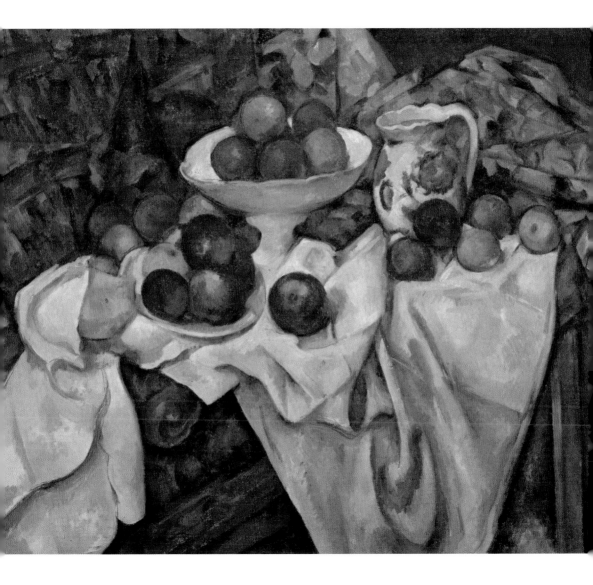

Cézanne, Paul

Bridge Over a Pond (detail), *c.* 1898

There is a sense of claustrophobia in this work – the canvas is dominated by Cézanne's pre-dominate green palette and just a glimpse of sky. The effect is heightened by the trees and foliage reflected in the pond, which becomes a mirror of reality, with the line between the actual scene and the reflection becoming blurred. The canvas is dense with green, there being little in the way of relief other than the few spots of brilliant light, and this creates a very intense feel, added to which there is a tension and rapidity in his brushwork. He has used broad, blurred strokes and has built a solid weave of geometric pattern across the surface. The reflection of the trees has become a surreal experiment with abstracted, cubist forms, while the trees themselves are painted with a more organic feel. The bridge divides the canvas both in terms of literal space (the natural above, the reflection below) and stylistically (the organic above, the abstract below) and so in one canvas Cézanne has created an extraordinarily modern and unique vision. His use of geometric blocks of colour, and the intensity of his work increased towards the end of his career.

CREATED

Probably Aix-en-Provence

MEDIUM

Oil on canvas

SIMILAR WORK

Landing Stage, L'Estaque by Georges Braque, 1906

Paul Cézanne *Born* 1839 Aix-en-Provence, France

Died 1906